Decorating Rich

Decorating Rich

How To Achieve A Monied Look Without Spending A Fortune

by

TERI SEIDMAN

and

SHERRY SUIB COHEN

FOREWORD BY MARIO BUATTA

Illustrations by Dani Antman

Villard Books
New York
1988

For my mother, Kitty

Library of Congress Cataloging-in-Publication Data

Seidman, Teri.
 Decorating rich.

 1. Interior decoration. I. Cohen, Sherry Suib. II. Title.
NK2110.S43 1988 747 88-40145
ISBN 0-394-56630-0

Designed by Tasha Hall and Marysarah Quinn

Manufactured in the United States of America

BOMC offers recordings and compact discs, cassettes and records. For information and catalog write to BOMR, Camp Hill, PA 17012.

Foreword by Mario Buatta

The rich do have an advantage: They rarely have to start from scratch when designing the interior of their homes. The rooms themselves are already rich in architectural details. There is usually a fabled aunt or godmother from whom they've inherited a house full of family heirlooms. When the affluent ancestors don't exist, the rich still have their money, either inherited or earned. It's always been fun to see how those who earn their money still try to look as if they've inherited it.

Still, one does not have to be rich to decorate with opulence. After all, having money, the inherited or the earned kind, never guarantees a beautiful or interesting home. Inventive people are those who know how to create the look of a luxurious past and how to reflect their present and private sense of beauty through the intelligent use of flea markets, antique shows, and the vast resources of their own imaginations.

An elegant home should be the stage setting against which you live out your life, all the time knowing that this isn't a dress rehearsal but the real thing. Why waste a moment moving within a setting that's mundane, trendy, or uninspiring? A setting should bear your personal stamp, your authentic style that stands aloof from what is

merely in vogue: What is in vogue is usually a visual cliché. A home should symbolize hopes, desires, and a sense of accomplishment. It should be enriched with the objects, memorabilia, and passions of your days. It should be a scrapbook of your life, emotional, romantic, sometimes witty, always individual.

Decorating rich is an appreciation of tradition as well as an homage to originality. Although I found my own design niche in the splendor of English manor houses [there is a reason I've been dubbed the "Prince of Chintz"), the charm of country, the fire and intensity of contemporary, the serenity of Oriental, and the distinctive vigor of our American inheritance can all reflect the art of living well, of living with soul and spirit.

Personally, I believe that the key to decorating rich is a devotion to details. Curtains and upholstery can be constructed from simple cottons—linen, ticking, even dish toweling. When enhanced with flawless details of fringes, braiding, rope, tassels, and hardware, they become superb. The sumptuousness is in the details. One of a wealth of details you will find in the book you hold in your hands concerns the effect known as "puddling." Nothing is worse than curtains that just miss the floor, looking as though they shrank in a flood. Curtains should drag two to four inches onto the floor for a luxurious look. In the official White House guest residence in Washington, D.C., the historic house known as Blair House, you can be sure the curtains puddled when I redesigned the interior in a combination of the finest in American and English tradition.

Rich interior design is often exploratory. It takes an adventurer, someone with personal style and assurance, to try combinations of antique and new, expensive and moderate in price. The designs of the eighteenth and nineteenth centuries have shown their staying power for a human and beautifully civilized way of life, but they are often priced beyond even the most extravagant budget. Excellent reproductions and even lesser pieces (if they reflect your personalized taste) mixed in with a few authentic touches lend éclat to your home.

Decorating rich is always comfortable. When you buy a chaise longue, attention must be paid to the slope of the back, the width of the arms, the height of the seat, the depth of the pillow fill. Interior design is organic—a work that's never completed. Life evolves, taste

evolves, rooms should evolve too. A home has to grow like a garden, with subtle layers and brilliant patterns.

Finally, decorating rich has a Rolls-Royce quality, a resistance to institutional-quality design. How to achieve it? I suggest you cleanse your mind of clichés and speak out loud to yourself about the travels you've loved, the homes that have entranced you, and the objects, rich in detail and character, that express your most essential self. Go to museums, go to the movies, go to designer showcases—avail yourself of visual and sensual impressions. Then pull it all together in your own special way.

Dip into this book with excitement and an open mind: It will teach you how to educate your eye to recognize the look of luxury and integrity, whether that look is derived from opulence or the most spare simplicity. It will teach you how to orchestrate rooms that are born of a heightened sensibility for color, balance, and dignity.

—MARIO BUATTA
May 1988

Acknowledgments

There are thanks to be offered. So many people with the richest of grace and style have given support and wisdom to *Decorating Rich*.

Diane Reverand, a classic among editors: Her taste, judgment, and wit are rare.

Connie Clausen, literary agent: the inspiration behind the book, its title, and its authors. She's tireless in her friendship and craft.

Dani Antman, for her magnificent drawings, a *Decorating Rich* hallmark.

One of the giants in the field—interior designer Mario Buatta—for his inspired contributions.

The Spiegel Catalogue organization for providing a wealth of *Decorating Rich* possibilities and our elegant cover photograph.

Guy Kettelhack, a practiced eye and a brilliant voice; Robert Pickering and Richard L. Bell for their consummate flair.

Glory Missan, Wendy Missan, Helyn Fuchs, Charlotte and Buddy Rashbaum, Beverly Weiss, June Nichols and Helen Seidman for their design sources.

My late partner, Jack Bodi, for his faith and gifted collaboration.

Sally Gilhooley for her creative energy.

My research assistant, Vicki Ceruti, for patience beyond the call of duty.

Acknowledgments

Emily Bestler, assistant to Diane Reverand, for her skill, reliability, and consistent good cheer.

Henrietta Blau at Delta Upholstery, Jack Soskin of Rosecore Carpets, and Roberta von Schlossberg at the RVS Gallery in Southhampton for their words of wisdom.

Thanks are surely due to architectural geniuses John Hill, Jay Sears, and Gamal El-Zoghby, from whom I learned so much.

Ira Howard Levy for sharing his vision and his stellar taste.

Diana Edkins, permissions editor for Condé Nast, for her warm efforts on behalf of *Decorating Rich.*

Trish Turk for her flying fingers and happy soul.

Superb friends Alfonso Triggiani, Marge Austrian and Sybil Evans for always being there.

My late father, Albert Seidman, for his grand style.

A special thanks to the talented craftspeople of Villard for spreading the message of elegance. In the departments of Design: Tasha Hall, Marysarah Quinn, Claire Naylon and Naomi Osnos; Production: Leta Evanthes; and Publicity: Sally Ann Berk and Corinne Lewkowicz.

A special acknowledgment to my colleagues at the American Society of Interior Designers, many of whom are the finest practitioners of Decorating Rich.

Sherry Suib Cohen wishes to thank, as always, her family, Jane, David, Lee, Larry, Adam, Jennifer, and Steven for their unqualified love and patience.

Contents

Foreword v

Acknowledgments ix

Introduction xiii

CHAPTER I: The Rich Are Different 1

CHAPTER II: Which Rich Look? 9

CHAPTER III: European Opulence 15

CHAPTER IV: Classic Contemporary 55

CHAPTER V: Country Charm 85

CHAPTER VI: American Pedigree 111

CHAPTER VII: Oriental Grace 137

CHAPTER VIII: All Through the House 159

CHAPTER IX: Making It Work 163

Contents

Conclusion 199

Resource Guide 201

Suggestions for Further Reading 220

Introduction

It was the room that first caught her attention—that beautiful, beautiful room. The young woman leafing through the magazine suddenly stopped turning the pages—she was riveted by an advertisement.

An elegantly dressed woman leaned on the arm of a lushly upholstered sofa. All around her were signs of the good life—a priceless Oriental carpet, silver-framed photographs, an ornately framed painting of someone's ancestor. Scallops of light from an eighteenth-century Venetian chandelier softly shadowed the room, which was heavy with mood, brocade, and rich. That is, after all, what the advertisement was selling—rich.

Actually, the advertisement was meant to lure the reader into buying an expensive fragrance, and it did: The lure that caught the reader's eye, however, was opulence, not scent.

The current mood of America calls for a look of prosperity that comes with professional success and an appreciation of tradition, individualism, and harmony. If ever there was a time when scruffiness was chic, it's not now. Now is the time for civilized elegance. Keep your eyes open to that new trend and you can't miss the unmistakable signs. Stores that successfully masquerade as mansions

where one must walk past polished woods, gleaming brass, and valuable antiques to get to the ties, are to be found in small towns and large. Catalogs that used to shout bargains now whisper image and quality: Instead of selling rayon slip covers and prints of cats on black velvet, the catalogs feature tasteful natural-cotton fabrics, reproductions of nineteenth-century statuary, and heavily embroidered bell pulls to summon servants who may or may not exist. Popular magazines—both those that cater to a richer readership and those that are sold in supermarkets—all highlight on their covers articles that tell consumers how to achieve a look of economic success in their homes —what I call the art of Decorating Rich.

Marketing geniuses who follow trends know that Decorating Rich is a seductive draw. It is a persuader. Decorating Rich sells fragrance, socks, statues, catalogs, and magazines because Decorating Rich sells image. We are bombarded with the idea of educated elegance because, despite stock market ups and downs and personal belt-tightening, those in marketing know that people are heartened and buoyed if their homes look cherished and more prosperous than the current state of their bank accounts.

This is a life-affirming and positive trend. Decorating Rich is a sensible way to make our homes reflect the style and confidence we aspire to in the rest of our lives. The wonderful rooms of our imaginations reflect our best and most optimistic selves: intelligent, witty, sure. Such rooms give the unwritten, unspoken message—"I belong in this place of quality."

If only we had the money to carry it off, we think. If only we had the money to create a gracious, tasteful home with the look of status, the monied look. If only we had a richly decorated home that gave a sense of education, good taste, and singular style—the expression of our inner souls.

I'm happy to tell you that bundles of money are not required to attain a rich look. The secret of Decorating Rich lies in creating a look. If you follow along with me, I'll teach you the tricks of my trade —the clear route to a look of elegance that is accessible for very little money. What you need is imagination, ingenuity, and an understanding of nuance; you don't need an original eighteenth-century room—only the suggestion of one.

Certainly, you must also be aware of what the genuine article looks like before you can duplicate it with reproductions, inexpensive but priceless details, and art and architectural touches that can be bought for a fraction of what anyone would guess.

Decorating Rich will teach you how to educate your eye and how to decide on a graceful, prosperous decorating style that's perfect for your nature and taste. It will show you clearly how to crack the code of rich decorating: How *do* the best interior designers invest a home with that character, that air of discerning taste? You don't need a degree in design to learn what makes for the indisputable touches of pure luxury. Finally, *Decorating Rich* will teach you how to "get rich quick"—how to substitute magnificent, far less costly alternatives for the expensive hallmarks of a rich look.

From the start, I must say this very clearly: *Good reproductions are absolutely legitimate forms of Decorating Rich.* The serious collector might have a vague stirring in his brain that tells him your furniture's not ancient, but if it's an intelligent reproduction, even he won't mind it. With today's extraordinary methods, an era's style can be surprisingly well and faithfully reproduced. Skilled and tasteful copies, crafted in the manner of the past, are available (the Resource Guide at the end of the book lists places to buy good reproductions in every signature) and the sense of antique, if not an actual antique, can linger in a home. For infinitely fewer dollars, using reproductions—and, perhaps, one or two authentic touches—your home can easily match the elegance of one that was decorated in the "money is no object" mode.

Rich, you will learn, comes with different faces: the very traditional, ornate, lush folds of *European Opulence;* the exquisite economy of the line, color, and proportion of *Classic Contemporary;* the pure, serene Japanese and lavishly hued Chinese forms of *Oriental Grace;* the nostalgia of romantic, wickery *Country Charm;* and the heritage-rich woodiness of *American Pedigree.* Each of these looks can be translated into elegance, once you decide which rich look is your personal preference.

Each signature also comes with distinctive features—I like to call them hallmarks: These are specific elements that reappear in almost every interpretation of the signature. The hallmarks are usually very

expensive, but I will show you how to duplicate them on a budget. Decorating Rich holds that imagination is more powerful than dollars in interpreting elegance.

Decorating Rich, you will also learn, means deciphering the code of the wealthy. If you understand the underlying style that motivates the rich to choose what they put in their homes, you're halfway to Decorating Rich. The truly rich, for example, confident in their taste and stature, do *not* fill their homes with exorbitantly expensive, showy doodads. Not every thread is made of gold. Their homes are filled with old familiar objects, lovingly cherished throughout the years and glimmering with a well polished, generations-touched patina. Whether their style is stunningly contemporary or splendidly aged, hardly a rich home exists that doesn't show respect for the past in a display of certain family heirlooms (or what look like family heirlooms). Truly rich people don't discard the sturdy sofa covered in cabbage-rose chintz because the chintz is slightly worn: the worn parts often best exude an air of tradition and "old money."

Decorating Rich means choosing the right categories and then orchestrating them so that the eye sees more, sometimes, than is really there. Isn't this deceiving? Perhaps—but it works. The glory of a Persian rug dominates the center of a study. You notice that the dark red curtains and the blue upholstered settee seem to pick out the richest of the rug's colors, but you don't know that the cotton twill curtain fabric has been purchased in an outlet store and that the sofa's deep blue slipcover is an inexpensive cotton velveteen. Not a scrap of damask in the room, but it couldn't be richer, with its symphony of burgundy and blue. You think: expensive Persian rug. You've seen much more.

This is a tiny example of the trompe l'oeil (fooling the eye) Decorating Rich makes use of. You will learn to create a rich atmosphere by choosing and highlighting exactly the right object or grouping of objects so that they become the source of color or design carried out by other pieces in the room. The eye is drawn to what's highlighted and assumes that everything else is of equal quality.

Getting "the look of rich" sometimes means acquiring the real thing (splurging on one or two truly luxurious objects) and then displaying the genuine article to such advantage that it seems to

reflect the quality of an entire room; sometimes it means "tricking" the eye in subtle ways so that a simple color, design, or historical theme looks as if it cost many times what it did; sometimes it means taking imaginative risks (like mixing contemporary art with more traditional elements) that sparkle with unexpected wit . . . there's a wealth of alternatives awaiting you that will make it possible to express whatever you want to express in the most beautiful and gracious ways.

In the following pages, you will easily learn how to decipher the code of rich taste, rich *good* taste, and discover the ingredients that are ubiquitous in each style. You'll learn how to spot and where to find the unique touches that make rich decorating quite different from every other decorating genre.

In each chapter that describes a specific rich look, or signature, you will find tip lists on how to achieve the look. In each section, for example, actual rooms are described so that you may better visualize what "rich" looks like. Each signature chapter includes a section called Get Rich Quick, which lists the elements traditionally associated with each style. Once you know what the look consists of and what specifics are "musts," it will be simple to check the extensive resource section at the back of the book to find sources where the rich elements (or reproductions of them) can be purchased at the lowest prices. Each signature chapter also lists the expensive hallmarks that mark the signature—and the Decorating Rich alternative method of achieving the look of the hallmarks for a fraction of the cost.

Read on: Within these pages you'll find a step-by-step guide to the art of luxurious interior design and the little-known places where you can dip into treasure troves of low-priced gems.

The rich look is within your grasp. One fact is undeniable: Your home sends out messages about you. Many of us have outgrown the messages we've been sending. We want them now to read "confident," "prosperous," "solid."

A new candor has lightened America. Now we can admit we prefer order to chaos, aesthetic luxury to ordinary. It's not snobbery to want elegance at home; it is, indeed, a sign of liking yourself and wanting your environment to reflect your worth.

Decorating Rich says "I've arrived." Come with me, then, on a treasure hunt—a hunt that will yield prizes without breaking the bank or bankrupting you; a hunt that will make your home as charming as it is impressive.

1

The Rich Are Different

It was F. Scott Fitzgerald who said, "The very rich are different from you and me," and Ernest Hemingway who commented, "Yes, they have more money."

Precisely. But it's more than money that sets the rich apart from just plain folk. There is another way in which the rich are always different from the nonrich and it is this: leisure time and the freedom to follow their interests. They may or may not choose to use this leisure for play, but let's face it, they can afford to play. *Vive la différence:* It rests in leisure.

As a result, rich homes are often decorated with reflections of leisure that set them apart. The homes of the rich are more personalized with expressions of that leisure.

Rich people travel, they play games, they have hobbies. They're often intellectual because they have money and time to educate themselves and to indulge their interests. They either have or like to pretend they have a lineage of rich or important ancestors. They entertain, they enjoy their privacy and their gardens. Since they do not have to work simply to "make a living," they get to spend time on themselves and what fascinates them. That's how they're different. Of course, nonrich people also play games, are intellectual, have

hobbies, but they don't have the leisure to play, travel, or collect as much as those with substantial bank accounts.

Let's take a look at some of the subtle touches of leisure the rich add to their homes that send the message of affluence.

- The rich travel and their homes mirror their journeys. One might have a room filled with pre-Columbian art picked up on a trek to Peru. Another might have a painting over the couch of the canals in Istanbul done in the natural colors of berry juice and cornflower extract. Rich people bring home a little of wherever they go—Chinese embroidery, Irish linen, French crystal, one-of-a-kind bibelots from distant lands.

- Rich people play games. Leisure means time for sports and the rich are usually passionate about bringing their games home. Monied homes sport symbols of rich play: a magnificent mahogany oar mounted on a wall; a game fish that swims forever in a den; the skin of a vanquished beast on the floor as a rug; hand-carved, beautifully painted wooden ducks on a ledge. Oil portraits of hunting dogs and racing horses are everywhere, in the rich, dark tints that say Money. Inlaid wood backgammon tables, golf trophies, and carved chess sets provide the look of the landed gentry which is easy to capture—even if you're not such gentry.

- Many people of means take their leisure with hobbies. Collecting is especially popular. Affluent collectors who own an interesting or beautiful object in multiples enhance its beauty and intrinsic value. One of my clients collected fabulous pipes—jeweled pipes, ivory pipes, opium pipes, plain old briar pipes, pipes to boggle the imagination—and displayed them beautifully on an excellent imitation of a Georges IV tortoiseshell desk. One client whose hobby is photography displays early cameras on unusual stands. I've seen magnificent postcard collections, framed and mounted in prominent glory, Fabergé eggs, Early American tools collected and displayed. You name it, someone collects it and makes it part of rich home decor. MOTTO: One antique Japanese fan is nice, twelve antique Japanese fans are fabulous and an icon of rich decoration.

- Many old- and new-monied families display their intellect and their education in their homes. Books, books, and more books line shelves, some in foreign languages; first editions and author autographs are prominently displayed. Art books lie on coffee tables as do magazines from faraway places. Original art or unfamiliar etchings and lithographs line the walls.

 Don't be surprised if some of the furniture bears a hint of seediness. Very worn tapestried chairs, for instance, and even peeling gilt finishes say antique and *very* valuable. The intellectual rich dote on aged imperfections. The Harvard Club, the very bastion of the intellectual rich

in New York City, is adored for its faint air of classy, somewhat musty antiquarianism.

- Most people of means entertain friends and business associates frequently, and homes of graceful opulence always bear signs of graceful entertaining. Well-appointed dining areas, visibly stocked bars, wine cellars, and built-in storage for silver and china are subtle evidence. Pianos, even if no one plays, stand grandly. In homes of size, private screening rooms are not unusual and now, their modern equivalent, VCRs and giant-sized television screens, are to be found in entertainment areas. Open a rich man's linen closet, and you will never find a sign of a paper napkin—even for lemonade breaks.

- The rich treasure privacy, and space is probably one of the only things that they possess that is hard to come by for others who are not so rich. Virginia Woolf wrote of the joys of "a room of one's own," but, increasingly, these rooms are rarely seen. Still, people with limited budgets can find ways to achieve personal space and privacy with, possibly, a beautifully screened-off niche, or a corner for quiet thought or meditation. Even the suggestion of space is a powerful nuance, an impression of the larger privacy that's apparent in every richly decorated home.

- One traditional leisure pastime of the rich has been gardening, and a display of fresh flowers and/or vegetables is ubiquitous in their homes. If rich people use their leisure time to get their hands dirty in their own exquisitely planned gardens, so much the better. Antique gardening tools, wicker baskets, transplanted seedlings, and gardening gloves are often to be seen somewhere on the premises. Ditto for wonderful, large, living potted trees. Meaningless tiny plants in tiny pots do not, as we in the trade are wont to say, make a statement.

- Most families are not of the vintage of *Mayflower* arrivals, but the wealthy love to give that impression. Portraits of ancestors who look monied, titled, or otherwise distinguished are always to be found in rich homes. People of means and leisure also often show their pedigree by displaying old silver and other family heirlooms they have inherited.

- The rich take care of themselves, and self-pampering in the best sense of the word is apparent in their homes. Dressing tables in dressing rooms— or a suggestion of them—are visible. Exercise equipment, magazines that discuss sybaritic pleasures, pure down lushness in pillows on beds and couches are symbols of the pampered rich.

The Decorating Rich Standard

We've all known wealthy people with abysmal taste who can never achieve a rich look no matter how much money they spend. The rich who have a discerning and educated eye operate with an unwrittten standard—which I'm about to write out for you. As they decide on each article of furniture, each accessory for their homes, they keep the following in mind:

- *Decorating Rich is timeless.* It gives an aura of roots, heritage, integrity, and stability.
- *Decorating Rich is comfortable.* It provides a conversational ease, dining smoothness, fluid living pleasure.
- *Decorating Rich is exclusive.* It is the look of unique, costly, and selective.
- *Decorating rich is quality.* It provides a sense of fine material and fine workmanship.
- *Decorating Rich is witty.* It offers a touch of the unexpected and the original.
- *Decorating Rich is appropriate.* It always is indigenous to surroundings. It has scale, balance, and harmony.

The standard must be met. As you judge the furnishings of your home, reject all that is trendy, tawdry, and clumsy. Beware the carbon copy. Beware the look of flash masquerading as flair.

Sound daunting? It's not. If there is one strong, clear note I wish to be heard in this book, it's this: You *can* learn how to spot rich hallmarks, how to use them most effectively in your particular style of decorating, how to pull it all together—and all this without a millionaire's bank account.

The Five Signatures of Decorating Rich

From a decorator's point of view, there are five basic decorating styles that are quintessentially rich. It is important to find the one approach that will express the aesthetic values with which you feel most comfortable. Your decorating signature is really a reflection of

your personality. Which of the following signatures sounds most like you?

This is the most classic and true autograph of luxury. Stately and refined, European Opulence was born in the royal courts of Europe. The operative word is *classic*. A classic is the best model of its time and has withstood the test of time. It endures. Although you may not love a hand-carved Italian Renaissance desk, you can tell it's an important piece—and expensive. European Opulence is lush folds of material, ornate carvings and curliques, gold and silver and crystal. European Opulence is a respect for the past and its stellar heirlooms.

Above all, it is comfortable. While tables may be intricately carved and delicately footed, chairs have plushness in which to sink. Rugs or carpets give off an ambiance of warmth and elegance.

Dollops of tassels, brocades, carved moldings are hallmarks of this particular brand of opulence. A green velvet Baroque settee, forgotten corners turned into art displays, time-worn textures (nothing *ever* brand-new looking), and a movable feast of gilt, folds, and exquisite china characterize the look.

Contemporary is chic, sometimes cool, sometimes colorful, sometimes witty. The best of Contemporary should be as classic in its own genre as European Opulence is in its particular time of history. The master designs of Classic Contemporary are easy to spot: The best in machine-age construction, which includes natural wood and fabric as well as superior plastics, typify the style. The look is sleek, simple, architecturally faithful; form always follows function.

The ambiance is uncluttered, linear, strong. Glass and metal tables glitter, often lit by soft, overhead spots. Textures abound—the nub of fabric, the gleam of glass, the buttery smoothness of leather. One needs to reach out and *touch*, so seductive is its pull.

This is a rich look that is ageless. It ranges from the spare and simple Japanese harmony to the lavish palaces of the Chinese emperors. The secure reputation of Oriental design never wavers with fashion trendiness. Century after century, Chinese coromandel screens and painted porcelains, the use of exquisite woods and semiprecious

stones are seen in the finest homes. Compelling Japanese design makes an eloquent statement that restraint can make stellar homes.

COUNTRY CHARM

Forget matched sets of gingham, buttons and bows, and *cute*. True Country Charm is comfortably elegant. It has its roots in the English country lodges, the enchanting stone homesteads of America's gentlemen farmers, the heritage-filled decoration of southwestern ranches, and the sea grace of ocean cottages. There is an enormous range in Country Charm decorating. It crosses boundaries from elegant farmhouse to lordly manor, from Ralph Lauren country to Grandma Moses primitive. Country Charm is often distinguished by magnificent quilts, acres of organdy, hand-woven wicker, converted antiques, and charming stencils. Country is charm, always charm, and with care, it can be rich. Staying close to the simple originals and bypassing the streamlined synthetics is what I mean by careful choice. Weathered shingles are always far richer than brand-new aluminum siding.

AMERICAN PEDIGREE

This is Yankee tradition at its most elegant; polished woods and gleaming brass, genuine "Americana." American Pedigree consists of legendary names like Duncan Phyfe and Paul Revere, or an excellent reproduction of these craftsmen's work.

Homes that are rich in American Pedigree rarely display matched sets of obviously new maple furniture. Instead, one may find singular vintage icons that testify to a specific moment of American history: perhaps a Queen Anne wing chair, a collection of presidential autographs well matted and framed, a silver tea service from Boston tea party days. American Pedigree is dignified, aristocratic, and yet respectful of the work ethic.

THE RICH MIX

It's important to note that few personalities are so rigid as to be inflexible: For this reason, many rich homes are often heavy in one signature but are actually a rich mix, offering touches of other cultures, other times, other sensibilities. But a rich mix should never be a hodgepodge of careless guesses.

The following formulas are examples of possible rich mixes that work well:

- Largely Contemporary with dollops from any one of the other signatures
- A mixture of varying European countries
- A mixture of similar woods, colors, or themes
- A mixture of compatible eras (American Country and American Pedigree)

Lesson for the Rich Mix: Whenever you add a disparate element to one look that is strong in signature, the element must not be in isolation: It should be repeated or echoed somewhere else. For example, in a Classic Contemporary room, you may include a carved Italian chair and repeat the carved wood in picture frames or echo the tapestry seat of the chair in throw pillows on the couch.

2

Which Rich Look?

First things first. You know you want a rich look in your home, but which rich look?

This is not a simple choice because decorating styles are not totally clear-cut, black and white affairs. Choosing a signature involves very personal likes and dislikes, attitudes and habits. Although it's possible to have an artful blend of more than one signature style, one basic look should prevail. Equal amounts of five different signatures add up to a mixed-up muddle; the overall effect is not Decorating Rich.

Keeping in mind that nothing is engraved in stone, let's discover which signature is the real you. In order to determine your most comfortable decorating style, it's necessary to pause for a moment and do some soul-searching.

As you read through the following pages, try to identify those elements in yourself that are your honest, personal passions—not your mother's or best friend's tastes and dreams. It's you who has to wake up in the morning looking at that chair or have a sinking feeling as you stare grimly at the Dreadful Flowered Mistake.

If your tastes and attitudes are not firmly developed, the following quiz will help you define the signature that is the quintessential rich look for you. You may be quite surprised with the result. It is not

inconceivable that someone brought up with Country Charm and accustomed to thinking that Country Charm is the last word in a prosperous look may secretly be yearning for European Opulence. The quiz is not meant to be deadly in tone. Enjoy it. However, do take seriously the message you receive from your own answers and inclinations. I have found, in years of interviewing prospective clients, that asking the right questions and listening hard to the answers gives me my most precious clues to their true personae—and that best points the way to the most wonderful decorating style for them. Anyone who, in her most secret heart, would feel terminally silly about sleeping in a canopied four-poster bed would probably not do well with European Opulence.

TWENTY-ONE QUESTIONS: A DECORATING QUIZ

Answer the following questions honestly. They are clues to the textures, colors, and accessories to which you're most drawn. They include the architectural lines you most admire, the era in which your soul really lives, and the essence of the decorating signature with which you'll probably be most comfortable.

1. On weekends, I'd best love to
 A. Browse at the Metropolitan Museum of Art—if I can't be at the Louvre
 B. Walk in a big city
 C. Meditate in a simple garden
 D. Sink into my wing chair and read history
 E. Pick blueberries

2. You wouldn't be wrong if you called me
 A. Old World
 B. Forward Thinking
 C. Contemplative
 D. Patriotic
 E. Bucolic

3. My heart could sing if you gave me
 A. Scones or croissants
 B. A bagel
 C. Sushi or Peking duck
 D. Turkey and yams
 E. Oatmeal

4. The television series I would hate to miss would be
 A. *Upstairs Downstairs* or *Dynasty*
 B. *Kate and Allie* or *Nova*
 C. *Shōgun* or *The Art of Ikebana*
 D. *The Adams Chronicles* or *The Constitution* with Bill Moyers
 E. *The Waltons* or *Little House on the Prairie*

5. The magazine to which I'd most likely subscribe is
 A. *Connoisseur*
 B. *Architectural Digest*
 C. *Oriental Antiques*
 D. *American Heritage*
 E. *Country Living*

6. I'd never get up if I could sleep on
 A. An Elizabethan gilt-painted bed with a brocade canopy
 B. A huge (almost endless) platform bed
 C. A futon
 D. A Federal mahogany four-poster
 E. A plain, wooden Shaker-style bed

7. Check me out walking down the street with a
 A. French poodle
 B. Greyhound
 C. Shar-Pei
 D. American foxhound
 E. Collie

8. You've been invited to a dinner party. When you arrive, the house
 knocks you out.
 A. Its white fluted columns are smashing; its lawn manicured.
 B. The entire house seems to be a vista of glass.
 C. You think those are shoji screens at the window, and you know
 that's a Zen rock garden at the side of the house.
 D. Brownstones, after all, are your favorite.
 E. You just know there's a roaring fire and a braided rug behind the
 yellow clapboards and black shutters.

9. If I put up a screen to divide a room, it would
 A. Have hunting scene panels
 B. Be free-formed and flowing
 C. Have mother-of-pearl lotus blossoms floating on black lacquer
 D. Be wallpapered with a Revolutionary War motif
 E. Be stenciled with charming flowers or maybe an art naif design

10. The best view is framed by
 A. Marvelous velvet drapes, lushly spilled onto the floor
 B. Floor-to-ceiling picture windows—no curtains at all
 C. A shoji screen
 D. Colonial double sashes, each with twelve panes
 E. Dormer windows under gabled roofs

11. Staircases should
 A. Have intricately carved balusters
 B. Be stainless steel
 C. Be nonexistent
 D. Be massive and dark-wooded
 E. Be spindled

12. An exhibit that would really speak to me would feature
 A. Van Gogh, Rembrandt, or collections of gorgeous Georgian silver
 B. Picasso, Frank Lloyd Wright architectural drawings, or Bauhaus chairs
 C. Decorated scrolls or flower arrangements
 D. Early American samplers, Chippendale furniture, or primitive art
 E. Quilts or wicker

13. My favorite novelist is
 A. W. Somerset Maugham
 B. Isaac Asimov
 C. Yukio Mishima
 D. Henry James
 E. Mark Twain

14. For just a little while, I'd love to go back to
 A. Ancient Greece or Rome
 B. The early twenties right here
 C. The Sung Dynasty
 D. Visit George and Martha Washington
 E. My Aunt Dotty's cottage

15. The colors that make me feel happiest are
 A. Jewel tones—deep rubies, dark sapphires
 B. Black, white, and gray
 C. Jades, carnelians, lacquered blacks
 D. Red, white, and blue
 E. Yellow, barn red, dimity whites

16. The fence around my ideal house would consist of
 A. No fence at all—I'd like a moat, though
 B. A colorful grid
 C. Bamboo trees
 D. Elegant ironwork
 E. White pickets

17. My favorite clothes are often made of
 A. Brocades, velvets, taffetas
 B. Leather, outrageous metallics, soft and natural fabrics
 C. Embroidered silks
 D. Tweeds, wools, cashmeres
 E. Denim, organdy, cotton

18. This gives me such pleasure
 A. The patina of much-touched wood
 B. The smooth sheen of steel and glass
 C. The gloss of lacquer
 D. The depth of polished brass
 E. The luster of copper and pewter

19. Give me a mirror with a back made of
 A. Hallmarked silver
 B. Lucite
 C. Mother-of-pearl and semiprecious stones
 D. Solid, carved maple
 E. Quilted chintz

20. I'd like the status feeling I'd get by driving in a
 A. Mercedes
 B. DeLorean
 C. Honda Prelude
 D. Vintage Edsel
 E. Jeep

21. If I had a mantel, over or on it would sit a
 A. French landscape
 B. Henry Moore sculpture
 C. Pair of blue and white porcelain urns
 D. Brass eagle
 E. Rooster weathervane

ANALYSIS

Did you choose mostly As? The essential you is tailor-made for European Opulence. A traditional, comfortable-yet-formal home is more to your taste than any other signature. Your heart is caught in the look of the fabulous past.

Did you choose mostly Bs? You're a child of the future, an admirer of modern technology; Classic Contemporary is your sleek, svelte signature.

Did you choose mostly Cs? Serenely magnificent Oriental Grace is

13

the signature that is most exciting for you. You could go, as well, for a Rich Mix—any of the other signatures accented heavily with Chinese luxury or Japanese simplicity.

Did you choose mostly Ds? I would think that American Pedigree would please you enormously. You admire the classicism of our heritage, the integrity of dark, deep woods, the comfort of a deep wing chair.

Did you choose mostly Es? Country Charm is your kind of posh. The charm of the hearth, the hunt, and naive art make you smile. The richness of the sea or the sun-bleached character of the Southwest are your cups of tea.

Read Before You Leap

The best advice I can give you is to keep an open mind. Your heart may seem to be caught in the look of the fabulous European past, or the streamlined Contemporary future. Your head may seem to be stuck in the majesty of Oriental splendor, the integrity of the American heritage, or the richness of Country charm.

But maybe a different choice would work better for you. Often the look you choose is the look you're accustomed to. Instead of Decorating Rich, you could be Decorating Familiar, perpetuating the taste of your childhood surroundings instead of taking a deeper look at a signature that might be much more delightful for the grown-up you.

Read *Decorating Rich* in its entirety instead of dipping into only the signature you think is most plausible for you. You might be in for a life-expanding—and home-expanding—surprise!

3

European Opulence

Does This Sound Like You?

- I see myself writing thank-you notes at an exquisite Louis XVI desk, the hem of my long skirt just touching its delicately carved legs, its inlaid woods

- I admire fringed and tasseled trimmings

- I love a Greek-style sculpture sitting on a classic pedestal

- My car of choice is a Rolls. Maybe a Bentley. Maybe some day

- A person shouldn't have to live without at least one magnificently cut crystal chandelier

- I wouldn't dream of covering parquet floors with wall-to-wall carpeting

- Skirted tables and gilded moldings are my kind of details

- Silks, satins, and brocades are my kind of materials

- Classic is my middle name

- If it doesn't look like it's been around for two hundred years, it's not classic

- I love the look of ruins

- I love the look of distressed walls

- Heavy, ornate sterling—that's the gift to turn me on

- The man I love belongs to a slightly seedy, leather-filled club. Or, would like to

- I like ducks. And horses. And Bergdorf's. And Brooks Brothers. And cherubs

European Opulence: I love it. It's the look of established power, cultivation, and stability. It's a look of timeless style.

The European Opulent Look

What a room—elegant in hallmark symbols, eloquent in interpretation of the "rich" code. For instance, note the ubiquitous triple-skirted table: a charming lace throw tops a layer of patterned silk shawl which tops the last layer of silk "puddling" on the floor. The familiar fringed and corded hassock serves as a "table" for a gleaming silver tea pot and porcelain cups. Note, as well, the magnificently faceted chandelier whose light plays softly on a myriad of textures.

The ambiance of this wonderful French salon is enhanced by carved moldings (cornice, dado, baseboard) which are echoed in a mantel carved with French bows and a ceiling medallion to accent the chandelier. (All of these carved details are available in replica—see Resource Guide.) The rug is French floral, perhaps in needlepoint. The carved, gilt, glass-topped coffee table is a rich mix of French and modern, but the gilt French clock

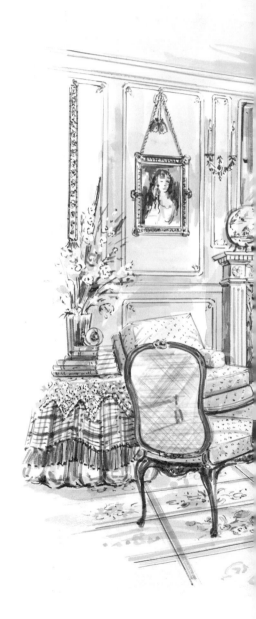

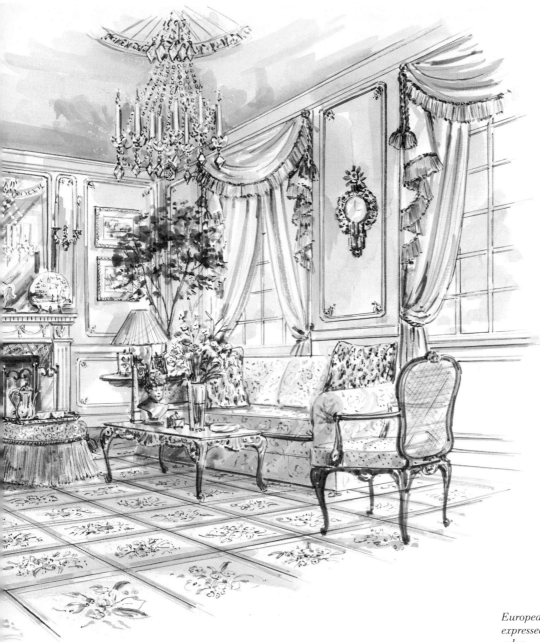

*European Opulence
expressed in a French
salon*

17

is quintessential French as are the charming candelabra that flank the mirror over the mantel.

Note the artwork displayed in ornate gilt frames; one painting even hangs on a golden cord. As if there weren't enough gold, even more shines from the fireplace screen.

The charming matched pull-up chairs are Louis XV, with cane back and silk seats. A slightly seedy club chair invites anyone seeking comfort, as does the ample upholstered sofa. Full swagged, fringed, and tassled silk damask drapes lend authority.

Grace notes:

- a touch of Oriental in the bronze horse on the mantel, flanked by two porcelain plates on ebony stands
- a needlepoint bell pull (at the left of the drawing), which can be hung for beauty even if the servants are nonexistent
- a tablescape, which reminds the viewer of the occupant's penchant for travel and collecting
- an explosion of fresh flowers, the perfect expression of European Opulence nestled amid the "layered"-look tablescape on the round skirted table

European Opulence is synonymous with refinement and meticulous attention to elaborate detail. It's a look of formality, classicism, and traditional dignity.

The roots of European Opulence are as differently flavored as the myriad countries that have traditionally shared heritages with each other. Although *Decorating Rich* will focus on the more prevalent influences of English Country, French Formal, and Italian Palazzo, never forget that Gaelic Flair, Greek Classicism, Victorian Ornate, and a hybrid of other aristocratic legacies add spice to European Opulence.

Although European Opulence is a look practiced for the most part by older, established people, it's a look I predict will become much more popular among younger achievers and would-be achievers. The national trend toward stability, tradition, and stronger, more conservative family values is clearer every day. In an age of technological brilliance and ease, many are finding elegance in the old ways, in the familiar forms.

Not that European Opulence has to be musty. Far from it. There is nothing musty about a romantic French chateau.

If you are in love with the splendor and romance of European Opulence, you can recreate the language of the chateau and put the shadows and the nuances of Old World elegance in your twentieth-century home.

What should European Opulence look like?

There are three different ways to go with the look:

In her 1818 novel *Persuasion,* Jane Austen describes a decorating style in London that is often copied today, that of studied casualness —what I call the "nothing-matches" look. Although furniture in Austen's time was elegant and formal (and no one put his feet on the sofa), there was a feeling of randomness, of individuality. Pairs of things were out. Small tables and unique chairs were deliberately placed at odd angles. "The . . . daughters of the house," wrote Austen, "were . . . giving the proper air of confusion by a grand piano-forte and a harp, flower-stands and little tables placed in every direction. Oh! . . . such an overthrow of all order and neatness!"

So, friendly overflow and nothing matched or lined up is one approach to an elegant room that breathes a particularly English distinction.

THE NOTHING-MATCHES LOOK

Another option for Decorating Rich reveres order and neatness. I call it the "matched-pair" look.

THE MATCHED-PAIR LOOK

- Two eighteenth-century love seats facing each other, each flanked by a small sofa table

- Two matching easy chairs flanking a fireplace

- A matched pair of sconces perched on the wall

- Four paintings, two on each side of the fireplace, same size, same gold frame

Many luxurious European-flavored homes today offer an eclectic mood. Instead of fanatically copying one period, a preponderance of French, English, or Italian can dominate a room with different European periods and styles mixed in. The ambiance is European— without slavish devotion to one country. If you love a classically Old

THE MIX-AND-MATCH LOOK

World look, it is freeing not to feel you have to recreate history with every speck of furniture placed with historical perfection. Instead, mixing and matching objects and furnitures from different countries can be much more visually appealing than doggedly sticking to one period. While a room filled only with Louis XV furniture usually can't avoid looking regal, it can also look boring and uncomfortable. One also runs the risk of looking like a furniture dealership.

This is not to say you shouldn't use some rhyme in your reasoning. A room that is very heavy leather and English in flavor would not be well served by the addition of a delicately gilded French chair and desk. Of course, you can mix copies of Renaissance silver with a carving from the Orient, but the sense and feel of a room should not be betrayed by an object that looks uncomfortably out of place.

GET RICH QUICK!—THE ELEMENTS OF EUROPEAN OPULENT STYLE

Certain elements are to be found in opulent homes on every European shore as well as in American homes with the same timeless elegance. Among these are:

Furniture Styles: Empire, Palladian, Renaissance, all the Looeys...: I could go on. There are many specific furniture styles that are mainstays of homes decorated with a European Opulent flavor. These are styles that developed in various European cultures and were adapted

Sixteenth-century Italian Renaissance chair

Eighteenth-century Louis XV Rococo curvy, cabriole-legged chair (French)

Late seventeenth-century French Baroque deeply carved chair

Late eighteenth-century Louis XVI Neoclassical straight-lined chair (French)

Early nineteenth-century, directoire (French)

Early nineteenth-century Empire chair (French): classical straight lines

Early eighteenth-century Queen Anne chair (English): curved cabriole legs

Mid-eighteenth-century Chippendale/Baroque chair (English)

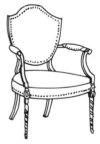

Late-eighteenth-century Chippendale/ Neoclassical chair (English)

Early nineteenth-century English Regency chair (similar to French Empire)

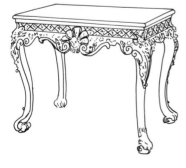

Circa 1730 English George I table. Note the popular cabriole legs.

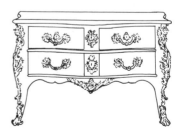

Circa 1735 Louis XV Wooden chest of drawers decorated with ormolu (gilded bronze)

and adapted and adapted yet again, depending on the way particular cultures saw them. Chairs, sofas, and other period pieces in reproduction give authenticity to your home. Some examples of the more familiar styles are illustrated here. Become acquainted with the lines, feet, carvings, and other distinguishing factors of the European style your taste most strongly suggests, and look for the best reproductions. The book *The Antiques Directory*, as well as other books in the Bibliography, is a wonderful guide to furniture style in the European Opulent mode.

Wonderful Moldings and Other Architectural Details: Moldings are to European Opulence what glass and steel are to Classic Contemporary. They can be used around the perimeter of the room, at baseboard, ceiling, or chair level. Some can be used as strips from which pictures are hung. Some can frame doorways or be used as objets d'art, all by themselves. Check photographs of old English, Italian, French, or Greek rooms to see the original application of moldings—then copy the ideas. NOTE: Moldings are traditionally made of wood, often carved elaborately, but there are other routes of rich illusion to follow. The look and feel of architectural embellishment can be accomplished with plaster, plastic or stock wood moldings, faux painting, or wallpaper borders in many patterns including "marble," "wood," or documentary prints (reproductions of historically authentic designs).

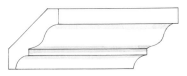

Stock moldings by the yard

Ceiling medallion (plaster or wood)

Wooden mantelpiece

Over-the-door pediment

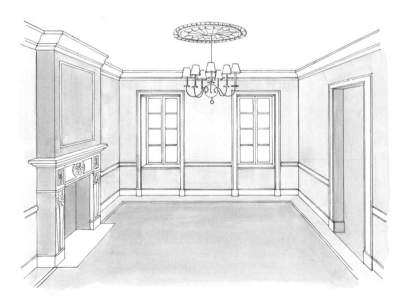

A model room showing placement of moldings, medallion, dado (chair rail), picture molding, and mantel. Architectural details lend elegance even in an empty room.

Lustrous Silver: Sterling silver, tons of the precious metal, were hallmarks of many European mansions. Scratched silver-plate versions of the real stuff, sometimes with the silver finishes rubbed off, can be found for relatively low cost in antique shops and flea markets, and a quick trip to your friendly resilverer (listed in the Yellow Pages) will restore these treasures. You can also do it yourself with "The Silver Solution" (see Resource Guide). One splendid silver basket filled with flowers or fruit, or even one ornate coffee pot from a silver service set long broken up, adds instant economic clout.

Oriental Rugs: The Oriental rug is ubiquitous, seen in every signature, but certainly always in European Opulence. Nothing gives a faster message of rich. It doesn't even have to go on the floor but can be thrown over a chest or hung on a wall, if it's fine enough. What an Oriental rug should never be is fake.

Pillars: Columns are fabulous. Originally structural necessities, columns are now used decoratively as room dividers, decorative pilasters, or pedestals for display. If you can't find a real column or even part of a column (check our Resource Guide as well as antique shops and salvage shops), consider a sonotube. Or a local carpenter can build a simple wooden version, and add molding strips for interest. Paint it and place an architectural relic or a copy of a Roman bust atop, and presto—you have a peerless look of elegance. (Don't use a familiar bust, by the way—Julius Caesar or the like—everyone will know it's a copy.)

Candelabra: Look for candelabra in your travels. No European Opulent home should be without them, standing on tables, hanging on walls, perched on columns . . . often intertwined with cherubs, and of course always filled with real candles.

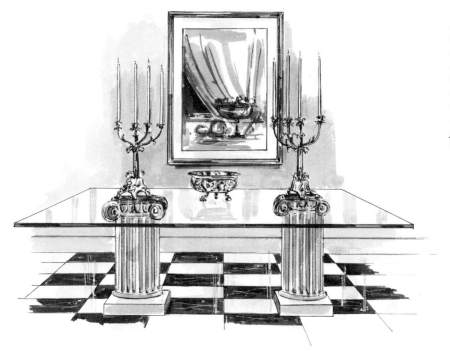

Elaborate Frames: In elegant homes, often the cost of the frames exceeds that of the art. You'll see no Lucite, no simplicity. What you'll see is curves, Rococo, curliques, carving, and gold, gold, gold, even on—especially on—mirrors. Thrift shops abound in great frames on terrible art: buy the piece, throw out the art, put in your own choice, and you'll really have something.

Paneling: The ladies of the castle set the taste for paneling. It was not only a sign of affluence, it kept out the drafts from the chinks in the castle walls. Even one paneled wall in a den sets the tone of the hobbied rich. But don't go for the imitation plastic or fiberboard paneling. It's a world apart from the real thing in a luxury look and not even that much less expensive.

Screens: Chinese screens, mirrored screens, beaded screens, Japanese screens—they are a deluxe touch and can be used for many purposes, among them:

Portable Japanese screens in three types: hand-painted, lattice-textured, and the single-leaf shoji design.

- Bridging spaces, connecting awkward corners to the rest of the room

- Giving height to a room, a must for the European Opulence signature

- Making separations—for instance, dividing living room from dining room in a charming manner

- Adding pattern and texture to a room

- Enhancing the European Opulent look of *abundance* by providing pattern upon pattern

- Replicating the European look of layers: Put the screen in front of a mirrored wall; in front of the screen, place a hassock or footstool; on the hassock, place a fur or paisley throw

Tassels: If there is one touch that symbolizes the finest European homes, it's the not-so-simple tassel. I'm not talking about your measly little cotton ornaments or pulls you find in dime stores, but rich, thick fabric threads of distinction. They're used as drapery tiebacks, on the backs of chairs where the fabric seat meets the legs, on pillows—in a hundred different places.

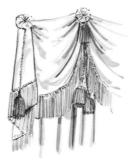

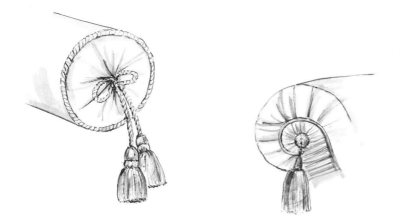

Chinese-Style Wallpaper: Things Chinese have always been an element of European Opulence, and Chinese wallpaper—murals depicting birds, flowers, bamboo, and landscapes—are perennially popular in the look, especially in dining rooms.

Fabric Walls: This is another rich touch that goes back to the castle, where tapestries were hung to keep out drafts. Fabric is usually more expensive than paper. However, with the advent of outlet stores, superb fabric can be had for far fewer dollars. It is particularly wonderful on walls that are in bad repair because it hides bumps, cracks, and other problems better than wallpaper.

The Skirted Table: Talk about ubiquitous. Every European house had one of these in the living room, bedroom, and dining room, not to mention the dressing room. They're wonderfully easy to make—any old round table will do the job. The table is layered with skirts: a richly brocaded square of fabric over a soft solid and over these two perhaps yet another skirt of lace. Underneath all the layers, many Europeans even concealed a blanket to give fullness and depth. The skirt must overhang onto the floor, as European drapes do, by about four to six inches; this effect is called "puddling" and implies abundance—rich excess, if you will.

Excellent Hardware: Lucite, cheap-looking porcelain, or stainless-steel hardware will not be found in European Opulent rooms. Stick to the period in hardware choices and cherish fine brass and other authentic materials. Door knobs, locks, hinges, and other metalware must ring true to the general ambiance.

Paneled Doors: Reproduction wood paneling can be purchased at lumber yards and added to quite ordinary doors in every room to give a look of great value.

Good Floors: An exposed wooden floor must always be stained darkly elegant and polished to a gleaming luster. Even inexpensive wood can be finished to look rich.

Attention to Detail: Europeans cared about the small things, and so must you in a home decorated to emulate this style. Fringes and tassels provide luxurious embellishments. Scented drawer liners provide touches of class; careful placement of hassocks, chairs, and footstools work toward graceful movement; absolutely clean and well-ironed table skirts look luxurious; and coat and hat racks to ward against the throwing of such outerwear on the furniture are only a few of the precautions the richly decorated European-style home must take. Hall closets look swell with upholstered hangers for guests.

Attention to detail provides the most luxurious ambiance; fringes are a classic European detail.

Stair Rods: Heavy brass rods were used to hold carpet runners in place in early European days, and today can be found in good hardware stores. Adorned with ornamental finials and polished finishes, they provide a rich link to the past.

Patina: One of the best guides to authenticity in antique wooden furniture (and European Opulence is rife with wood antiques, or what appear to be antiques) is the gentle, mellow, almost golden sheen of the wood that has been created by the rubbing and polishing of use through the ages. It is the gloss that time produces on the surface of woodwork. Furniture polish cannot give the same effect on new wooden pieces. Look for that lovely, soft sheen on the items you purchase: A piece doesn't have to be a genuine antique for you to possess it and often a cherished and loved table that's knocked around for only a few years or so will glow with patina. Take care, however: You may find a true antique, not even a reproduction, with a splendid patina—and it can still be ugly. Every age has had its disasters, and just because something's lasted doesn't mean it's great. In 1804, someone probably hated it.

It must be noted that all furniture doesn't have to have a natural wood finish to fit the look. The French, for instance, often paint their woods with gilt and pastels.

Wood is not the only material to have patina. Brass, bronze, copper, terra cotta, and the like also acquire a distinctive mellow beauty with age. The "weathering" of history comes in different colors, and, luckily for us, the weathered copper of Parisian mansard roofs, the greenish-brown appeal of Pompeiian bronze candelabra, the ancient verdigris of artifacts, and even the outdoor patina on stone and terra cotta—the Italian Palazzo look—can be simulated, and obtained, almost overnight. Experts can take an almost new piece of "junk" you've found and loved and bought for next to nothing, and create an instant artifact, perfect for a European Opulence signature. Patina, then, can be authentic or created by metallurgical specialists (look under *metal furniture* in the Yellow Pages); one way or another, it is a fail-safe route to the aura of European Opulence.

Fleeting Things: Often it is "fleeting things"—flowers, bowls of fruit, potted trees, an arrangement of branches—that bring a room to a

luxe look rather than the room's proportions, furniture, or art. Fleeting things are as difficult to get "just right" as are fabric, wallpaper, or beds. Instead of studying conventional flower- and fruit-arranging books, look in art books or go to a museum—a traditional museum—and see how the great masters painted their natural beauty. Dutch and Flemish painters like Brueghel and Peeters and French geniuses like Cézanne and Monet really understood the style that ephemeral objects bring to an elegant room. They painted luxuriant bouquets. Sometimes, half the flowers are out of the container of water, carelessly dropped on a table or plate. Heavy-headed blooms hang deeply down, other times creating asymmetrical designs. Fruit (peaches, currants, blackberries), often still on the branch, give delightful color and spontaneity. Often, unusual containers were used in these paintings—containers that clearly were not designed for flowers and fruit: goblets, silver soup tureens, or excavated antiquities, for example.

Hands-On Antiques: Of all the elements of Decorating Rich, European Opulent style, this is probably the most significant: The truly rich use their antiques, they don't just display them. Treasures that are used are infinitely more alive than those that gather dust. Real-life wear encourages patinas and warmth. Only those who feel, in their deepest hearts, that they don't deserve elegance will refuse to sit on their precious chairs or put flowers in their authentic Venetian bud vase. Rich people, rich in heart as well as taste, don't live behind museum ropes.

THE EUROPEAN OPULENT LIVING ROOM

NOTE: This is a combination of two rooms—the drawing room and library—traditionally found in rich European homes.
It contains most, if not all, of the following:

- First and foremost, comfortable seating arranged in groups for conversational ease

- A tall piece, like an open armoire or secretaire bookcase to show off silver, heirlooms, and trophies

- A focal point, like an elaborately framed oil painting highlighted by an art light, or a magnificent mantel

- Another furniture grouping, somewhere else in the room—perhaps twin chairs flanking a fringed, tasseled hassock which serves both chairs as a footstool and also as a tea table, despite its soft surfaces

HIGHLIGHTS:

- A grand piano covered with a fringed antique paisley shawl, an "ancestor" painting (who has to know the impressively dark-toned aristocratic subject is not really your ancestor?), or an inlaid game table

- An Oriental rug (its color palette can give the room a color scheme)

- Symmetrically gilt-framed prints or paintings of dogs, the Hunt, mallards, fruit, vegetables, or flowers are de rigueur

- A large, masculine writing desk (the woman's writing table, more delicate, perhaps marquetry inlaid, would be in the bedroom)

- A coffee table displaying prized objects such as a bronze sculpture or a Chinese bowl holding a few fresh flowers

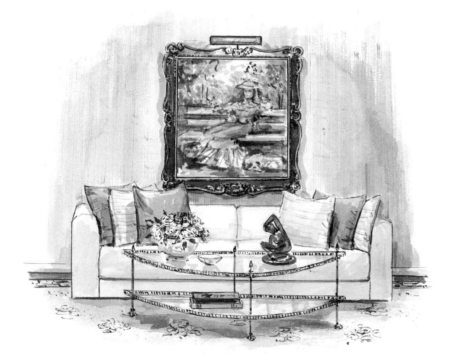

Paintings and sculpture can be highlighted by art lights and by prominent table display.

31

- Books, books, books, on walls or tables, with objets d'art interspersed among them. (Include some with leather bindings and gold-tooled titles and designs on the covers)

- Library steps: A two- or three-stepped piece of furniture, a classic in European homes. (Read: I have Culture up to There and I need to get to the top book shelf)

- Silver-framed photographs that whisper Rich . . . Pedigree . . .

- An antique screen to separate conversation areas

- A collection, prominently displayed: obelisks? wonderful canes? old crystal?

- A garden seat (an ornate porcelain, stone, or metal "barrel"-shaped stool which was ubiquitous in every European garden and was brought indoors to act as a table, pull-up seat, or decorative touch.)

THE EXPENSIVE HALLMARKS AND THE DECORATING RICH WAY

Throughout this book, the reader will find lists like the ones that follow these sentences. They consist of specific hallmarks—furniture, accessories, and other components—that make a room special, richly elegant, and faithful to a signature. The most common elements of rooms like couches, armchairs, and coffee tables are not usually included in these lists. Here, instead, you will find the subtle touches that provide the affluent and tasteful ambiance in richly decorated homes and suggestions of ways to duplicate the expensive hallmarks inexpensively—the Decorating Rich way.

THE EUROPEAN OPULENT LIVING ROOM: THE DECORATING RICH WAY	Expensive Hallmarks	Decorating Rich
	Little, statusy, needlepoint-covered stools; slightly larger, lushly covered ottomans	Look in the thrift shops for old dresses and gowns of slightly worn velvet and embroidery for torn or frayed needlepoint pillows. Paint any old upholstered stool in gilt (or a color to match your scheme) and recover with undamaged parts of the fabric (either do it yourself or hire a local seamstress)
	Fabulous antique needlepoint pillows	Hunt out very worn, small Oriental rugs at auction or thrift shop, and take the best parts to use as pillow covers. Or, make needlepoint pillows yourself

A collection of crystal obelisks that cost a small fortune	It's the shape that says rich. In wood, glass, or porcelain, an obelisk collection is wonderfully chic on a tablescape, and costs next to nothing in dollars and only a few weekends in time to search out at local flea markets
An antique wooden tea cart, circa 1700	Reproduction wooden tea carts can be purchased for a fraction of the cost: Set them up with a china tea service on a silverplated tray. Brass tea carts can also be found for reasonable prices
Fur throws and fur pillows	Your mother's, the thrift shop's, or your own oldest furs—resurrected (surely there are whole, good spots) into usable touches of class. Or, a fur print pillow is great!
Expensive tassels	Retrieve them from old belts in flea markets or thrift stores; old lamp shades occasionally sported great tassels. Keep an eye out for them almost everywhere. It is also possible to go straight to tassel resources (see Resource Guide) and find *new* treasures
An antique library globe	Always available at flea markets. Caution: Children's plastic globes don't count; leather or pressed paper ones are what I'm talking about
A garden seat: expensive when antique	Copies are available (see Resource Guide) and the real thing can be found in flea markets. They're splendid, particularly in patterns, and they add a subtle touch of opulence, suggesting the rich penchant for gardening
Opera glasses, preferably pearl	Opera glasses imply a rich taste for culture; thrift shops always have them
An antique telescope posed near a window	It doesn't have to be antique; any telescope sings of a rich hobby
Collections of very old, leather-bound books	Just one or two stacked on a table or bookshelf strike a note of elegance
An antique table with whiskey bottles and crystal decanters on a sterling silver tray	A refinished thrift shop chest with a silver-plate tray and glass decanters with sterling silver labels denoting whiskey
An antique terra cotta, mustard-glazed flower vase	A plain ceramic pot painted mustard color: The eye sees the fresh flowers, if they are abundant, not the actual pot (it just gets a sense of a mustardy pot)

French porcelain plates and bronze sculptures, antique jewelry, for shelfscapes: available in fine antique shops	Reproductions are available in museum shops and department stores
An antique paisley shawl thrown over a piano, couch, table, or chair	A yard of good paisley fabric, hemmed and finished with fringe or tassels
An antique desk set: intact, it is very costly	A piece of an antique desk set, such as an inkstand or silver-backed blotter; it's far less costly to buy when the set is broken, and all you need is a suggestion to set the tone
An antique fireplace screen	Find a rusted version in a flea market and spray-paint it with a matte black finish
An ornate fireplace mantel, perhaps Louis XV Revival style: costs over $10,000 at the antique store	Reproductions are available in stores specializing in fireplace equipment and old mantels are to be found in flea markets and salvage shops
Library steps (authentic) near a book-lined wall	Reproductions used near bookshelves for end table (in the bedroom, can be used for night table with stacked books or a pretty cup and saucer placed upon it)
Armfuls of flowers in crystal vases	An orchid plant—it lasts; available wholesale at flower markets
Pictures in sterling silver frames on table or piano	One rather ornate sterling silver frame, several good silver-plate frames, one clearly antique wooden or porcelain frame
The "layered look": a Venetian glass mirror hung on an antique-mirrored wall	Hang a new mirror on new mirrors, but hang it with a silken cord and tassel
A framed masterpiece on an antique wooden easel	A well-framed print from a genuinely old book (an obscure drawing—not a familiar masterpiece) on a relatively new easel of darkened wood
Art lights illuminating masterpieces	Art lights on unfamiliar paintings or sculpture (the light makes them look important). Make sure you only illuminate good art because bad art singled out stands out like a sore thumb

Marble baseboards encircling room	"Marble" wallpaper border
Hand-carved dado molding along wall (this is known as a chair rail). Molding is also used along ceiling and floor perimeters. Pictures are often hung from decorative moldings	Glue-on stock machine-made molding from the lumber yard (or see Resource Guide)
An Italian Palazzo wrought iron and glass table, antique iron chairs, weathered (for centuries) terra cotta urns	Find a thrift shop iron base, add a glass or marble top; paint six iron chairs a weathered green (or have them artificially "weathered"— see Resource Guide). Buy new terra cotta pots and leave outside to weather
A priceless antique screen	Cover a broken-down or inexpensive screen with wallpaper or fabric that coordinates with your decor
Antique silhouettes (very popular in old Europe) mounted in valuable gilt frames and hung in a group by silken cords	Reproduction silhouettes (available in many museum shops) in not-so-valuable gilt frames and hung similarly (or have your own made, see Resource Guide under Art)
Oversized expensive accessories: large porcelain animals, urns, statues; tall mirrors, pedestals	Don't be afraid of size—it gives a feel of grandeur.
Ornate antique window seats (benchlike areas under windows) heaped with antique pillows	A simple window seat built of ordinary wood by a local carpenter. Inexpensive but marvelous pillows hide the cheap wood
Expensive art books on tables	Expensive art magazines
Heavy brocade draperies	Drape a good paisley shawl over white muslin curtains: It gives the look of handsome drapes— minus the cost of brocade

A bell pull connected to a bell in servants' quarters: usually a long brocade ribbon with a brass ring attached	Use a bell pull for a wall decoration (beside a picture or other work of art); many are available in antique stores, thrift shops, etc.
Brass-studded club chairs (usually leather) such as are often found in men's clubs, etc.	Brass nail heads are available at any upholsterer's; for a look of polished detail, either put them on worn leather chairs yourself, or have the upholsterer do it

THE EUROPEAN OPULENT DINING ROOM

It contains most, if not all, of the following:

- A huge wooden table, usually fitted with leaves to extend its usefulness, or a marble-topped table

- Either a set of dining chairs or, much better, a collection of different chairs. (This has historical precedent: Many pieces of furniture are passed down generation after generation and in the best homes tend to be uniquely unmatched.) Still, to avoid a wildly disparate look, the chairs must be of similar style and size and have a unifying factor:
 —If the frames of the chairs are dissimilar, upholster the seats in the same fabric
 —*or* upholster two chairs alike for the heads of the table and keep the others dissimilar
 —*or* keep all the chairs dissimilar *if* they are identical in height
 —*or* keep all the chairs dissimilar *if* they are made of very similar woods

- Another classic dining option is a table placed near a wall, serviced by a built-in banquette

- A buffet for serving, perhaps topped with marble

- A crystal or brass chandelier

- A silver tea service (or brass or silver-plated tea set)

- Candlelight: many individual silver or porcelain candlesticks grouped together on a table or server, or a candelabrum, always with real candles, lit during dinner

- Fresh flowers in an unusual container (a polished silver samovar?); fresh fruit mixed with real leaves in an antique cut-glass bowl

Expensive Hallmarks	*Decorating Rich*

Expensive Hallmarks
A huge antique mirror in an ornate gilt frame. NOTE: The best mirrors are spotted, even pitted with age. (Never buy new mirrors that are veined with bold or black to look old. They don't.)

Decorating Rich
An old mirror in a regilded tarnished frame *or* ornate "newish" frames painted white look wonderfully crisp when placed against darker walls; *or* a collection of small, old, framed mirrors hung in a group: splendid when they reflect the candlelight

A set of antique dessert plates and cups and saucers displayed in a china cabinet

Collect one-of-a-kind antique dessert plates and cups and saucers: They're much cheaper to buy this way, and even more charming than a matched set

Animal-skin chair seats (especially leopard—a small fortune)

Leopard-skin-print cotton fabric goes with almost anything and looks spectacularly "rich" on dining-room chairs of wonderful wood. (I prefer animal prints to real skins for humanitarian reasons.)

An antique tassel on an antique brass key inside an antique chest

Reproduction key with reproduction tassel: To give an aged look, rub key with hands frequently, or rub in cigarette ashes

A collection of crystal

A collection of glass pitchers, glass teapots, or glass candlesticks develops prestige when they are unified by the glass motif; one or two really old glass pieces thrown in won't hurt

A collection of brass, sterling silver or antique porcelain candlesticks

A collection of silver-plate or reproduction candlesticks

Antique hardware (old brass, porcelain, or cut glass "period" hardware) on antique chests or doors, to hang draperies and pictures. (Of course, such hardware also appears in other rooms throughout the house)

Excellent hardware—door knobs, locks, hooks with classic designs—provides a heritage look. No job is easier than changing a door or chest knob, and superb reproductions are available (see Resource Guide). The simplest chest can become an "instant antique" for pennies!

Table and sideboard tops of antique marble, slate, and granite	New stone tops can be cut to fit: buy at "seconds" shops
Priceless marble or parquet floors	Bleached, trompe l'oeil painted, floor-clothed, or stenciled floors. It is not inexpensive to commission a fine artist to do a trompe l'oeil floor, but it is far cheaper than installing the original; many techniques of stenciling and bleaching can be self-taught and accomplished by less-than-stellar craftspeople; see Bibliography: *Decorating Furniture* by Jo-an Jenkins for how-to book
Porcelain cachepots holding fresh flowers or potted plants	Repro cachepots holding large ferns or flowering plants
Eighteenth-century Chinese wallpaper (the European rich loved Oriental papers)	Reproduction Oriental wallpapers: can be bought as "seconds" or at discount
Armloads of fresh flowers for the center of the dining room table —caught in priceless crystal	A collection of small, individual glass flower holders—perhaps placed on Chinese stands. It's far less costly to exhibit five or six unusual fresh flowers instead of masses of them, and often more classy as well
Tapestry, old and priceless, framed magnificently	An excellent panel of wallpaper in a "tapestry" pattern can, if it's very good, look like the real thing when mounted behind glass and beautifully framed. Try a fine piece of white lace framed in the same way for a rich tapestry effect

THE EUROPEAN OPULENT BEDROOM

It contains most, if not all, of the following:

- An absolutely fabulous bed: choose from:
 A canopy bed with a full or partial canopy covered with
 —the same brocade as the bedspread
 —the same chintz as the quilt
 —white linen or white lace
 —white mosquito netting and then a shock of rich color thrown over the netting

A four-poster bed draped in any marvelous fabric or, if the posts are magnificent, standing proudly alone. (One client created a four-poster bed from four discarded street lamps she found in a flea market: From post to post, she draped organdy eyelet and had the most romantic bed imaginable)
A corona bed, with folds of material cascading from the crown

- A tall armoire for hanging clothes

- A bureau cabinet with drawers for clothes

- A cheval mirror, often standing tall on arched splayed feet or a shorter version propped on a bureau top

- A chaise longue

- Bedside tables to hold books, bibelots, milady's toilette articles

- A small bench, trunk, or footlocker situated in front of the bed, either painted charmingly or upholstered with a plush fabric seat

A full-canopy bed: Note how the material "puddles" on the floor.

A quarter-canopy bed: note the tassel tiebacks.

- A skirted table, perhaps used as a vanity, draped with three layers; a fabulous tasseled shawl could be a fabulous top layer

- Two identically framed portraits or scenes symmetrically hung in the room

- A wonderful rug—perhaps a small dhurrie? a small Oriental?

- A lady's writing table and chair

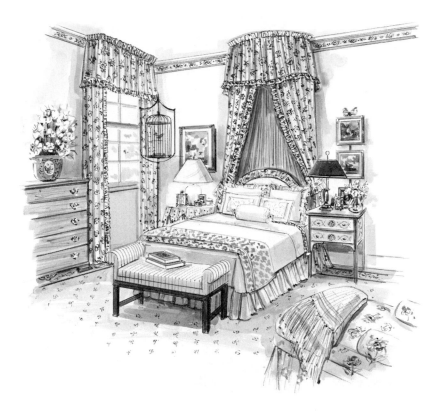

Decoding the English Manor bedroom: florals on fabric, rug, wallpaper, painted surfaces; a classic corona canopy bed; abundant fabric: drapes, skirted table, dust ruffles, pillow shams; image makers: books on bench (the rich have leisure time); silver-framed photographs (the rich display ancestors); fresh flowers (the rich garden); art (the rich travel and collect).

- Piles of pillows, European square-style among them, in crisp antique linens

- A white crocheted throw or a wonderful fringed scarf over the back of a simple chair

- The ubiquitous silver- and porcelain-framed photographs

- A three-paneled dressing table mirror, standing or wall-hung

Expensive Hallmarks	Decorating Rich	THE EUROPEAN OPULENT BEDROOM: THE DECORATING RICH WAY
A magnificent antique canopied bed	Have a simple frame built into the ceiling above a simple bed. Hang curtains on the frame (made of gossamer silks, good sheets, chintz, or netting, or heavier brocades or satins) so they form a draped canopy: Gather them at the four corners with braid or silken cord with tassels. The fabric can be fastened to the frame with Velcro	
A magnificent antique "corona" bed	A discarded bicycle wheel or an oval picture frame can be fastened to the ceiling to get the round corona shape, and fabric can be hung from the shape to make a perfect corona	
Expensive potpourri in antique Chinese porcelain bowls	Not-so-expensive potpourri in a country-auction reproduction of a Chinese bowl	
Antique lace linens purchased in an exclusive linen shop; antique lace pillows scattered on the bed in front of a large linen-covered European square pillow	New white linens with eyelet ruffles and a few small "antique" lace throw pillows scattered in front of square linen-covered pillows	
A servant to deliver breakfast in bed	A standing bamboo breakfast tray with floral china cups and saucers and lace-trimmed napkins. Get your own breakfast (and that of your companion) and then luxuriate. You have to believe you deserve rich decorating to pull it off (see the Act-As-If Principle, p. 163). Whatever you do, don't forget to put a fresh flower in the bud vase that stands on this tray	
An antique wooden music stand (can also be used in living room)	Reproduction music stand topped with old sheets of music	

A skirted antique vanity table topped with a period mirror	Inexpensive sheer white fabric over an old table; buy a "three-way tryptich mirror" for the top (available in flea markets)
Antique inlaid-wood armoire	Inexpensive reproduction glossy-painted the same color as wall or in a pale color derived from the wallpaper
Authentic architectural moldings	Wallpaper borders—even an unhandy person can install them. They outline a room and add rich architectural interest. Consider applying the border not only around the perimeter of the room where the wall and ceiling meet, but also down the wall corner line, from ceiling to floor, as a chair rail, or around the windows
Ancient embroidered cushions on bed or window seat	Not-so-ancient-cushions stuffed with pure down. This is an invisible luxury that always reads *rich* the moment one leans on them. Not only the down but the lush trim make them look like jewelry in a room: Tassels, braid, and other trim are the last word in elegance!
A table de toilette with a brocaded skirt	A table covered with remnants of an old wedding gown
An ancestor's fabulous overscaled chandelier (instant opulence)	A fabulous overscaled chandelier unearthed in an obscure shop. Look for it—it exists for less than you'd pay in an expensive antique store
Baccarat crystal on the tabletop	Splurge on hand-blown crystal, but you can get it for far less than Baccarat prices—even in stores like Tiffany's
Antique gilt picture frames, antique gilt chairs, gilt curtain rods	*New* gilt. It says rich when it's applied thoughtfully. Ask your local antique dealer— after you've made friends with him—the best way to "antique" with gilt. One technique I know involves first applying a base of paint to an object you wish to gild, letting it dry, then brushing on the gilt as directed and rubbing off the excess: The paint showing through in spots can look like it's been there for hundreds of years. Gold-leaf kits are available in art supply stores
Huge European Elegant rooms	Small rooms can be given a feeling of deluxe expansiveness with large furniture, which makes a small room look larger when not overdone. On

the other hand, teeny weeny pieces clutter up a small room, making it claustrophobic in feeling

A skirted side table layered with expensive fabrics and an antique lace throw

A skirted side table layered with marvelous hemmed sheets (fringes at the end?). Top with antique lace from a flea market and cover any worn or repaired spots with tablescape items

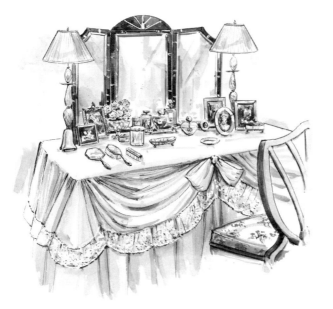

A boudoir table with antique three-panel mirror. Note the layered skirt, ancestor photographs, vintage silver accessories, perfume bottles on pretty tray for a "pulled-together" look.

Crystal perfume bottles or silver or crystal decanters on an expensive silver or porcelain tray (or obelisk collection on tray)

Trays always "pull things together." Look for silverplate or flea market Limoges trays: The tray must be pretty—not perfect. Glass reproduction perfume bottles can be filled with varying shades of amber-colored water

A Sheraton-period cheval glass

Reproduction standing mirrors are available; this item immediately whispers English elegance—especially if you throw a ribbon garland of satin hearts over it

An abundance of floral chintz and English floral print wallpapers

A coordination of lots of floral sheets and "seconds" in comforters and wallpaper. Upholster a plain headboard in a floral sheet. Ditto with a small tufted chair. Make floral dust

	ruffles for the bed and floral drapes full enough to "puddle" six inches onto the floor
Custom-made crystal or ceramic lamps and antique silk shades	Spray-paint an old lamp base in a coordinating color and buy a new silk shade in a discount shade store (see Resource Guide)
An antique chest or bench (with or without a cushion) at foot of bed	Search for a usable flea market trunk or bench. Make an upholstered pillow from a servants' wide embroidered bell pull (often seen in flea markets)
Wit and whimsy (an inherited antique teddy bear, doll, music box, or sled add character)	Buy someone else's heritage at flea markets and thrift shops. If the object is charming and appropriate to the decor, try to see it in a new, useful way: Use an old sled to hold plants, flowers, or books. Often a fabulous old chest can be wall-mounted to house new (but ugly) electronic equipment
Custom-lined dust ruffles on the bed (infinitely more elegant looking than an unlined dust ruffle)	Use the old dust ruffle under a new one to give that fuller "custom" look
Carved wooden details on doors and on moldings surrounding doors	Louvered doors or stock lumber yard molding placed on and framing plain doors can change the look of a "modern" ordinary room to one with "historical" architectural interest

Fail-Safe Tips for Achieving the European Opulent Look

EVERYTHING OLD IS NEW AGAIN

"In America," said one staunch European, "people wake up one morning, can't stand the look of their homes, throw almost everything out, and start all over again. In Europe, 'throwing out' is close to sacrilege. *Refurbish* is our middle name."

This is an important clue to European Opulence. Nothing ever looks new. And often in fact, things look downright seedy—a result of having been well appreciated over the years. It's a warm look.

Naturally, you can mix and match, but keeping a schematic point of view when it comes to color makes it all fall together in the most European Opulent way.

Whenever I'm doing a home with a flavor that is basically French, Italian, English, or any other specific European country, I love to think of the colors most traditionally associated with that country. For instance, for one home whose owners loved the Italian instinct for elegance, I pulled out the colors of sun-drenched Tuscany: mellowed golds, burnt sienna, the reddish-brown tones of the Tuscan landscape. The terra cotta of the frescoes, the splendid bronzy almond hues of the countryside, the Titian red of the Venetian court all became inspiration. We also studied paintings of Italian masters in museums to copy the warm Italian hues.

Thinking French with another client, we were moved to copy the inside of one of those marvelous French music-jewel boxes she had inherited from her French grandmother. The jewel tones of aquamarine, topaz, rose quartz, pearl gray, pale amethyst dominated our fabric choices.

For one English-inspired country den, the colors had to be somehow more robust and deep than the French colors: royal blues, masculine chocolate leathers, and sturdy paisley prints were the order of the day. The hunter greens and fox-hunt reds for the English look are wonderful on walls, especially with a favorite of mine, a leopard print carpet.

I keep going back to the paintings. Find your European-rich colors from the great masters and focus in on what you need. Don't just study a Matisse or a Rembrandt for its human subjects: Check out the rooms portrayed as well.

If you are in doubt as you shop for fabrics or furniture, keep this thought in mind: People do take their color inspirations from the surroundings they admire, and that is how it should be. If you love a French influence, your Decorating Rich colors will come from the Parisian salons because the aristocrats lived in the city, for the most part. The French rich colors are, as in the Parisian opera house, bonbons and jewels—yellows, roses, blues. The furniture is delicate and small in scale and the colors are true but delicate, as well. The Italian aristocrats lived in country palazzos and Italian rich colors are not

only those of the sienna landscapes but also of the iron, stone, and marble of the grand palaces. The English aristocrats may have lived in their London townhouses for part of the time, but their hearts were also in the great, gorgeous country manor houses inherited from their lordly ancestors. The English rich look is a comfortable, cabbage-rose look, a floral, plushy look, a horse-and-hound look, a garden look, a bigger look—they had the acreage!

Since the European aristocrats were fascinated by their Oriental neighbors, they carried on a vast trade exchange and brought the colors of the Orient into their homes in the popular imported wares. The French, English, Italians, and Scandinavians were all influenced by the wondrous colors of the Oriental rugs, the blue and white Chinese porcelain, the lacquered black and cinnabar furniture, the mother-of-pearl, the turquoises, the golds, the aubergine purples often set against the contrasting backgrounds of which the Japanese and Chinese are so fond.

THE MASTERSTROKE

Every room in every signature deserves a Masterstroke, that One Grand Touch . . . the piece of art that is fabulous, the inherited sculpture, the collection of porcelain hands, the Louis XV chair, or perhaps the exquisite artifact that demands attention. A Masterstroke is spectacular, in size or presence or quality, and should be used as the center interest of the room; from it, take the room's colors and mood or flavor—its point of view.

Some possible Masterstrokes for a European Opulent living room:

- A grand piano (the rich often have musical hobbies)
- A Roman bust of a small child (the rich love to display signs of travel)
- A Renaissance gaming table (the rich play games)
- An inherited crystal chandelier (the rich entertain in luxury)
- A set of antique botanical prints (the rich love to garden)
- A handmade tapestry (the rich revere the work of fine artisans)
- A French Rococo hand-painted gilt chair (ditto)
- An antique mahogany tea table near a classic chintz easy chair (the rich revere comfort—especially the English rich, who also revere tea)

NOTE: It goes without saying that you may choose any of these Masterstrokes in reproduction—and no one will know the difference if you have educated your eye to what's a good reproduction. Many of the books listed in the Bibliography as well as frequent trips to museums where one can study the originals will give you an education in "good." Consider a course in furniture fine points as well: These are often offered by local schools.

Wealthy Europeans, past and present, have used the surfaces of tables in every room to display the status symbols that mark them as people of Culture and Means. Tables are turned into personal galleries. Not everything displayed on a table has to be a priceless treasure. Objects given prominence acquire prestige. When well displayed, ordinary objects can look like museum-quality acquisitions.

TABLESCAPES

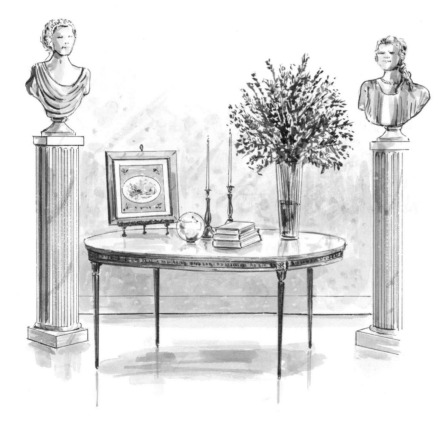

Creating a tablescape: Different heights and shapes add lushness and interest. The "pair principle" adds symmetry.

Link your own treasures in a tablescape by a unifying theme: a collection of eggs, different ivory objects, or photographs. HINT: Never arrange objects in visual clichés (the shortest going toward the tallest, for example); stagger heights and add surprises to the arrangements.

Pictured here is a tablescape I created for one client: leather-bound, gilt-edged antique books, a pair of silver candlesticks with slightly burned-down candles whose wicks have been blackened, to show that you use your good things, a well framed miniature painting on a table easel, an armful of fresh leaves in a tall crystal vase, a crystal sphere reflecting light and color. The tablescape is flanked by two architectural columns on which stand reproduction busts.

A tablescape does three things: It says, "I am traveled and cultured and able to afford symbols of leisure"; it provides a fascinating look, for guests, into the rich life-style of the hosts; and it adds individuality and personal appeal to a room, quite apart from even the finest "decorated look."

COLLECTIONS

An indispensable aspect of European Opulence—and of the other decorating signatures as well—is "the collection." Collections are the major status playing pieces in the prestige game. No collector will ever really admit he's in it for the impression it leaves: No, he simply has an uncontrollable passion for collecting as many rare porcelain rabbits as he can lay his hands on. Interesting collections always exist in high society—which is not to say they can't be fun as well. The higher the value of the collection (depending on its age, rarity, and loveliness), the higher the status that's derived.

Although collections are a Decorating Rich symbol in every signature, the flavor of the collections changes with each look. In European Opulence, collections are usually comprised of antiques—or what can pass as antique.

Some suggestions for European Opulent collections:

• Obelisks	• Porcelains	• Antique coins
• Porcelain plates, vases, or animals	• Duck decoys	• Vintage silver inkwells
• Bronze figures	• Victorian dolls	• First-edition books

Certain kinds of art go hand in hand with a European Opulent signature. **ART**

Some suggestions to lend culture and charm to your home:

- Old Master-type oils
- Ancestor portraits
- Still-life paintings
- Bronze sculptures

- A marble bust
- Animal paintings
- Tapestries

- Flower paintings
- Sporting prints
- Art on an easel

Botanicals, suitably matted and framed, add to the English Manor look. Grouped over a marble-topped commode, their beauty is enhanced by unique containers of fresh flowers. (TIP: Marble can top any inexpensive flea market chest and change it dramatically.)

Detail of beveled matting with inserts of marbleized paper. Touches of gold lend richness.

**FABRIC-
SWATHED
WINDOWS**

Lots of swag (loose and heavy hung fabrics) billowy festoons, ruffled valances, "puddled" lengths . . . you could get lost in the fullness of a European window, and many small children and pets did just that.

These romantic, lavish, fabric-rich window treatments provide a look into a more formal era, and are becoming increasingly popular in European Opulent homes in America. Luxurious draperies, with or without curtains underneath, balloon and Austrian shades, braided cord tie backs, fringes, rosettes, tinted underlinings reflect the fortune that the upper class invests in its windows. What's more, fabric-swathed windows are cozy! Lavish yardage makes a house or apartment a haven, ensuring privacy and muffling street noise. But careful: The most elaborate drapes need tall windows—heavy brocade and rosettes look silly on teeny windows.

Lace as a window fabric is making a serious comeback in tradi-

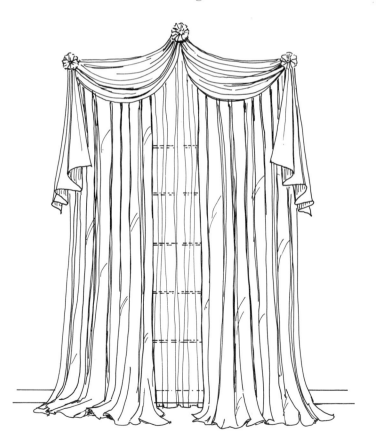

Rich swag: Folds of fabric draped over sheer curtains and caught by rosette hardware. Drapes "puddle" on floor.

50

tionally European-formal homes: It gives polish without being heavy or elaborate. Lace draped over a rod or held in place by swag holders (metal brackets) looks elegant.

Another popular European window treatment is the "insertion curtain," inspired by the Victorians and copied widely everywhere. These are simple layers of lace, muslin, or any transparent, light fabric hung under a heavy brocade or velvet swag which is pulled back and left in that posture. The airy curtains permit the entrance of light, but still give privacy and mute the fading effects of the sun on the heavier, most costly fabrics in the room.

Drapes and curtains are often hung on heavy brass or wood ornamental rods, finished off at the ends with finials in the shape of fruits or vegetables (the ubiquitous acorns). Fabric-coordinated valances are also appropriate.

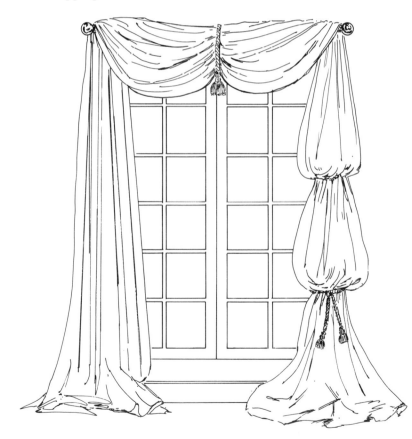

Pouf swag accomplished by silk cord tiebacks, or fabric draped over rods as shown (detail) if you prefer. Let the fabric simply hang and "puddle."

LIGHTING

A contemporary swing-arm lamp looks fine but crystal and brass chandeliers, elaborate candelabra, brass and crystal column lamps, and true candlelight look even better in an elegant European-style home. Still, I do feel strongly that bringing lighting from the modern world into an Old World home can work splendidly. If one is subtle about track lighting, it will not take away from an Old World look. An innocuous baby spot or two from the ceiling, focused on a conversation or art area, works magic. After all, gloominess does nothing for elegance.

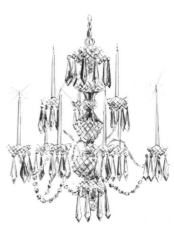

A crystal chandelier

A standing torchere

A crystal candle sconce

A brass chandelier with pleated silk shades; a shirred fabric sleeve covers the chain.

Dimmers are wonderful and perfect for European Opulence. They bathe a room in a rich rosy glow when you need rich rosy glows and in sparkling clarity when you need sparkling clarity.

Marvelous Old World lamps can be created from old vases, which, by the way, are easily electrified, so if you've inherited a beauty, you can have it transformed. Also consider refurbishing possibilities. You found a peeling, wooden or blackened brass column lamp someone threw out? The lines are classical but the condition is terrible? Paint it, polish it, add a great brass, painted, or silk shade, and you have something special!

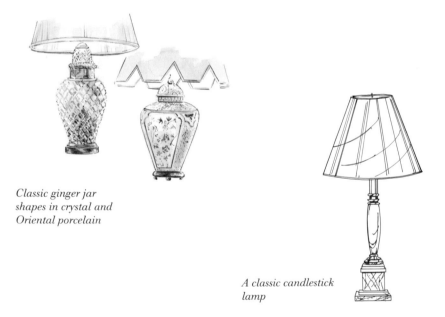

Classic ginger jar shapes in crystal and Oriental porcelain

A classic candlestick lamp

EUROPEAN OPULENCE can tend to be excessive, but it is never, ever boring. It is an ample, lavish, generous look that celebrates history and culture. It is a signature for those who are always on the prowl for a delicious antique or a piece of furniture that looks as though it had a story.

4

Classic Contemporary

Does This Sound Like You?

- I know what Bauhaus is
- Good words for me: *crisp, clean, uncluttered*
- A monochromatic color scheme (beige, gray, off-white) is so elegant
- The new Italian designers are nothing less than inspired
- Built-in furniture—an idea that's appealing
- Promise me anything but give me a Wassily
- If I had a beach house, I'd put white tiles on the floor
- High Tech is interesting: plastic laminate, rubber, chrome, industrial lighting
- Purple and orange? Maybe. Chintz? Never
- I like visual puns, like furniture on a slant
- Rich mixes are fabulous: Give me a Formica platform bed and white organdy pillows; a chrome and glass dining room table with Louis XIV chairs

- The fifties were nifty. A touch of neon, an old jukebox or a plastic radio make interesting accents, but an overall fifties look is not a rich look to prevail

- I'd *definitely* dip into Deco

- Keep your long-stemmed roses: Give me a long-stemmed torchère lamp

- Solid blocks of color could make interesting art

- The best lines are linear

- I'd die for a *huge* zigzag steel sculpture

- Less is more

Classic Contemporary: I love it. It's the look of the forward thinker, of the person with the most eloquent voice of her era. It's the look of timeless style.

The Classic Contemporary Look

No-nonsense, power-stunning, this sleek contemporary room immediately sends messages of state-of-the-art taste. The person who lives here appreciates the finest of her time. The appeal of the room is strong, seductive—classic.

Can you see yourself entertaining in the midst of such pristine elegance? The media center replaces the hearth as a focal point. Your guests sink into the icons of modernity—the Barcelona chairs—while you share the couch with a business associate who leans into the absolutely decadent lushness of the pure down pillows.

To begin to understand the richness of Contemporary, you must let go a prejudice against

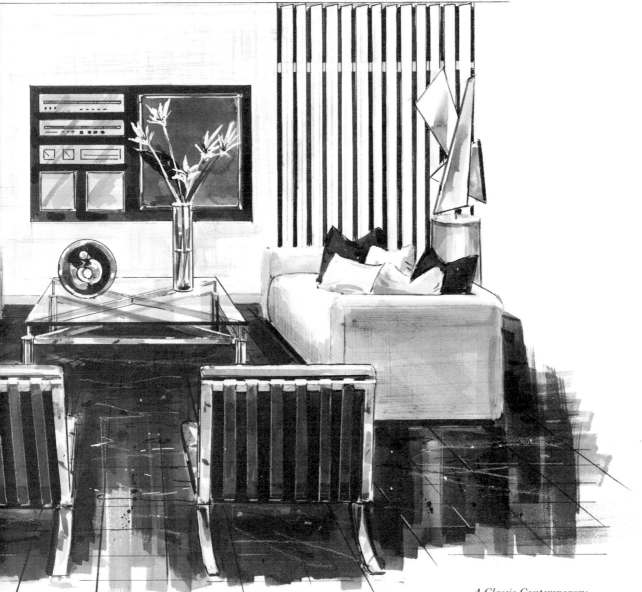

*A Classic Contemporary
living room*

machine-made. Most of us have grown up with a built-in respect for things "handcrafted." The laborious, inspired work of the artisans will always be worthy of respect. Still, the machine has grown up. Classic Contemporary came of age during the Machine Age (1918–1941) when man began to understand the beauty, the power, and the potential glory of machines. The Machine Age was also a time when people became enamored with technology.

As streamlined trains, planes, cars, and highways and soaring buildings free of filigree and moldings appeared, people with taste and money began to think of new ways to translate mechanical forms and energy into home decoration. Artists who appreciated the clean, unbroken lines of jet planes, glass, and steel wanted to live with those lines. All the new materials of the Machine Age distinguished it from former times; the steel, chromes, plastics, and fiberglass were fresh and inventive. The machine constructions were sleek and simple. Why not bring them inside? Why not make homes of uncluttered comfort from the same materials that were used in communication, transportation, and mass production? Why not substitute contour for frills and froufrou?

It's difficult to define Classic Contemporary because much of today's design that calls itself contemporary is merely controversial and not very classic at all. In every age, faddish furniture designers appear to have great influence when they've sprung something outrageous on the world. Although these designers make conversation, they rarely make history. Their innovations are often forgotten when the next "rage" appears.

What masquerades as "modern" today is often tacky, poorly made, quite the opposite of rich decoration. The clean lines of good Classic Contemporary furniture conform to human forms as well as they do to human life-styles. They are sturdy, well constructed, and balanced. They have simple surfaces, devoid of decoration, and they utilize the best of natural as well as man-made materials.

The good news is that because Contemporary was born to be machine-made for the most part, excellent copies of expensive originals are readily available. It is not difficult to create a splendid, richly restrained contemporary look with an equally restrained budget.

SCHOOLS OF MODERN DESIGN

The Bauhaus, a school of art and architecture founded at Weimar, Germany, in 1919 and headed by Walter Gropius, was a leading influence in design in the twenties and thirties. The teaching concentrated on functional craftsmanship applied to industrial problems of mass production. Its philosophy was profound: the belief that a different way of educating people through art and design could eliminate social and national barriers. The people who studied at and brought their talent to the Bauhaus school were to become influences in architecture, furniture, and weaving design throughout the world. Lyonnel Feininger, Wassily Kandinsky, Paul Klee, Josef Albers, Miës van der Rohe, and Marcel Breuer were among the leading standard-bearers.

If you are interested in decorating your home with Classic Contemporary flair, you ought to at least be familiar with the name Bauhaus and the understanding that so many of today's contemporary classics were actually designed by the artists of this school.

Not a real school, but a school of thought—a style of decorative art popular in the twenties and thirties. To my mind, Art Deco—the art of the Jazz Age, as it's been called—was one of the finest developments in contemporary decoration. Deco is many things: Oriental and flower motifs, combined uses of metal, glass, lacquer, wood, and shagreen (a kind of untanned leather with a granular surface); deep, hot colors (my personal preference runs to pale peach and seafoam green). Cubism influenced Deco and so geometric shapes often prevail. Things that say speed (greyhounds, cars, lightening bolts) incorporated into a design are Art Deco.

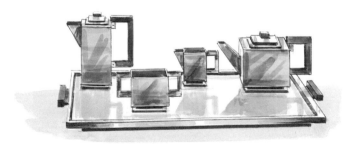

A silver Art Deco tea set with square cantilevered design and squared-off hardwood handles

Baskets of fruits and flowers, female deer, ebony, mother-of-pearl, enamel fans, and nudes with hair streaming out behind them are all Deco motifs found on furniture, pictures, lamps, picture frames, and other accoutrements of the home. Some Art Deco items were of unquestionably shoddy taste (pottery ashtrays in the form of nudes with bulging bosoms, Leda and the Swan statues) and became known as "kitsch," the German word for trash. Other works of the masters of Deco—glass from Lalique (a master of Art Nouveau, as well), enamel from Faure— are, quite simply, glorious.

Even a small piece of Deco, good Deco, added to a Classic Contemporary home gives a strong message of luxury and opulence. Two curvaceous Art Deco chairs can set the tone for a whole room. A mirrored vanity, a copy of a Ruhlmann ebony armchair, a silver Deco desk set, supply infinite glamour and luxe.

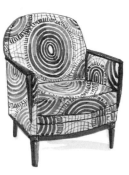

An original Ruhlmann chair with fabric reminiscent of African art: luxurious comfort

ART NOUVEAU

My clients are forever confusing Art Deco with Art Nouveau, which came earlier. The Nouveau school of decorative art, which originated in Europe in the 1880s and flourished until World War I, utilized rich ornamentation, concentrating on unusual expressions of nature —curving, elongated stamens, stems, and leaves—as its theme. Japanese art and artifacts had a major influence on the style, and the asymmetrical shapes of the Orient were frequently used.

In architecture the Art Nouveau style was expressed in dancing, twisting ironwork. Outstanding Art Nouveau designers include Aubrey Beardsley, Charles R. Mackintosh,

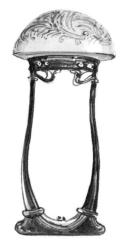

Curving, twisty ironwork on an Art Nouveau lamp

Hector Guimard, Gustav Klimt, Louis Sullivan, and Louis Comfort Tiffany.

The best examples (prohibitive in cost) are marvelous, but imitations tend to be ticky-tacky.

Trendy experimental forms of post-modern art and decoration are known as avant-garde. Two influential avant-garde schools have been Pop and Memphis. They're shock-provoking, fascinating, and, because they're so very different, quite risky when it comes to Decorating Rich.

Pop Art was a sixties avant-garde movement. Artists like David Hockney, Andy Warhol, Roy Lichtenstein, Jim Dine, and Claes Oldenburg found inspiration in the "schlock and kitsch" of comic strips, magazine advertisements, and detergent boxes. These artists created an entire art form from the satirization and parody of the images seen, and ignored, by millions every day.

Full of whimsy and insanity, Memphis art is extravagantly outrageous with busy, wild colors and designs. Radical Memphis designers were rebels. Their name was taken from the Bob Dylan lyric, "Stuck Inside of Mobile with The Memphis Blues Again," and they aimed to make a statement with their design ideas. For example, they were quite sensitive to the cultural connotations of certain materials like marble (code: high class, expensive) and plastic (code: low class, cheap) and so they loved to design in contradictions such as a table made of marble *and* plastic. Their furniture carries an unspoken social critique that reads "Let's do away with rich and poor distinctions, hierarchies of taste."

Still, despite pure ideals, hierarchies of taste do and will always exist. Which is why extensive use of avant-garde in home decoration is not Decorating Rich, no matter how elitist that may sound. Rich decorating (even on a budget) is not meant to shock. A fetish for the ephemeral usually cancels out elegance, which relies on designs that have stood the test of time.

Avant-garde originals can sometimes be spectacular if used sparingly. One original

Michele de Lucchi's avant-garde "Memphis" chair

61

Warhol or a lively piece of Memphis art can revitalize a dull, contemporary-style room. However, originals cost a fortune and copies have become too familiar. What is meant as a piece de resistance can turn, too quickly, into a freak novelty.

MORAL: A chair in the shape of a giant hand or a punk art painting of a psychedelically painted Rolls-Royce does not rich decorating make—even though it may give you a giggle.

USE THE CLASSICS

A Sheraton desk, a Windsor chair, a Shaker bed—every age has had its classic designs that were instantly recognizable as superior, elite. Contemporary is no exception. The contemporary classics are described below in Get Rich Quick! and every one can be obtained in low-priced reproduction. Some of the stores that specialize in contemporary classics (see Resource Guide) even use the same molds from which the originals are crafted today; only imperceptible differences, if any, set them apart from the extremely high-priced models.

Before you purchase any of these classic designs in reproduction, however, be sure your eye has been educated. Copies can be superb, terrible, or something in between. Examine the originals in fine stores and in modern museums. Test them out whenever possible.

Go to magazines, find contemporary rooms, and see how the classics work within them. Then, shop for your reproduction. Since the originals were designed to be mass-produced by machine, it's easy to reproduce them faithfully—much easier than to reproduce, for example, a hand-carved Chippendale mahogany side chair.

If everyone can have contemporary classics, why would the rich want them? Because the classic design, when followed in general concept, is simply perfect. Unfortunately, contemporary classics are often reproduced in a shoddy way, with little respect for the original lines. These must, of course, be avoided when Decorating Rich—which is why you have to go back and become familiar with the originals before you buy the reproductions. Occasionally, hybrids, a combination of classic lines can work, but be wary.

GET RICH QUICK!—THE ELEMENTS OF CLASSIC CONTEMPORARY STYLE

It is virtually impossible to Decorate Rich in the contemporary genre without incorporating some of the emblems, the recognized classics of contemporary style. These specific furniture forms symbolize the very essence of the style:

Bentwood Furniture: Cabinetmaker Michael Thonet, at the tail end of the nineteenth century, opened the doors to the twentieth century and Classic Contemporary style. It was he who developed the first assembly-line mass-produced furniture process that is so significant in contemporary design. The furniture that is Thonet's trademark is characterized by molded, laminated sandwiches of thick veneer that gracefully bend into curves.

Bentwood chair

The Vilpuri Chair: Alvar Aalto, a Finnish designer of the twenties, designed this chair in his native blond birch; its legs are bent at a right angle that can wrap around a seat or table top. This "Aalto" leg also comes on a very classic stool.

Vilpuri stool

The Wassily Chair: In 1925, architect Marcel Breuer created a landmark breakthrough in furniture design—a boxshape chair of tubular steel, with canvas strategically stretched over the steel frame to support the body. Breuer also designed the Cesca chair, a cantilevered design bent from a single length of S-shaped steel tubing.

Wassily chair

Breuer Cesca chairs

63

The Barcelona Chair: First introduced in 1929, the Barcelona chair was designed by the German architect Miës van der Rohe. It has leather cushions with buttons and tufting that sit astride a flared-leg, X-shaped steel frame.

Barcelona chair

The Tugendhat Table: This is the classic, glass-topped, steel-based table seen everywhere, and it is also a Miës van der Rohe design. The original (which has had many incarnations) consists simply of a four-legged, chrome-plated flat-bar steel base topped with glass. The best reproductions incorporate van der Rohe's famous welded joint at the top of the X-shaped brace.

Tugendhat table

The Le Corbusier Chair and Chaise Longue: Known as "the grand confort," the chair looks like a metal cage holding squared-off leather cushions. Le Corbusier also designed an incredibly relaxing, adjustable chaise longue with head, back, seat, and footrest blended into one line. A black enameled steel base supports a curved upholstered pad; the feet are higher than the head, providing maximum relaxation.

Le Corbusier lounge

Le Corbusier chair

The Eames Chair and Ottoman: Charles Eames, an American born in 1907, really changed the look of the Classic Contemporary home with his "shell" chairs that would soon dot the landscape. The leather-upholstered Eames chair and ottoman took the place of European Opulence's traditional feather-filled upholstered armchair. The chair, made in three sections, is mounted on shocks and supported on a pedestal. The contours of the wood provide unsurpassed body comfort. He who has leaned back in an Eames chair won't soon forget it—it's close to floating. Eames's piece de resistance is widely and successfully imitated.

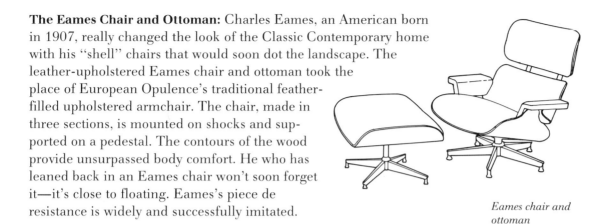

Eames chair and ottoman

The Womb Chair and the Saarinen Pedestal Armchair: The Finnish architect Eero Saarinen gave new form to the contemporary look. A chair should be part of its occupant, he thought, and Saarinen's "womb chair" is very wide and deep with a thin profile; when one sits in it, it's almost impossible not to assume a relaxed fetal position. Looking for a chair that would not clutter up a pure environment with its four-legged jumble, Saarinen also came up with a classic tulip-shaped pedestal chair, stool, and table, copied today in many materials: marble, plastic, and wood, among others.

Saarinen pedestal chair; Saarinen womb chair

Modular Couches: In the old days, it took only two people, one at each end, to move a couch. Today, contemporary couches come in many sections and many configurations, a tribute to the twentieth-century penchant for change. What fits as one piece along a wall in

65

your first apartment can be taken along when you move, broken up into three separate units to fit a smaller room, and utilized forever.

Built-in Furniture: Built-in cabinets, storage space, closets, and even beds are ubiquitous in the Classic Contemporary signature. Look in the Yellow Pages for carpenters and get estimates before you proceed.

Platform Furniture: Part of the interest in a contemporary room is often derived from levels. Beds or couches resting on a platform (easily and inexpensively constructed) are given attention.

Cubes: With or without glass tops, cubes are used everywhere in Contemporary-land. Try them as tables, as stools, as bases for collections, lamps, and sculptures, as foot rests. Imagination prevails. Caution: Eschew colored plastic cubes and look for those created from wood, clear lucite and other simple, "quiet" materials.

Parsons Tables: Equally wonderful as coffee, end, night, sofa, or hall tables, these versatile pieces come in materials ranging from plastic laminates to wood, and finishes from painted to linen-like fabrics.

Parsons tables

Make Your Own Classic Eclectic Bases for Glass-Topped Tables: The glass-topped table is so common, it hardly qualifies as an innovation today. The variety of objects used to support the glass is extraordinary. You can make your own classic. One client of mine made a coffee table by putting a glass top on a crate covered in Mylar.

The collection of Steuben glass she put on the table as a Masterstroke gave richness to the already dramatic base. Glass blocks have been used by another client. Yet another base was a trompe l'oeil Gothic column, providing a touch of rich mix to a contemporary table. NOTE: The glass on a coffee table should be a half-inch thick for stability and a substantial look. Try to get the edges beveled, as well. Smoky tints are an interesting option.

A glass-brick base topped with a glass slab

A CLASSIC CONTEMPORARY BEDROOM

The uncluttered appeal of this stunning contemporary bedroom is achieved, in part, by the clean look of the simple vertical blinds that echo the architecturally pristine wall panel hung over the head of the bed. Classic Miës van der Rohe chairs (copies are readily available) grace the scene. Recessed lights play softly down on a sleek black lacquered platform bed. A quilted comforter and a lush mohair throw soften the scene.

A horizontal line appears in the equal heights of the Parson's table and the bed and night tables. A pair of classic Italian Tizio lamps (also available in reproduction) are reflected in the unbroken line of floor-to-ceiling mirrors.

Abstract modern art provides a Masterstroke.

Storage is important to this look: No clutter, knickknacks, baskets, or tassels distract here! Even the bedside clocks are sleek and unadorned.

This is a dramatic room deriving power from its monochromatic color scheme, its forceful shapes, and its dominating art. By decorating rich, its allure is easily matched for a modest pricetag.

A Classic Contemporary bedroom

Expensive Hallmarks	*Decorating Rich*	
Large rooms	Use mirrors, one of the decorator's most luxurious tools. They open up rooms like nothing else. If you mirror a wall, extend the glass all the way to the corners	**A CLASSIC CONTEMPORARY BEDROOM: THE DECORATING RICH WAY**
Built-in beds	Platform beds on carpet, Formica-covered or spray-painted plywood	
Lacquer built-ins	Ready-made Formica cabinets in the same color as the wall	
Built-in upholstered seating	Ready-made modular couches	
Electronically controlled blinds	Mini-blinds	
Built-in recessed lighting	Track lighting, available in hundreds of discount lighting stores	
Modern Italian hardware on bureaus and cabinets	Touch latches or reproduction hardware	
Original Art Deco furniture and fabric	Reproductions of Art Deco fabric and furniture. Don't buy "interpretations" of Deco—stick to copies of the originals. It's the interpretation that gets "kitschy"	
Original Art Deco luxury-liner accessories: tea sets, etched glass doors, ashtrays, etc. (The rich have retrieved the treasures of these fabulous out-of-commission ships)	Similar Art Deco treasures can be found at old hotel remodeling sales, flea markets and salvage companies	
Built-in night tables and bureaus	Unpainted stock wooden furniture, spray-painted in the same color as the wall to simulate built-ins	
Custom-designed room-sized rugs in chic, contemporary patterns	Small area rugs give the same chic message when placed on a bleached or stained wood floor. A portable floor cloth also gives an impression of a more costly rug	

A CLASSIC CONTEMPORARY DINING AREA

The dominant color is a neutral wheat wherever the eye falls (see color insert). It makes for a pleasing, monochromatic appeal, broken only by varying shades of chocolate. Inexpensive plywood is used extensively and invisibly to build a dining banquette base which is covered in the same industrial carpeting as the floor—a continuation of the monochromatic scheme. Soft beige cushions line the banquette. Two or three down-soft pillows in chocolaty velvets complement the look. The industrial carpet creeps up to cover the plywood base of a glass-topped dining table, bringing further unity to the room.

The Masterstroke? It has to be the wonderful fakes at the table: Two chairs stealing a bit of the Wassily, a bit of the Breuer lounge, and incorporating a lot of an unknown designer's skill, look like classics. An expert could tell they are hybrids in steel-framed cages, but their lines are simple, their structure sleek and well made. The room seems to take its tone from these two chairs.

The windows are covered with hard-edge blinds that will either keep out the night or let in the light at a flick of the wrist.

Track lighting runs along the wall and its soft glow is directed to strategic spots—one of them being the clear glass Deco-style sculpture that provides texture but does not detract from the one-note color. Shining strips decorate one wall—a touch that contrasts with the dull walls and built-in wooden storage unit below. Large green trees provide strategically placed interest as do pots of yellow chrysanthemums unexpectedly planted in country wicker to warm up the place! The yellow of the mums is repeated in the table mats—a nice, unifying touch.

A CLASSIC CONTEMPORARY DINING ROOM: THE DECORATING RICH WAY	*Expensive Hallmarks*	*Decorating Rich*
	Exotic trees	Ficus trees
	Marble-topped sideboard	Faux granite (Plastic simulated to look like granite) sideboard
	Breuer S-shaped tubular steel chairs around a black marble table	Breuer reproductions—or any S-shaped chairs covered with long, black pillow cases—around a glossy black lacquered table
	Lucite-base dining table with beveled glass top	Glass brick-base table with plain glass top

Contemporary crystal vases	Straight-lined chemist flasks
An exquisite garden view	One or two truly spectacular exotic flowering plants add an air of luxury to the simplest room. Try: flowering orchid, hibiscus, an exotic rhododendron known as vireyas
Expensive modular furniture	Used foam-cube furniture recovered in sleek canvas or other contemporary fabric
Status Italian lamps	Excellent reproductions
Marble floor	Marbleized vinyl or a faux-painted finish
Mirrored placemats	Buy sheet of Mylar, cut your own placements

TWO CLASSIC CONTEMPORARY "SHARED" AREAS

A Living Room/Dining Room

A sleek faux-granite table dominates one corner; a hand-painted fabric drape shields a storage area (see color insert). Air conditioning ducts, left exposed, are highly polished, and large gold balls conceal the radiator knobs with a touch of shining metallic. A gray couch blends quietly into the bleached gray wooden floors and is serviced by a van der Rohe glass-topped table (available in reproduction). The wall behind the couch is left in natural brick, "warming" the cool room and a large, abstract chalk drawing is lit by a black-necked Italian lamp.

The Masterstroke? A huge cardboard sonotube (used originally for casting concrete columns) serves as a soft pink corner pilaster and gives warmth and stature to the room. The wall above the radiator is partitioned with dividers that echo the lines of the sonotube pilaster.

A One-Room Apartment

All-in-one-room Classic Contemporary with stock pieces of modular furniture upholstered in a uniform tufted beige to blend with the beige industrial carpeting (see color insert). Cube tables of gray plastic laminate take on a rich look from a simple sculpture, a fabulous vase filled with radiant tulips, or several "art" magazines, casually placed. A classic steel floor lamp gives a soft glow, a mohair scarf draped over the simple couch lends expensive chic. An unseen-in-the-photo Masterstroke is an enormous ceiling-to-floor abstract

painting. Unseen in the photograph as well are built-in eating and storage areas: a table that flips down, then neatly stores against the wall, and hanging closets camouflaged behind a mirrored wall. Graceful warmth note: One softly draped, color-of-the-couch fabric shade, hung from the ceiling, effectively divides the sleeping and visiting areas. On one gray cube, a collection of Deco jewelry and perfume bottles are massed in a cluster.

A CLASSIC CONTEMPORARY SHARED AREA: THE DECORATING RICH WAY	*Expensive Hallmarks*	*Decorating Rich*
	Sleek architectural columns, recessed room dividers, built-in display cabinets, corner pilasters, lighting sources	Construct these hallmarks from sonotubes—the miracle item perfect for every Decorating Rich signature. Sonotubes are large cylinders made of cardboard or fiberboard that were originally used to cast concrete columns (see Resource Guide). Painted, sliced in half, wired for concealed lighting, covered with fabric, covered in canvas or painted in trompe l'oeil designs—they can be used in a myriad of rich ways!
	Warhol drawing, Rauschenberg graphic	Work of talented art students (check at art school shows all over the country: Rhode Island School of Design has a yearly art show and the student work represented is hard to match in quality and verve)
	Spare lines— everything of pristine quality standing out in stark, precious relief	Give the look of quality in rooms that are purposely spare. Try setting out books without book jackets, one obviously cashmere throw over the arm of a couch, a Tizio lamp casting shadows on an unadorned wall
	A Brancusi sculpture or Calder mobile	Museum copies
	Polished steel tables or table bases	Mylar-covered bases
	Glass and chrome table	Glass topping a "seconds" Lucite base
	Expensive director chairs in black linen, sitting next to an authentic Wassily chair, sitting next to a standing chrome sculpture	Seedy director chairs painted black, refitted with new black canvas, sitting next to a reproduction black and steel Wassily chair sitting next to a Deco-style polished-chrome standing ashtray, a left-over from some old Automat (can be retrieved for pennies at a flea market)

Fail-Safe Tips for Achieving the Classic Contemporary Look

The powerful, self-confident Classic Contemporary look is the look of the cutting edge, and that edge is linear. The aim is to achieve smooth, unbroken, unadorned, architecturally faithful lines, not only in each piece but in the look of a whole room. European Opulence is gathered, layered, plump, many different shapes, sizes, and heights; Classic Contemporary relies on level heights of furniture in a room where one object leads smoothly to another, extending the eye in an unbroken flow. Contemporary relies on unblocked vistas, which is why glass is so important, why monochromatic color (not the English floral chintz) reigns, why lighting is accomplished without the use of wires and eye-stopping switches and shades. Think of the vapor trail

THE LINEAR PRINCIPLE

A conversation area with classic Le Corbusier chairs denoting thoroughbred style. Contemporary power flows from overscale painting, eight-foot tree in geometric planter. Touch of class: a crystal obelisk. Horizontal lines dominate.

73

of a jet plane soaring through the sky and you have the uniformly horizontal look of Contemporary. The eye must see the whole and not just isolated puffs, stops, and starts.

THE GEOMETRIC PRINCIPLE

The shapes of Contemporary Chic are not sinuous and curliqued—they're pure geometry. Tables are squared off. Sculpture and painting are often triangled or rounded. Angles are everything.

STATE OF THE ART MENTALITY

Contemporary relies on using the best of the newest materials, art, inventions, electronics, and construction techniques. A cantilevered chair and an aluminum table are state of the art; intricate tassels and fringes are not. Clean surfaces are state of the art; a skirted table topped with photographs and bibelots is not. Function instead of frippery. Sonotube pilasters instead of floral wall borders.

STATE OF THE ART CAN BE COMFORTABLE

As one client put it, "I don't want any ditzy little gold Louis XIV chairs." There's no question that the best contemporary furniture, with the most chic appeal, is as comfortable as it is sophisticated. The whole point of this look is that function must be satisfied, and if the function is seating, comfortable seating is number-one priority.

The furniture must also be comfortably flexible so as to fit into a modern fluctuating environment. Since the twentieth-century family is usually peripatetic, always on the move with job and life-style, furniture had to be created to be comfortable in the varying spaces it often has to occupy—from apartment to country home: Enter modular furniture. Pulled apart, put together, it provides style and comfort in many incarnations.

DEAL IN ABSTRACTIONS

Like comfort and beauty, Contemporary style does not always come in expected and recognizable forms. One must be willing to risk change, to think of the familiar in new ways in order to be comfortable with Classic Contemporary. A contemporary version of a chair or couch may be so imaginative and creative that you'll have to rethink all your old notions of chairs or couches. Scale, rhythm, and proportions are often realized in startlingly novel forms. An excellent example? Sonotubes serving as architectural columns. Their shapes can be echoed in cylindrical table bases and vases, which can hold dramatic but inexpensive branches. Abstract ideas are integral to this

signature and often provide the standards for the classics of the future. The Windsor chair was an earlier era's abstract design. If you need every chair to look like a chair you've once seen, Classic Contemporary is not your signature.

It's simple: Most furniture in this signature is made by machine. Don't look for the Old World craftsman laboriously hand-stitching the seams.

THE MACHINE'S YOUR FRIEND

Although wonderful art is important in every Decorating Rich signature, there is an extraordinarily heavy emphasis on art in Classic Contemporary. Art here must not whisper intimately . . . it must

ART WITH A PRESENCE

Poster power: The effect of a series is striking. Track lighting is an inexpensive substitute for recessed lighting.

make a statement. Either its grand size, or its interesting subject matter (soup cans?) or its abstract design makes it always a focal point. Where European Opulence's message is often a rich profusion of clutter, Contemporary's message is expanse—space, air, light . . . all of a piece. This lends a perfect backdrop for art to dominate. A spotlight gives drama to the really interesting pieces and integrity to not-so-expensive pieces.

Some suggestions for art that will make a statement:

- Abstract sculpture
- Huge linear paintings
- Collages
- Architectural prints
- Posters (not of cute animals)
- Photographic murals
- African sculpture

A BALANCED ACT

We're not talking about identical pairs or symmetry (so prevalent in European Opulence), but balance of scale or weight. A wall and a half of low leather couch must not sit opposite one teeny-tiny table. An enormous floor-to-ceiling painting must be balanced by a table/chair arrangement that is its equal in presence.

KEEP IT UNCLUTTERED

Lots of hidden storage space is essential to maintaining this principle. An elegant contemporary look is a look of uncluttered space.

KEEP IT MONOCHROMATIC

One color reigns. The floor treatment is the same as far as the eye can see and it is identical to or blends in with the walls. Small patterns and florals are wrong. Use vast amounts of neutral color on floors, walls, ceilings, upholstery. There are so many splendid neutrals—all the grays, beiges, taupes, off-whites, puttys, gray-greens, khakis. Boring? Is the ocean boring? Is the sky boring? Relief is

achieved by lighting, small dashes of color, major artwork, huge live green plants, small accessories (carefully controlled and arranged). One "almost" monochromatic version and a popular contemporary color treatment is black and white with a small accent of color (say, red or yellow) popping up as unexpected pepper.

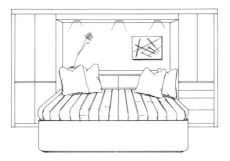

Stock modular furniture gives the appearance of custom built-ins. Recessed lights are in overhead bridge. The fitted coverlet and storage headboard keep the room sleek and spare. The contemporary painting is balanced by the linear orchid plant.

TEXTURE AND FABRIC

Again, to foster the smooth, unbroken linear appeal, fabrics are usually solid shades or quiet tone-on-tones, and are softly textured. The texture is important to prevent monotony and so are occasional accent colors in throw pillows. Sometimes an abstract print will make an interesting point. Usually, the upholstery in all of the seating is the same. Textures? They are supple and sumptuous, if you aim for the best: nubby wools, lush buttery leathers, tweeds, velours, cottons, and canvas. If you have a good eye, you can select a well-made manmade material like Ultrasuede or a vinyl, but these are tricky. If it's not choice synthetic, it will give you away immediately. Luckily, choice synthetics are readily available.

DULL/SHINY

Keep this in mind: If you use varying textures, the look becomes more exciting. A plush mat carpet takes on radiance from shining mirrors. A stunning but lusterless couch is more stunning next to a gleaming glass coffee table.

Dull/shiny: Contrasting textures on a glossy pedestal glass-topped table flanked by Miës van der Rohe chairs.

CLASSIC FLOORS Remember: The unbroken look is optimum, punctuated only occasionally with light colors that blend with simple floors. Tile and tile substitutes are terrific and, of course, so is marble, though the cost is enormously prohibitive. Wall-to-wall carpeting belongs in a contemporary look and less expensive, industrial-pile carpet is often better looking and more suitable than an expensive high-pile wool carpet. The same industrial carpeting or tiles can creep up onto the furniture or walls, really allowing the eye to sweep along an unbroken vista.

Contemporary style (geometric print as opposed to braided) area rugs are often used to delineate areas for dining, conversation, entry, or sleeping. The ubiquitous Oriental rug shows up here as well as in European Opulent homes, and indeed is a grand touch of art on the floor.

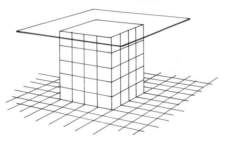

A dining or coffee table created from a plywood cube covered with floor tiling and topped with beveled glass. Be careful to align it perfectly with the tiled floor for a rich custom look.

Floor tiles creep up the plywood bed base for a clean, built-in effect. The same effect can be achieved with carpeting.

BLEND-IN WALLS Again, solid, often pale color, which tends to extend space. To give textural interest, try tone-on-tone, faux granite, or marble paper. Plain walls, unadorned by moldings, trims, and other distractions, can provide a superb museum-like background for large-scale art.

SIMPLE WINDOWS Try for the airiest look. Large windows and large panes of the picture-glass genre are, of course, optimum, but even tiny panes can be kept uncluttered—no heavy draperies, hardware, cornices. The best look is either unadorned windows or "hard-edge" blinds, pleated Roman shades, or narrow vertical or horizontal louvers. Whatever you choose, it ought to be in a color that mimics the wall to keep the eye moving.

Blinds combine form and function; choose mini horizontal or vertical pattern.
DECORATING RICH TIP: If they match the wall in color, the effect is richly architectural.

Roman shades have a softening effect for another contemporary window treatment.

Blinds can always be bought at competitive prices, so shop around. Often the best place to order them is from a catalog. Ask in a retail store just how to measure your window frame; then don't feel guilty about ordering discounted blinds.

Drapes in a mesh, linen, or other contemporary woven fabric are also an option for Classic Contemporary, but keep them tailored.

LIGHTING

The proper lighting is a very important element of a contemporary room. To do away with bulky shades, ugly switch plates, and eye-stopping electric cords, lighting is often recessed. Rich image makers are long-necked, Italian-style lamps often housed in black and/or anodized satin silver with "baffles"—sconces or panels behind which light bulbs are concealed in order to direct light in a particular direction. Commercial track lighting is versatile, very "now" looking, can be mounted on walls or ceilings in almost any configuration, and can be used to wash down walls with light, illuminate specific works of art, and bestow room light. Chrome torchères are wonderful—very Deco. In one apartment characterized by tall, clean geometric lines, I used geometrically precise lighting panels in the wall as a design element as well as a light source. The new halogen lamps come in

A pendant light

*Sleek flexible table
lamps in metal*

*Reproduction of an
Italian Tizio lamp*

*Floor lamps, self-
shaded*

The classic Hansen lamp is functional for table, floor, or wall.

Track lights in varying designs

stunning and sometimes quite wonderfully playful and colorful designs. A dimmer is a useful control to obtain exactly the amount of light you need. One of the most interesting bathrooms I've done incorporated neon lights that were reset and hidden behind frosted glass panels. Some clients like to stick to periods within a contemporary classic signature and one dining room I designed featured Thonet Bentwood chairs around a mirrored table from the thirties; on the corner of the table perched a Bakelite lamp also from the thirties, a surprising but delightful touch for a dining room table.

An opalescent calla lily vase transformed into a charming lamp can warm up the atmosphere of an otherwise starkly contemporary dining room, and a superb copy of the lily-of-the valley Tiffany lamp can do the same quite elegantly for a predominantly glass and steel dining room.

Although Classic Contemporary says try to do away with traditional lamp shades, which are simply not in the sleek tradition, every rule is made to be broken, and this is no exception. Many decorators feel, for example, that the classic Hansen swing-arm lamp goes well with every decorating signature, especially Contemporary. Finally, a hanging pendant lamp is effective over a table or desk.

CLASSIC CONTEMPORARY MATERIALS

- Chrome
- Molded plastic
- Lucite
- Glass
- Mylar
- Mirrors
- Tubular steel
- Plastic laminate
- Lacquer
- Rubber
- Corian
- Wood

THE ELECTRONIC AGE

In most decorating signatures, the problem is: What shall we do to hide the TV? How can we camouflage the stereo? Not to worry. If your signature is Classic Contemporary, electronic items that are important to the quality of life are often integrated into rooms as sculptural elements. As you purchase your electronic equipment, consider the outer housing, and even if it costs a bit more, go for the high tech styles. You might also ask your dealer's advice on mounting and displaying this media-turned-art medium for the most stunning effects. A television that can project on the wall can also be used for interesting visual options.

WARM IT UP

One of the pitfalls of Classic Contemporary is its tendency to be cold and austere in its sleekness. Some people don't mind this; others do. I tell clients who mind to include one or two "warm-ups" in starkly modern environments.

For instance, in the room pictured:

- A Classic Contemporary Eames chair is featured, and its rosewood tones warm the sleek modern art and link up nicely with the wood tones of the trunk "coffee table"
- The Oriental rug provides further warmth to the room, setting off the contemporary, modular sofa

PROVIDE IMAGE MAKERS

- The backgammon set, rare books topped with a "priceless" Oriental bowl, and telescope suggest the owner's leisure time and hobbies, adding image makers and a personal touch to a room that might otherwise seem somewhat sterile. The fan provides a lingering, romantic ambiance and the screen gives architectural interest and counterpoint to the boxier lines of the trunk

CLASSIC CONTEMPORARY appeals to those who like their art abstract, their rooms sleek, their lives hard-edged and exciting. One

would never open the door to a Classic Contemporary apartment and find it in a hodgepodge of disarray. It is a look for the avant-garde intellectual, for the experienced tastemaker.

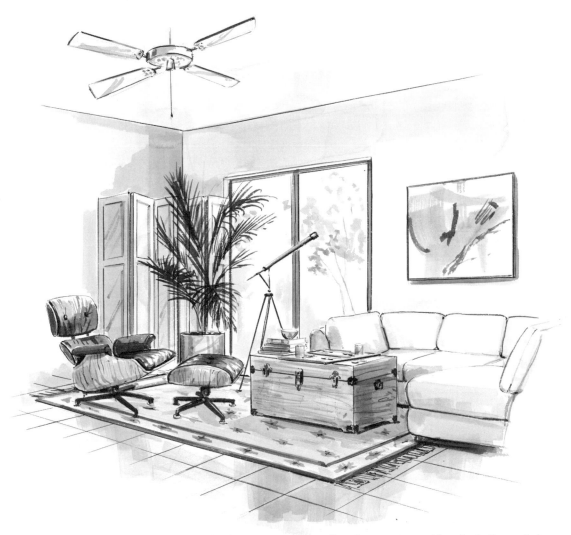

Decoding the Contemporary Classic Den: Set status tone with a classic Eames chair and ottoman, telescope (the rich have hobbies), backgammon set (the rich have leisure and play games), and rare books (the rich are educated). Masterstroke: An oriental rug or large painting.

5

Country Charm

Does This Sound Like You?

- I wish I could marry Ralph Lauren

- I wish Laura Ashley were my best friend

- A blazing fire, a cozy hearth, the Sunday papers: That's life

- I love the look of polished pine, burnished copper pots, and a cheerful window seat for reading

- Patchwork quilts are splendid, but they must be vintage!

- Promise me anything but give me wicker

- I've always dreamed of an organdy-skirted dressing table

- Is there anything sweeter than a windowsill lined with crocus-filled clay pots?

- Cactus can definitely live in hand-painted Navajo crockery

- Chintz, charm, and hand-painted floor tiles make me happy

- Ditto porch swings

- But don't misunderstand me. I'm not corny country: There is such a thing as sophisticated twig furniture, you know

- What's more, it's not only "country-country" that turns me on. I also love a fish-jumping ocean, sun-bleached dunes, arid, dry desert, and Monopoly at the ski lodge

- The most delightful find? Antique wooden farm toys painted in crayon colors

- Once I saw, and I'll never forget, a country corner piled high with hat boxes—flowered, chintzy, striped: That's style

- *Weatherworn.* A good word

- I can find a hundred things to put in a straw basket

Country Charm: I love it. It's the look of cultured informality, of knowledgeable charm. It's a look of timeless style.

The Country Charm Look

Positively redolent with charm, this breakfast nook illustrates low-key opulence. Country Charm is warm, cracked, slightly shabby, rich with country patina; the look of the noble landed gentry on the family farm. Spanking newness doesn't even enter the picture.

Can you see yourself, all flushed and flyaway from gathering the herbs in the country garden, from walking the dogs, or riding to hounds, settling in this charming corner for a cup of hot chocolate? The beautifully rustic chairs show loving patina, the stunning antique hatboxes piled up in the corner harbor the newest pile of seed catalogs, the elegant pine buffet server shows off priceless, cracked porcelain treasures from yesteryear, and the baskets on top of the server are hand-looped

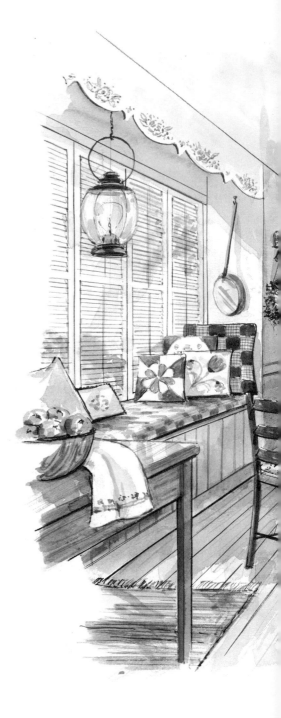

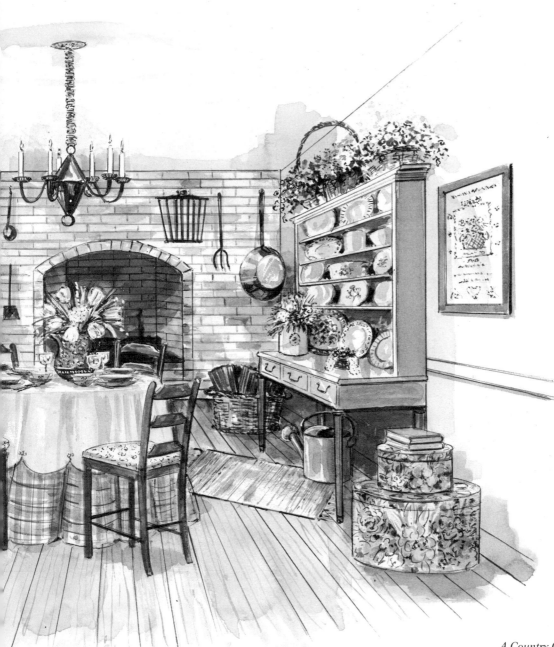

*A Country Charm
family room*

wicker. But what warms your heart the most is the priceless sampler some little girl made for her mother just when America began.

People often make the mistake of thinking that a country look can't possibly be a rich look. They're wrong. They're thinking of the wrong kind of country. There's Over-the-River-and-Through-the-Woods-to-Grandmother's-House-We-Go kind of country. And then, there's Country Charm.

The two are vastly different even as each is marvelous in its own way.

Grandmother's House kind of country is warm and spice-smelling, and comfortable because it has Grandmother, but it's not Decorating Rich. There may be ruffles on the toaster, and there is Grandfather's vinyl imitation Eames chair and a brand-new (made to look old) "period" telephone on the Formica table.

Country Charm may also be warm and spice-smelling, with the nice old Lab galumphing around, but there the resemblance ends. You would not likely find a Formica table in a Country Charm kitchen and you'd never find cute imitations like that silly telephone or a new magazine rack in the shape of a swan with machine-made gauges trying to pass for weathering. You wouldn't find the vinyl chair imitation, either, even if it does lean back at the press of a lever. You *certainly* wouldn't find a brand-new butter churn masquerading as old—that's terminally cute.

Grandma's pine table: Extend the handmade look with a hand-crocheted tea towel, hand-painted bowl and pitcher—perhaps a hand-woven basket.

Country Charm is hand-stroked, hand-painted, hand-crocheted, hand-polished, or very good imitations of these. Its richness is derived from the earthy or sea-worthy heritage it cherishes, and it stays true to that look. Like Grandma's house, it is comfortable and utilitarian, but it uses authentic, indigenous-to-the-area artifacts, colors, forms, and textures. You can get the rich Country Charm look with inexpensive reproductions, but they can't be cute, they can't look brand new, and the furniture must never come in cookie-cutter "sets."

GET RICH QUICK! THE ELEMENTS OF COUNTRY CHARM STYLE

Certain elements of Country Charm are to be found in Country style homes whether at the farm, in the desert, in the woods, at the seashore. Furniture styles and materials vary from home to home, and sometimes a little of each pervades. One often finds an eclectic mix of Shaker, Late Victorian, Early American Cottage in materials as varied as wicker, machine-made golden oak, and pine. Look for some of the following touches in the most charming of country rooms:

Throw Rugs: Just about any hooked, braided, or woven rugs make a wonderful setting for the look. Probably the most beautiful are the primitive hooked designs whose makers were not such hot artists but found inspiration in every day life. Many of the true antiques can be hung on the wall for a splendid Masterstroke.

Baskets: What obelisks are to European Opulence baskets are to Country Class. Anything can go into a basket: magazines, flowers, eggs, fruit, bread, pots, plants, cats. There never seem to be too many baskets in a country home.

Quilts: Country could well be spelled with a Q—that's how elegant the country quilt can be. Handmade quilts are to fall in love with, and the look of a room changes as fast as you can change the quilt. Quilts made of appliquéd squares, patchwork patterns, pierced calico. Quilts with repeated patterns, quilts that are graphically inspired. Collections of quilts in the same colors, quilts over other quilts on a bed . . . You can't have country without quilts: hung on the wall, covering the bed, used as skirts for tables, framed, or just displayed on an old, wooden drying stand. Quilts. The best!

Cracking the Country code: an heirloom-looking quilt (the rich have ancestors) and a hand-loomed country rug (the rich buy one-of-a-kind objects). The rich extend the country look with country textures (wooden wainscotting, planked floor, rattan and wicker furniture, patchwork pillow).

Wicker: Known through the ages as wykker, wyker, and wycre, it was a popular symbol of wealth even in Chaucer's time. People have always been wild about wicker work, whether in the form of rattan, willow, straw, or bamboo, and it shows up in baskets, boxes, and—best of all—furniture. Both natural and painted wicker give Country Charm homes the unmistakable aura of old money.

Gardens and Plants: The wealthy rich in the country almost invariably tend their gardens, whether they be sandscapes, flowers, vegetables, herbs, rocks, or sea grass. Even if you live in the city, a classic look for your country-flavored home will be touches of growing things . . . brought inside. Simple containers are the very best: a partially rusted Mexican copper pot holding white hyacinths; a stoneware pitcher of violets; a child's painted wagon full of pots of daffodils.

Shaker: Not the salt and pepper kind, but Shaker-inspired furniture. The Shakers were a religious sect that flourished in the eighteenth and nineteenth centuries who believed that work was consecrated, a form of religious devotion. They expressed themselves in incredible furniture design: chairs, cupboards, boxes, wall pegs—all marvelously clean in line and bereft of carvings and other adornment. Shaker furniture is a sure sign of elegant Country Charm. Originals cost a mint, but luckily, fine reproductions exist.

A classic Shaker chair with woven tape seat and back

COUNTRY CHARM ART

Folk Art: From the seventeenth to the nineteenth centuries in America, untrained artists interpreted life in pastoral scenes, portraits, wooden toys, and other objects, and this "art naif" remains today the most telling history of the times. Poor itinerant artists, often witty

Folk art: metal rooster weathervane; hand-carved, painted wood horse (the tail is real horse hair); painted, hand-carved figure (its primitive aspect gives the charm).

and creative, pedaled their versions of life in the form of black "mammy" dolls, watermelon slices, tin and painted-wood animals, weather vanes, children's toys, sculpture, and paintings. Early American paintings in naif styles have become so valued for their intrinsic beauty it's hard to find ones that are affordable, but they're there if you look. Exquisitely painted toy soldiers, tinware, and large carved and painted wooden people, birds, and game boards are only some of the examples of folk art that give charm to Country.

CAUTION: There are good reproductions available, but it's really essential to educate your eye in this area. Go to folk art museums and antique shows and see what the best pieces look like. There are too many people in tiny towns grinding out wooden calico cats, watermelons, and cows that are decidedly not exciting, not original, not rich looking. True folk art is rarely cute. It doesn't look like something you saw last week.

Silhouettes: In the eighteenth and nineteenth centuries, silhouettes were enormously popular and they remain so in several decorating signatures. At the Museum of American Folk Art in New York City and other institutions across the country specializing in American

The silhouette is classic Country Charm art. The instant rich canopy was created by fabric draped over a wooden rod and casually knotted. Masterstroke: an antique (or reproduction) wicker rocker.

art, examples of silhouette are displayed. Curators and other experts at these museums can usually recommend current artists who are reviving the old art (also see Resource Guide). Framed simply, hung singly or in masses, the silhouette is a clue to the code of rich country.

Samplers: A powerful Country Charm Masterstroke. Originally samplers were used in colonial America as school or home study programs—a way to teach young ladies the niceties of embroidery, spelling, arithmetic, and religion. Display an old sampler with, perhaps, an art light, and you've got the last word in Country Charm. (The more aged or even ragged a sampler is, the better!)

Prints: Country subjects such as botanicals, pastoral scenes, seascapes, desert blooms are all charming possibilities.

Use Your Imagination: Found objects can be hung on walls or arranged as tablescapes. Antique tools, wagon wheels, even a whole child's primitive wagon, wall-hung, make great Country art.

Found art: wine keg bottom, collection of old bottles, beach stones.

Found art: Old doors mounted on a wall look like sculpture.

A COUNTRY CHARM FARM FAMILY ROOM

NOTE: In early homesteads a combination sitting room, eating room, and kitchen was a favorite place for all to gather.
It could contain most, if not all, of the following:

- Rustic luxury: art symbols of animal life, fruit, vegetables
- Country pine (it's elegant and inexpensive) in large dollops: an American pine harvest table complete with the attrition of time
- Naif art in the center of the table: perhaps a colorfully painted folk carving of a chicken? Pig? Cow?
- Ladder-back chairs around the table: each different but linked together by identical rush seats
- A pair of rocking chairs
- A Welsh oak cupboard holding a collection of ironstone
- A French cupboard (Country Charm shares heritages) holding jars of tomatoes, pickles, yellow corn, orange preserves . . .

- A stenciled English stepstool used to reach the high hanging pots

- A woodburning stove with Dutch delft tiles, and a brass bucket for firewood

- Copper pitchers—a collection?

- An antique wrought iron chandelier

- A hooked rug on the floor whose colors echo the blue of the delft, the red and yellow of the folk art chicken

- A Shaker chair in a corner, a rugged stool in front

- On the rugged stool, a hand-carved checkerboard (game pieces are hand-carved black and white wooden cows) ready to be pressed into a cozy game of checkers

- Someone's Pilgrimish ancestor in a naif painting

- Along the wall, a row of Shaker pegs on which hang utilitarian objets d'art (a burlap seed bag, a plain muslin Shaker-style child's dress, a straw hat)

A COUNTRY CHARM FARM FAMILY ROOM: THE DECORATING RICH WAY	*Expensive Hallmarks*	*Decorating Rich*
	Stenciled English step stool	Easily constructed from cheap wood, hand-stained and -stenciled (even an amateur can do this), step stools look extraordinarily rich!
	Original ladder-back chairs	Reproductions, available from catalogs. If you buy genuine ladder-backs at thrift shops (cheap because of torn seats), recover the seats in identical fabric to provide unity, or use identical seat cushions with big fabric bows
	A handmade wooden bowl, circa 1800, filled with fresh red apples	A machine-made wooden bowl, circa 1988, aged outdoors, filled with fresh green apples
	Antique folk art carvings	New, carved animal toys available at good toy stores and through catalogs
	An antique wrought iron chandelier or lamp	Excellent reproductions are available at lamp sources. Also, almost any sculpture or vase can be electrified, so genuine antique finds can be pressed into other kinds of service from that originally intended
	Antique Shaker peg board and utilitarian objects	Any plain wooden pegs of varying lengths can read "Shaker" (and you can get new Shaker pegs for $7 a peg) if you hang unadorned, simple

Shaker-type objects on them. In library books check out many pictures of Shaker furniture and clothing until you have an educated eye for the look

An antique wood valet stand	A new wicker valet stand can be purchased inexpensively: The objects (a wonderful velvet ribbon? an organdy apron?) that hang from it suggest a rich mode
A small lace-lined antique basket, filled with potpourri	A dime store basket, lined with white lace handkerchiefs, filled with potpourri
Original botanical prints hanging from ribbons (virtually a signature of decorator Mario Buatta) or watercolors of various vegetables (cabbages, radishes, lemons, etc.) —pure decorating cachet!	Botanical prints cut from old gardening books or seed catalogs and framed identically in simple gold tones and hung from ribbons
Made-to-order Portuguese needlepoint carpeting	Stock floral carpeting
Wool carpet topped with an Oriental rug	Sisal carpet topped by a small, stock floral-crewel area rug

A COUNTRY CHARM LIVING ROOM

Country Charm can live almost anywhere and it lives most charmingly in this Texas farmhouse (see color insert). The one-hundred-year-old floors are beautifully preserved pine planks, stained and topped with a woven cotton rug that warms with color and texture. The walls in white stucco blend with the white-painted cedar ceiling beams, giving breadth and space to the delightful room.

Country Charm should always be comfortable and much of the room's furniture is upholstered in variations of solid and tattersall-patterned fabrics. Behind the couch stands a tall, smoky, wood-grained cupboard on top of which rests a painted primitive basket

holding babies' breath flowers. An Amish quilt dominates one wall as art and next to it hang a wooden coat rack from which dangle bundles of dried herbs, further carrying through the Country Charm point of view. Simple drapes of sailing cotton hang from wooden rings on a painted wooden pole. A scrubbed oak, plank-topped dining table surrounded by varying kinds of chairs, some upholstered, one Windsor wood, invites a late afternoon cup of tea.

In front of the couch and serving as a coffee table rests an old blanket chest with a scrubbed oak surface, its original paint peeling in engaging authenticity. Country green and red apples are inviting in an old Shaker basket that perches on a weathered wooden side table.

The Masterstroke? It could well be the wonderful eagle weather vane, also with its original paint intact, now used as sculpture.

The lighting carries through the country point of view with a primitive, Americana iron candle-holder chandelier, brightened by working red candles. Grandma Moses as well as a country-loving city slicker could both live happily ever after in this elegantly bucolic setting.

Country can walk east to a New England farmhouse, southwest to the desert, or in almost any direction to hit the beach.

A Country Charm room on the farm could contain most, if not all, of the following:

- Antique weather vanes

- Painted storage or blanket chests to serve as lamp or coffee tables

- Early American Shaker baskets, iron candlesticks, wooden plank floors

- Early American quilts serving as art

A Country Charm room near the desert could contain most, if not all, of the following:

- Accent colors indigenous to the land: cactus-desert-sky-sagebrush inspired. Sunset pinks and purples, American Indian turquoise, rough adobe textures, nubby rugs and weavings reign

- Hand-painted tiles and silver accents

- When Country Charm walks west, it sheds its Early American heritage.

Picture a massive, dark harvest table in the middle of the desert. *Wrong.* Lightness prevails

• Boldly patterned carpets (Indian weaves?)

• An old painted-turquoise Mexican table

• On one sun-bleached wall the sun-bleached horns of a long-forgotten desert creature

A Country Charm room near the sea could contain most, if not all, of the following:

• White wicker everywhere (plant stands, tea carts, floor lamps, love seats, rockers)

• Antique baskets filled with shells, sea grass, or ocean-bleached stones

• Antique Oriental rug (it turns up everywhere!) on bleached white floors

Expensive Hallmarks	*Decorating Rich*	**COUNTRY CHARM LIVING ROOM: THE DECORATING RICH WAY**
French country Provence-embroidered tablecloths with lace-trimmed napkins caught in silver napkin rings	Linen cloths (perhaps with floral appliqués?) and cotton tea-table napkins to match, available in discount linen stores. Even pretty linen dish towels can be terrific napkins caught in wicker napkin rings	
Authentic farmhouse table from nineteenth-century Normandy	Reproduction "groaning board" table (see Resource Guide)	
Antique weathered weather vanes	Reproduction weather vanes, artificially "weathered" (see Resource Guide)	
Antique baskets	Leave new baskets out in rain and other aging weather for a few weeks to get the look of antique. Baskets soaked in tea or rubbed in ashes also take on age	
Petit point rug on gleaming wood floors (or a floral Oriental rug?)	Dhurrie rug on gleaming wood floors—or try a painted sisal area rug or a floor cloth	
Hand-embroidered throw pillows	Quilt remnant pillows from the shop at the Museum of American Folk Art in New York (or	

	at a folk art museum in your vicinity). Tattered old quilts are often found in thrift shops and the good parts make fabulous pillow covers
Antique Pueblo Indian woven carpets for Southwest country (a fortune in antique stores on the east coast)	The same carpets bought from local Indian peddlers on your (or your friend's) next trip to the area
Antique one-of-a-kind hand-painted tiles for trivets or window-seat fronts or fireplaces	Stock tiles found in country stores, particularly at warehouse sale times (check your local newspapers); or have a local artist hand paint the exterior of your fireplace or window seat in faux tiles, then glaze to give a tile "gleam" effect
Antique rattan chairs	Reproduction, new or painted old, wicker chairs (see Resource Guide)
Antique easy chairs or sofas covered in rich Marseilles cloth	Furniture recovered in seconds from discount fabric stores: Inexpensive cottons on "little nothing" couches or chairs take on elegance with the addition of truly smashing pillows covered in obviously costly fabrics (bought on sale or at discount—see Resource Guide)
Antique armoire	Absolutely plain armoires are inexpensive and relatively easy to find in reproduction shops: reproduction hardware and reproduction "antique" mirrors to affix to the armoire are available at modest prices. They are the touches that speak for the whole piece
Country canopy bed— pampered luxury at its best	If you build the simplest of cheap wood frames from 3 × 1 inch posts, drape it with gauze, mosquito netting or sheeting, and secure it over your bed, the whole room starts to read class. It wouldn't hurt to place a simple wooden bench in front of the bed and display some truly elegant objects on it: Mexican silver, fresh flowers caught in painted pottery or even a flea market "crystal" vase, a driftwood sculpture?
Bouquets of exotic flowers in Lalique crystal	Unusual display of flowers: a flat of tulips or lilies of the valley (bought in local garden shops), *masses* of lilies or hyacinths—not just a few stems. Flowers in every room, including the bathroom, please, perhaps on the edge of the tub?

98

Early nineteenth-century hand-carved side table	Large barrel or crate covered with oversize, charming, perhaps fringed, calico scarf
Objects of art on table made by early craftsmen	Objects of art made by local craftspeople or kindergarten children on table interspersed with one or two legitimate antiques
A fabulous view of miles of horse country	Walls painted with an illusory trompe l'oeil garden or pasture scene give the feeling of alfresco even if it's all happening indoors
An antique quilt hanging on wall	"Bait sacks" from the turn of the century were wonderfully designed; they're often spotted selling for from $20 to $40 at flea markets and, pieced together, make "displayable" quilts. (Be on the lookout for any old fabric, homely as its original purpose may have been, to transform into art)

Fail-Safe Tips for Achieving the Country Charm Look

One-of-a-kind handmade objects are always precious and more valuable than those that come in multiples. In fact, the Masterstroke of any Country Charm home ought to be:

HANDCRAFTED IS THE HALLMARK OF EXCELLENCE

- Twig or willow furniture

- An original folk art painting, purchased or inherited

- A colorful collection of duck decoys, hand-carved and hand-painted—or an excellent imitation. (Be careful here: Fake antique decoys can be easily distinguished from genuine antique unless the fake's quite good)

- A country-fair merry-go-round horse. These are often seen at remote antique stores in great need of loving restoration. (But be careful here, as well: Often the chips, fading paint, and scratches on such a treasure add to its appeal. Only restore if the horse is in terrible shape)

- Earthenware crocks

A twig table shows off a crock collection.

99

- An enormous harvest table, scratched and nicked
- An eclectic collection of blue and white enamelware (iron or steel household utensils coated with gleaming porcelain glazes)
- Charming dried floral wreaths for the front door

THEMATIC LINKS Try to find an umbrella under which everything will nicely fit. All will share the same code, the same mood, the same color patterns. What you are searching for is a common theme to give coherence to your room; a farm theme with country baskets, calicos, salt-glazed stoneware, and friendly candles will be jarred by a sudden introduction of a mounted sailfish. Sailfish don't often swim in the cow pasture.

COUNTRY COMFORT If Country Charm is anything, it's comfortable. While certain objects may transcend signatures (a wing chair could be European Opulence, Country Charm, or American Pedigree, for example, depending on the fabric), when they're country, they're stuffed, bountiful, generous. Country is never for display only, but to sit in, touch, use, put your feet on.

OLD THINGS IN NEW WAYS One of the joys of country is the way it lends itself to new uses for old objects. A wrought iron sausage rack gets electrified and turns into a chandelier; a wooden wagon becomes a magazine rack; a great big old milk pitcher serves wine; hand-painted floor tiles find their way to facing a window seat; an old slatted apple-gathering basket holds a collection of antique teddy bears; an old school desk becomes a night table; blacksmithy tools as art hang from wooden rafters. Nothing has to be used as it was originally intended.

AGAIN, AGAIN, AND YET AGAIN . . . A Decorating Rich secret of Country Class—and of other signatures as well—is the repetition of motifs, colors, or patterns to larger and lesser extents. A wonderful country kitchen will repeat the same barn-red color in a painting, tile, wallpaper border, and bowl of red straw flowers. A tiny print will find itself in a larger version and myriads of smaller versions on wall, table, or bookcase. A collection of old dollhouses will be repeated in a wall stencil of houses, a quilt of patchwork houses.

Antique wood "candlestick" lamps are wonderful and available through catalogs or in thrift shops. Or buy a wrought iron standing lamp at a tag sale, put a wonderful linen or calico shade (available in discount shade shops) on it, and you've got something fine. Try pottery lamps with shades that diffuse the light, pretty paper globe chandeliers, or a Hansen swing wall lamp (see p. 81) with a floral shade and an arm that brings the light to varying positions. Brass fixtures are elegantly Country and charming; blue and white porcelain bases with translucent lamp shades give the feel of an English country home. One of my clients found a pierced tin lantern complete with candle, which she uses in the authentic way—with the candle—to give a flickering, romantic country light. An old tin or wrought iron candle chandelier can be electrified into twentieth-century Country.

COUNTRY LIGHTS

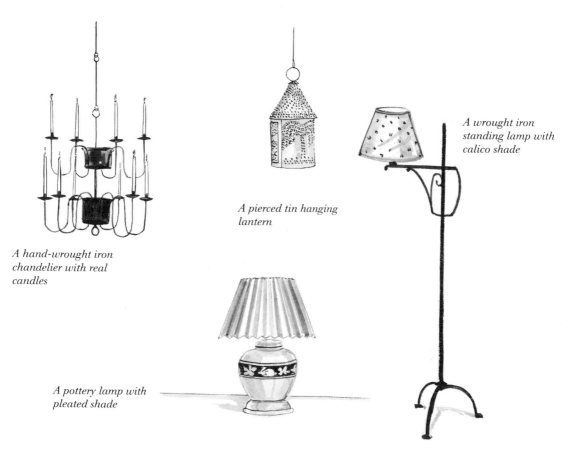

A hand-wrought iron chandelier with real candles

A pierced tin hanging lantern

A wrought iron standing lamp with calico shade

A pottery lamp with pleated shade

101

COUNTRY CLOTH

Country fabrics can be amazingly inexpensive and of all possible rich touches, they give the strongest flavor to an informal room. Patterns and colors interpret the rich code instantly. These are Masterstrokes, pulling the eye from whatever is mediocre in the room. Even damaged or cheap furniture is eclipsed by great fabric. Ginghams, muslins, linens, calico cottons, and cotton blends are available in the small floral or dotted prints that are so beloved by admirers of Country Charm. A country home à la Provence ought to sport copies of French Provençal fabrics in colors that are lifted from a rug or even a wonderful French chair cushion with which you've fallen in love. In a country home that means to recall the English tradition, glorious window chintzes ought to prevail. American Country means small-scale prints, hand-woven gingham, delightful

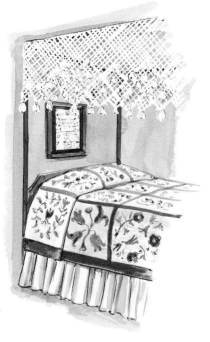

Shirred fabric sleeves give a Decorating Rich touch to a plain wood four-poster.

Country Charm bed; a fishnet canopy gives an antique flavor. An appliquéd quilt is used as a spread. Masterstroke: an antique sampler— quintessential Country.

white organdy, or crocheted muslin. Country-by-the-sea ought to evoke beach colors, "sand" fabrics.

Have a boring bed? Add a simple wooden post at each corner and decorate with charming material. Fishnet draped in canopy form looks antique. An appliquéd quilt used as a spread brings incomparable warmth. A hand-stitched sampler on the wall over the bed adds authenticity and more texture. Or, for another bed possibility, consider shirred sleeves pulled on simple wooden posts and add bows for dash!

Do you have an innocuous round work table? A delightful checkered skirt gives it a decorator touch. Think Chintz, in particular: Of all the fabrics, chintz is the most deliciously opulent in elegant country homes. Although printed fabrics can date easily, some timeless patterns are always in style.

Window treatments can set the tone for rooms, and fortunately, the options for country windows are legion. Keep in mind that the windows should follow the general theme of your home.

CHARMING WINDOWS

Some suggestions for Country window treatments:

• Wooden shutters

• Softly gathered drapes and billowy curtains

• Ribbons and bows,
 scallops and embroidery,
 stencils and valances

• Window shades laminated
 with the same fabric
 you've chosen for the walls,
 a process many hard-
 ware stores can accomplish
 relatively inexpensively

• Heavy cotton printed curtains
 hung simply from
 wooden rings on a
 natural wooden pole

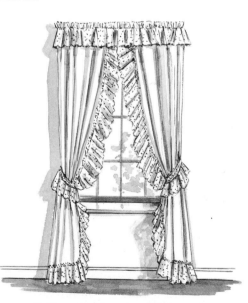

Softly gathered, eyelet-ruffled curtains

103

- Airy, delicate tiered curtains of pure cotton organdy
- A hand-crocheted valance over simple cotton cord tie-back panels
- Shirred styles, in lighthearted, frilly fabrics as opposed to European Opulent's quite serious, heavy brocades

Short balloon poufs are enchanting Country.

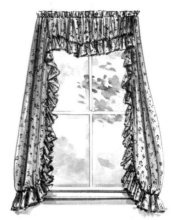

The French provincial print swag gives cachet.

COUNTRY MATERIALS

These almost always live in a Country Charm home:

- Ironstone
- Terra cotta
- Basketry
- Brass
- Clay
- Old tin

- Hand-carved wood
- Hand-painted wood
- Hand-woven fabrics
- Papier mâché
- Pewter

- Tile
- Wrought iron
- Burnished copper
- Cast iron

COUNTRY COLORS

Country Charm colors take their cue from the materials. One antique carousel horse can provide the inspiration for a whole room. The burnt orange or terra cotta of the Italian countryside, the blues and whites of the French tile you discovered, the gray of the tin lantern that was your grandmother's, the bleached silver of the beach beyond your window—all these can be your color possibilities. Operative notion: If it has precedent in a rug, a collectible, or a painting, it can serve as the color theme.

The Decorating Rich principle for mix-and-match patterns, practically a hallmark of Country Charm, is to find the common color denominator. A shade of yellow in a green and yellow floral print may be repeated in a yellow and white gingham check and then in a yellow, white, and green stripe. The yellow is the unifying element within the varying patterns.

NOTE: If you have several prints, varying the size of each print gives a more interesting effect. Four large florals can drive you crazy. One large, two medium, and one tiny floral print can be quite pretty.

I love the endless moods and variety that wallpaper offers to Country Charm. The traditional patterns used on large areas instantly relay the message of substance and affluence. English florals, French foulard prints and fleur de lis or cat's paws provide charming backdrops to the Country Charm look. Wall murals are also exciting. Ditto country trellises and country tavern checks. Ditto stenciled repeats. A wallpaper border is the most inexpensive way to imply opulence. Other wall treatments? Paneling is as great for the beach as it is for the farm or ranch. Stucco is super for a Southwestern country look.

Wallpaper borders can be placed in a variety of locations for architectural interest.

Brick is lovely for city-country. Wood beams deliver character almost everywhere. Wainscotting, a border of wood with paneling beneath that traverses the perimeter of a room approximately three to four feet from the floor and chair rails, is elegant. Stenciling and trompe l'oeil are fantasy touches. Take your choice!

COUNTRY FLOORS

Heavy-duty planking instantly says Country. Hand-painted ceramic tiles instantly say Rich Country. These, incidentally, are usually costly, but seconds are very often available: slightly off-color or with indistinguishable scratches. Earthy quarry tiles and simple slate are wonderful throughout the house, warmed up here and there by a great throw rug. I also love the classic black and white checkerboard floor, which can be interpreted on a wood floor by paint, cork, or linoleum inserts.

Wall-to-wall sisal (a rope fiber made from the leaves of a tropical plant) carpeting is pure country and fine for the Southwest as well. Add rag, hooked, crewel, dhurrie, braided, or Oriental throw rugs for accents on top of the carpeting or on the wooden floor.

Bound sisal can be used as an area rug as well, and it's especially fine when finished off with a leather band or fringed. It can also be painted with a border or in checkerboard squares.

In the old days, gracious country homes abroad and in this country almost always displayed a plethora of boxlike chests with hinged lids in which people kept their linens and blankets, their prospective dowries for their daughters, and all the junk that today we throw in closets (something almost nonexistent in the early days). Shelves gradually grew up and became cupboards where clothes, dishes, tools —whatever—were stored. These chests and cupboards were usually free standing and painted beautifully. Today, lush country homes either display the originals or reproductions in various rooms in the house; on the open shelves of such cupboards are displayed soaps, collections, baskets, statuary, dishes. In the closed drawers of the cupboards and within the chests rests the junk overflow. Chests are also fine to house televisions and bars.

There isn't a Decorating Rich signature that doesn't profit from an interesting themed collection, and Country Charm is no exception. "Collecting," Malcom Forbes once said, "is like eating peanuts. You can't stop."

Traditionally, collecting has been a hobby for the rich. However, although those with modest means can't afford the Fabergé eggs, they can assemble "nostalgia-based" collections which will give great status.

Those who decorate with Country Charm have the world at their fingertips when collecting. Sleuthing and serendipity can turn up primitive marvels! Persistence and luck will help spot treasures in the most unlikely places. Artifacts from decoys to earthenware cover a range from rustic simplicity to medieval vigor. Although the most rare and old objects are superexpensive, many collectible luxuries are among the most affordable on the market.

A Country collection: baskets in varying sizes, shapes, and textures hanging from a hook and piled over and under a dry sink

Here are just a few of the things a Country Charm collector might find in street fairs, flea markets, and auctions in and around country byways:

- Early nineteenth-century bellows
- Sewing items, especially nineteenth-century thimbles and sewing baskets
- Baskets
- Whale oil lamps
- Clocks
- Eighteenth- or nineteenth-century stoneware crocks and pots
- Pewterware or woodenware
- Hooked rugs
- Country chests
- Shaker boxes or Shaker hats and other Shaker clothing
- Salt and pepper shakers
- Wooden farm animals
- Garden ornaments, cast iron lawn creatures
- Majolica (highly colorful tin-glazed pottery, mostly nineteenth-century American)
- Miniature Indian totem poles (usually from the Southwest)
- Candlesticks (pewter, ironstone, tin, wood, brass, glass, or porcelain)
- Tobacco tins
- Hand-carved wooden birds or paintings of birds or fowl
- Indian artifacts
- Antique children's and doll clothing
- White ironstone
- Old cast iron cookware
- Cookie cutters
- Stenciled wooden toys
- Farm tools: Think about hanging these on the wall. Old farm tools, taken away from the field, become works of art when displayed properly. One wagon wheel is merely okay; three different overlapping wagon wheels hung on the wall become a major statement

In choosing your collection, stick to your decorating point of view or theme. If you are collecting for an oceanview country home, old nautical maps, captains' uniforms, or old ship lanterns might be the perfect touch. A hunting lodge hideaway might display beautifully made guns or saddles.

Take note of this encouraging thought: Any one thing you find and cherish may be the start of a fabulous collection. It may be the flagship piece that will give your home a richly lingering charm that evokes the ancient past.

Displaying Your Collection: Of course, you can pepper and salt your home with wonderful odd collection pieces, but the very best way to display is en masse. When objects are linked in shape, theme, and color, massing them together makes the most decorating sense. The best way to gain top visual impact is to group various collections in close proximity. Clusters of duck decoys look more splendid than here a duck, there a duck, everywhere a duck, duck.

Haunt the local school fairs to find displays of children's art. You might pay $6,000 for a folk art painting and find almost as good a gem of "primitive" work among the third grade offerings of the downtown community school. Use your creative eye: Just how would that nine-year-old's painting look in a superb frame? Probably like the last word in Country Charm.

THE BEST DECORATING RICH TIP IN THIS CHAPTER

COUNTRY CHARM radiates warmth and exuberance, and those "natural buffs" who love the look can also feel very much at home with sophistication. Pure textures, the clarity of honest color, and an appreciation of the work of artisans bring them closer to the land, sea, woods, or desert.

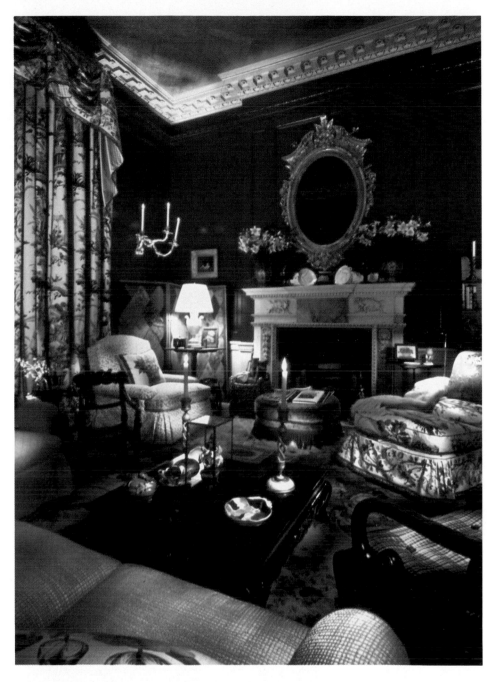

EUROPEAN OPULENT SITTING ROOM: *A gloriously red-walled, fabric dominated room where patterns, colors, and historical periods are combined in opulent layers. The ceiling is covered in squares of silver wallpaper that catch the light. The hallmark touches, like the Georgian mirror, English dog portraits, and Victorian needlework carpet, can easily be achieved in reproduction.* (Interior design: Mario Buatta; photography by Peter Vitale)

This is a EUROPEAN OPULENT
BEDROOM *of enormous charm. The
focal point is the bed with its
four-poster canopy fastened to the
ceiling, providing height and
grandeur. Plain, sheer linen lush in
its volume cascades to the floor. The
walls, glazed in two shades of
lavender, provide a soft backdrop
and color inspiration for the
enchanting print window treatment,
the print rug, and the
print-upholstered furniture. A
skirted dressing table with its
contrasting color fabric "puddling"
on the floor is perfect for displaying
favorite possessions. Note the
bedside antique bell pull from which
hangs an antique mirror.*
(Interior designer: Mario Buatta;
photography by Peter Vitale)

CLASSIC CONTEMPORARY LOFT: *This room has been effectively divided into a dining/living
room. The imposing pink Sonotube covers the plumbing and gives interest and
importance to the area. The message is dramatic but prosperously modern.* (Interior design:
Kiser Gutlon Quintal Inc.; photography by Peter Vitale)

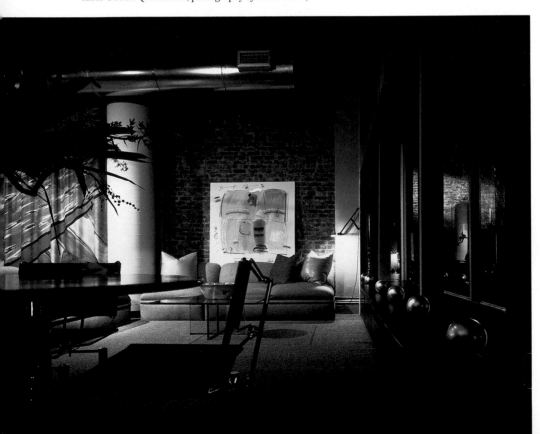

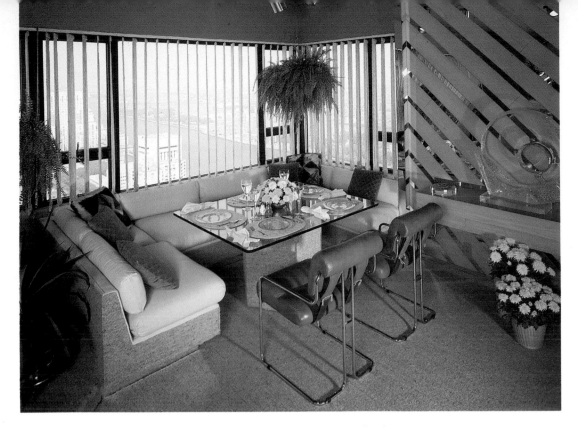

CLASSIC CONTEMPORARY DINING ROOM: *The monochromatic color scheme unifies this room. Note how the carpet creeps up the banquette and the table base for an unbroken and refined visual effect.* (Interior design: Yvette Gervey, courtesy Stark Carpets)

CLASSIC CONTEMPORARY ONE-ROOM APARTMENT: *Lack of clutter makes it possible to sleep, dine, and entertain in one room with grace, comfort, and even elegance.* (Interior design: Yvette Gervey)

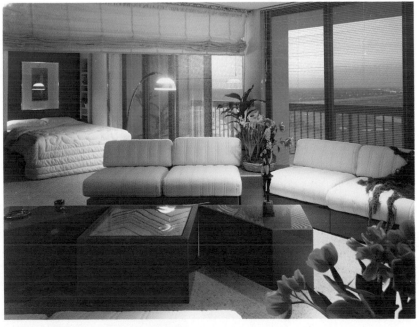

COUNTRY CHARM GARDEN ROOM (*above*): *Snowy white unifies the textures in this airy haven. Wicker personifies polished, cultured country.* (Photograph by Oberto Gili. Courtesy *House & Garden*. Copyright © 1987 by The Condé Nast Publications, Inc.)

COUNTRY CHARM BEDROOM, SHAKER STYLE: *The nearly monastic, exquisite bedroom of Ira Howard Levy, senior vice-president of Creative Marketing and Design for Estée Lauder, captures the Shaker sensibilities in its purity. Rectangular shapes and warm, unadorned woods are echoed in the bedposts, canopies, furniture, and windows.* (Photograph by Wulf Brackrock)

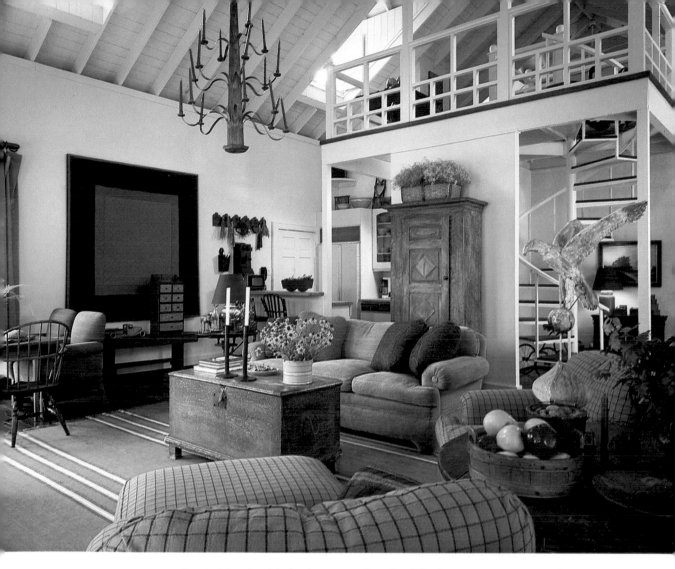

COUNTRY CHARM LIVING ROOM: *Provincial authenticity lends an atmosphere of well-bred country. This casual farmhouse is never maudlin and always dignified and gracious.* (Interior design: Billy W. Francis; photo courtesy Houston Home and Garden. Photography by Fran Brennan)

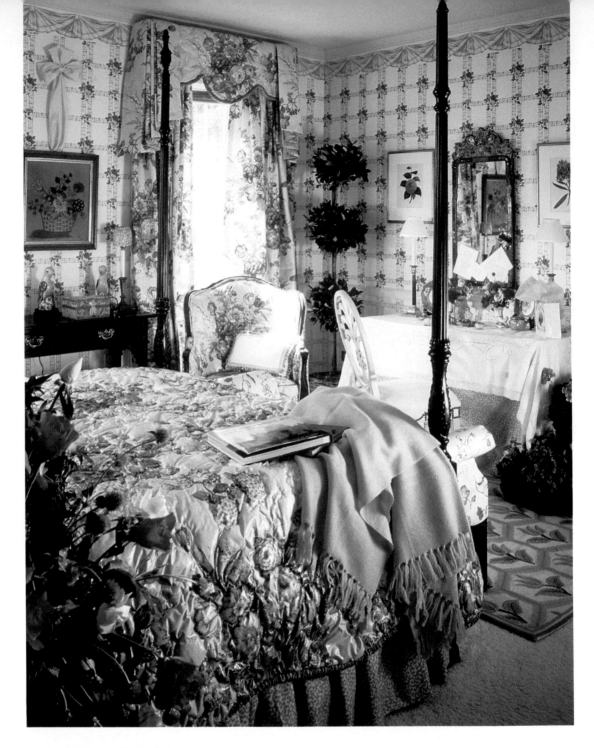

A RICH MIX (*above*): *This English country manor-house bedroom, featuring designer Mario Buatta's accessible wallpaper and fabrics, spans the Country Charm and European Opulence signatures. The designer's trademark florals are repeated on the wall, bed, and at the window, lending a richly unified ambience. The wallpaper border nicely compensates for the room's lack of expensive architectural details.* (Courtesy Sterling Prints' Mario Buatta Collection)

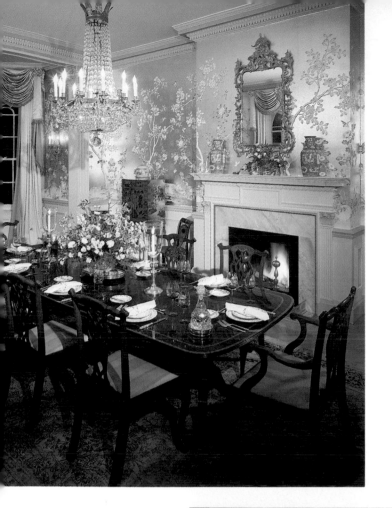

AMERICAN PEDIGREE DINING ROOM
(opposite): *The room is dominated by the reproduction Duncan Phyfe table, Chippendale chairs, and classic moldings, which are quintessentially American. The American Pedigree signature is often married to elements with Far Eastern flavor, such as the wallpaper, porcelain urns, and Oriental rug in this room.* (Interior design: Marilyn H. Rose Interiors, Ltd.; photographer: Jeff Heatley)

AMERICAN PEDIGREE LIVING ROOM:
The wing chairs that are icons of this signature, the warm wood paneling, and the sporting motifs provide warmth and formality at the same time, as well as a sense of heritage. (Interior design: Richard L. Ridge)

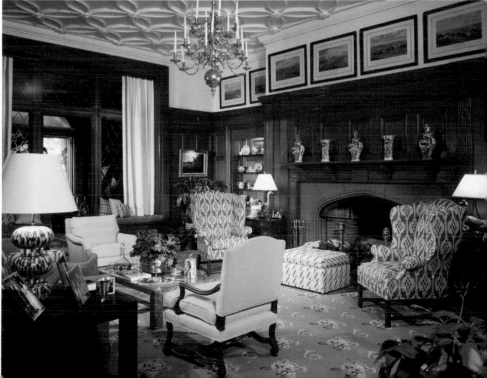

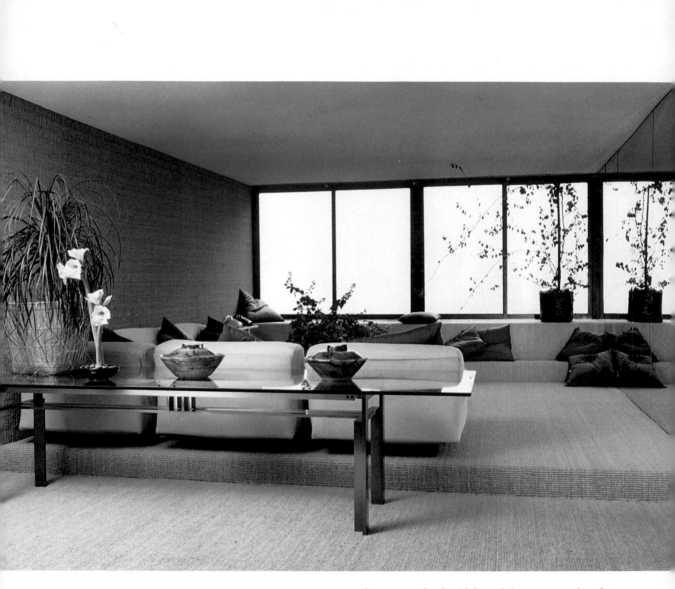

ORIENTAL GRACE LIVING ROOM: *Spare, serene levels, rich but subtle textures, and earth tones distinguish this Japanese-inspired living room.* (Ronald Bricke and Associates, Inc., NYC)

6

American Pedigree

Does This Sound Like You?

- True elegance rests in dignity and heritage
- American eagles are my favorite birds—but only in brass, please
- My bedroom really ought to have a beautifully crafted, gleaming mahogany armoire
- Whatever happened to front porches and their swings?
- Pewter is the most elegant metal
- Camel-back sofas and wing chairs are the way to a man's heart
- Windsor chairs and grandfather clocks whisper *Class*
- I yearn for a paneled room and a collection of British warship prints
- Wallpaper scenes can be splendid backgrounds
- I love those little carved animal paws on furniture legs and arms
- Get George Washington back
- I loved JFK's rocking chairs
- I hate to tell you what I'd spend for Teddy Roosevelt's autograph

- Frederic Remington is my favorite artist

- Jackie was right to spend a fortune refurbishing the White House

- I think flourishes of Victoriana would be fun for a bedroom

- Promise me anything but give me a set of books on Old New York

- I feel so proud to be a part of this country, and that isn't just patriotism. When I see the beauty of the land and read the spellbinding chronicle of our craftspeople, our folk heroes, and our aesthetic values, it is simply a terrific story!

American Pedigree: I love it. It's the look of our country before the machine age. It's dark, rich woods, handcrafted hallmarks, silver and brass, hearths and eagles. It's a look of comfort and tradition. It's a look of reverence for ancestors. It's a look of timeless style.

The American Pedigree Look

This living room is so warm and quintessentially early American that it could be Thomas Jefferson's. The classic Chippendale chair and its conversation mate, the Martha Washington chair, flank a piecrust tea table in gleaming mahogany. The silver service recaptures the colonial zest for the hard-to-break tea habit brought over from Mother England.

Can you see yourself leaning back in the blue and white striped camel-back sofa in front of a fire set at the stone hearth? The room is so traditional, it could be nothing else but American heritage: The furniture looks like it was made in Philadelphia, Boston, or New York

*An American Pedigree
living room*

by early American craftsmen. An elaborate mantel and paneling surround the fireplace, lending an aura of dignity and richness. As it always does, the ubiquitous Oriental rug gives warmth and a feeling of luxury. Other Oriental grace notes appear in the cracked antique plates on ebony stands that also provide balance on the mantel. Paul Revere silver stands on a cabinet. Swag drapery caught in rosette hardware flatters the window and picks up the color of the sofa, in back of which stands a simple but elegant sofa table: on the table— period pewter candlesticks in perfect balance. Reigning over all—a fabulous brass mirror topped with an imposing American eagle.

There's romance in American Pedigree. We're reminded of the bravery and imagination of the young colonists every time we look at Early American furniture because there was a close connection between the craftspeople and the products of their labor. An even deeper romance comes from a sense of connectedness to this heritage which is, after all, our own American family. Although many of us derive from far-flung places of the world and cannot trace our American ancestry back to Mayflower days, we still feel a kinship to those early settlers of the land that is now our land.

Many of the earliest Americans became extremely rich: no more log cabins, no more furniture hewn from the wood of the land. Thousands of early Americans in the late seventeenth and throughout the eighteenth centuries built themselves incredibly magnificent colonial mansions. The cabinetmakers became prominent and honored in their communities, sometimes even rich because they earned good money for their labors from the wealthy colonists. In making fine furniture, they'd use only the finest woods joined together by dovetails, not glue; the veneers were so thick they rarely blistered or cracked, unlike today's versions. The designs were graceful and elegant.

Since most of the colonists came from jolly old England, Early American furniture designs took their inspiration from Britain—and to a lesser degree from France and Holland and the Chinese influence that was found everywhere in Europe. Nevertheless, the great American craftsmen reinterpreted the European touches and made them their own. Although honesty insists we acknowledge the overlappings of European influence, American Pedigree is distinctive in that it is less ornate and less frivolously detailed. It is original in some

designs, like the Pilgrim slatback chair or the exquisitely simple Shaker designs (discussed in Chapter V, Country Charm).

When thinking American Pedigree, therefore, think of the finest rooms in the world. Think of gleaming dark woods. Think of beautifully handcrafted furniture. Think of subtle but unmistakable symbols of freedom: eagles carved in wood or brass, flags, framed copies of historical documents dating from the American Revolution, old maps, busts of American presidents, signed letters of historical interest—all possible Masterstrokes. Think of high-backed chairs and firmly tufted, richly colored fabrics.

American Pedigree is serious, never whimsical, and quite lovely.

American Pedigree furniture comes in several distinctive styles, all influenced by the delightful mix of backgrounds that comprise melting-pot America. The strongest furniture influence comes, of course, from the mother country, England, which is parent to Americana in architecture, design, and even tradition. One can emancipate one's self from parents, as the colonists did, but the heritage lives on in the new dreams, despite the rebellion, and nowhere is this more apparent than in furniture style.

Those who wish to adopt this rich Early American decorating signature must be able to recognize good reproductions of the American furniture that is so clearly evolved from English, for the originals are very costly. If you have been fortunate enough to have inherited or purchased any of the original American treasures, consider yourself blessed: One client of mine purchased an original Queen Anne highboy in 1957 for $4400; she was offered $220,000 for the piece in 1987!

In the early eighteenth century, English furniture styles were named for ruling queens and kings. Later, when certain English cabinetmakers of taste and skill began to popularize their own designs, styles began to be named for them instead of for the monarchs. The names of Thomas Chippendale, George Hepplewhite, and Thomas Sheraton, for example, have been immortalized by the styles they created. Corresponding Early American furniture styles for the most part retained these English names. In my judgment, there are five styles that are ubiquitous in American Pedigree homes of beauty. Your home in this signature ought to include some examples of the five furniture styles.

**WILLIAM AND
MARY (1688–1720)**

The massive, heavily baroque classic English version of William and Mary style had spirally turnings, scrolled feet, curved legs, and silk upholstery. Much of the furniture was decorated with marquetry and exquisite veneer. A clear identifying mark of much of this furniture are the "stretchers" which joined the legs and were either arched, bowed, or flat serpentine pieces that criss-crossed diagonally from leg to leg.

The American Version: When American craftsmen began to make William and Mary furniture, it became greatly simplified. Smaller and lighter translations appeared with needlepoint upholstery substituting for silk. Carvings were flatter and less detailed and the plain surfaces show how basic the colonists' needs really were. Indigenous woods like maple and walnut replaced the fine mahoganys and oaks of Europe.

*A William and Mary
heavily carved chair
(English)*

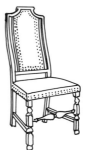

*An American version of
William and Mary
chair, simpler and
lighter*

**QUEEN ANNE
(1720–1750)**

The most distinctive feature of the classic Queen Anne style was the cabriole leg, an S-shaped leg often with carved knees, which curved and tapered and ended with a simple animal's paw. For the first time, a woman had major influence on furniture style and Queen Anne opted for comfort as well as grace. Padding and upholstering were introduced and seats were widened in front to allow for women's petticoats. The wing-back chair, an icon of the look of America today, was originally designed during Queen Anne's time to protect the head against drafts. Furniture was made almost completely from walnut.

When the colonists began to turn to Queen Anne style for inspiration, stretchers went out and chair-back splats (often decoratively

pierced) came in. "Broken" pediments (or-
namental tops with a carved out opening at
the apex—see illustration on page 132) ap-
peared on highboys and are an unmistakable
feature of Americanized Queen Anne, though
the Americanized version is somewhat simpler
than the English. Finials were introduced to
top both highboys and lowboys and they were
often carved as flames or urns. The animal
feet became more complicated and carving
in general took precedence over inlay work.
I particularly love the Queen Anne tea tables,
which the early Americans brought into their
homes to keep alive their tea-drinking habits.

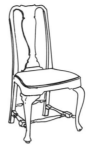

*A Queen Anne chair
(circa 1720)*

Thomas Chippendale was a superb furniture craftsman and the En-
glish Chippendale period was named after him. His claim to fame
rested in an ability to combine many different
influences into his work (among them Rococo,
Gothic, and Chinese) and still make his de-
signs unified and magnificent. Early Chippen-
dale was heavily ornate and richly decorated,
and the claw-and-ball foot was everywhere.
Later, the artist himself became more class-
ical and pared down his pieces. He was best
known for his camel-back sofa, block-front
chest, and side chairs. During the American
Chippendale translation, carving became more
in vogue than veneer or inlay.

**CHIPPENDALE
(1750–1779)**

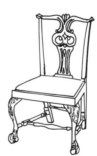

*An American version of
Chippendale chair*

Windsors: In this same time period the colonists
adapted an English cottage style into what is
now an American classic: the Windsor chair,
with its wheel-rim back and spoke spindles driv-
en into hickory or ash plank seats. A point to
be made is this: A Windsor chair in fine-
grained, polished wood is appropriate for formal

117

American icon: Windsor chair

American Pedigree. Take the same Windsor chair in bleached pine or painted white or a country color and it becomes a candidate for Country Charm. In the same time frame as the Windsor chair came a piece of furniture that was purely American—in fact, Ben Franklin invented it—the Boston rocker.

**FEDERAL
(1785–1820)**

At last, we're dealing with the American Pedigree look that is perhaps most familiar. Federal style is neoclassicism at its best, with many different motifs derived from the English classics of the period such as Adam, Hepplewhite, and Sheraton. Federal furniture generally has straight legs, a minimum of decoration, a maximum of delicacy and symmetry. The straight-backed, no-nonsense Martha Washington arm chair (just like Martha herself) is an excellent example of Federal design as are the popular Hitchcock chairs. Duncan Phyfe was a prominent American Federal cabinetmaker. His specialty is familiar: use of the lyre and the acanthus leaf in chair backs and table bases. Look for the originals in the American museums, then find them in good reproductions for your own home.

One of the most important pieces of Federal furniture was the sideboard used to store silver and other items in the home. Dressing tables with attached mirrors and sectional dining tables are also quintessentially Federal, as are chairs with heart-shaped, shield, and oval or rectangular backs.

A Federal Neoclassical chair: Duncan Phyfe design in chair back

A Federal inlaid sideboard

Queen Victoria had a passion for the arts and what is known as Victorian is not one single style but an eclectic collection of substyles popular during her reign. The hefty queen liked to incorporate things Chinese, Gothic, Turkish, French, and English all into one room, and curves, curls, carvings, and clutter epitomize American Early Victorian style. Victorian style is different from all the previously mentioned styles because it encompasses many different designs— kind of a catch-all approach. In America, the most typical Early Victorian furniture was elaborate and highly ornate. Furniture of the Late Victorian period in America (1865–1880) was no longer hand-crafted and not appropriate for American Pedigree style.

Queen Victoria's influence went beyond furniture style to the entire decorative treatment of a room including walls, windows, and accessories. The overall effect is one of rich clutter. What follows are some examples of a general Early Victorian approach:

Victorian Wall Treatment: A documentary wallpaper (one that takes as its theme something that happened in American history) combined with painted moldings, could be terrific. Or, look for the work of English designer William Morris, who in the late 1800s influenced Victoriana in a major way with his floral and geometric patterns; copies of his wallpaper designs are available today in the original rich colors.

Victorian Rooms: The Victorian room itself would be brimful of stuff—furniture, accessories, plants, ceramics, souvenirs of travel (which the rich always love to display) like beaded pillows with Turkish or Moorish ancestry, Indian artifacts, carved ivory. Certainly, one would find elaborate moldings and woodwork.

A Victorian chair, button-tufted arms, seat, and back

Victorian Accessories: Look for them in the flea markets of the world. They include reproductions of ornate picture frames, mirrors, green-shaded brass lamps, fringed lamp shades and pillows, cut glass, fancy bed linens, ribbons, tassels—you name it!

A word of caution: Victoriana goes in and out of style. Often it's overdone and too dark, ornate, and curlicued. However, carefully chosen touches will add a flourish. A rich mix, rather than a whole room in Victoriana, is the way to approach this style.

GET RICH QUICK! THE ELEMENTS OF AMERICAN PEDIGREE STYLE

Certain elements are always found in opulently American Pedigree homes. Among them are:

American Pedigree Fabrics: Some of the most wonderful fabrics for furniture are found in documentary printed linens, scenes of English or American triumphs. Often, these are "museum authenticated" . . . a stamp of approval. This means that the research department of

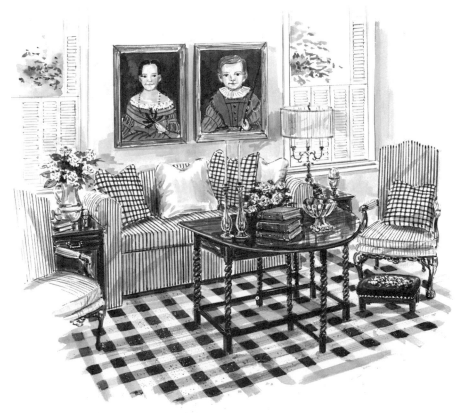

Repeat fabric motifs by varying the scale and design to achieve a unified scheme.

120

a museum has researched the particular print and asserts that it is a scene frequently used by our American ancestors in their own decoration. Besides linen, more informal "American" fabric might include damask, chintz, paisley, printed or solid toiles. More formal fabrics include striped satins, tapestries, silk brocades, velvet.

There are three major ways to use fabrics with American Pedigree flair (and these decorating approaches apply in the other signatures as well):

1. The whole room is unified by using the same fabric on furniture that is similar in style and period.

2. The whole room may be unified, as well, by using the same fabric on decidedly different furniture styles.

3. Finally, the room may be unified by using a repeated motif in different fabric. By varying the motif's scale and design but keeping the color of each version the same, a room can be charmingly consistent, yet different. For example: A small blue and white checked pillow can rest on a blue and white striped couch; the small check of the pillow can be echoed in a larger check on a rug which is also in blue and white. Add solid blue or white pillows or a blanket.

American Pedigree Color: Eighteenth- and nineteenth-century Americana looks wonderful with backgrounds of muted mustards, blue and white, light cocoa browns. Reds, golds, and blues are traditional accent colors. Intricately carved pieces of American furniture, usually in dark woods, are brought to life with deep, deep shades of the above. Never consider the pale baby pastels—light pinks, blues, yellows—for the signature. Blues must be classic delft shades or even navy; reds are more oxblood than cherry; greens are jade, emerald, or moss—rarely lime or turquoise.

American Pedigree Windows: Traditionally, American windows are soft treatments in fabrics that coordinate with upholstery and wall coverings. Long draperies are often the order of the day. They hang from wooden or fabric-covered cornices that can be cut to order at a lumber yard. Simple tiebacks give interest to the fullness of the fabric. Make sure draperies puddle on the floor in the European manner. Cornices can be scalloped, classically straight, or softly rounded to mirror the lines of a scrolled or spiral detail on a piece of furniture

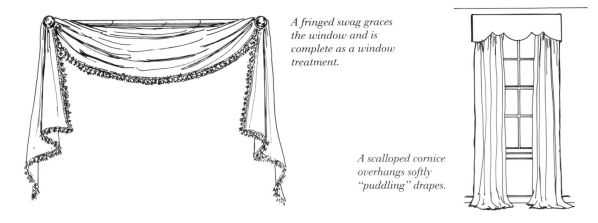

A fringed swag graces the window and is complete as a window treatment.

A scalloped cornice overhangs softly "puddling" drapes.

you wish to emphasize. Sheers or lace can be used as undercurtains. Fabric-covered shades (to coordinate with furniture), plainly painted period shutters, or wooden Venetian blinds are also fine for this signature.

A balloon curtain on a single rod has hidden cords to allow varying curtain lengths.

American Pedigree Walls: Reproductions of hand-painted wallpaper with historical scenes (Washington crossing the Delaware, the Pilgrim fathers and their Indian friends, etc.) are a staple in this style. Indeed, many of the walls in the White House are decorated in this

manner. Hand-painted murals are an adaptation of this look. Also typical is Chinese-style wallpaper, often used in the dining room. Solid-color walls, often given interest by chair rails and other architectural details, are also quite popular as are walls that are papered just to the chair rail and then continued in paint. Reproduction moldings to contrast with the walls are an exquisite touch of Americana and ceiling medallions in shell and other designs (available for about $40 each—see Resource Guide) give special focus. Another excellent Early American touch is wood paneling, discussed below.

American Pedigree Wood Paneling: There is nothing so American as fine wood. For years, designers in American Pedigree have capitalized on the richness and nobility of this most natural of all materials.

For a wood-paneled library look, you needn't use the best of woods, but do use genuine wood and not a plastic simulate: Real wood has a grain that is easily recognizable and no one of taste would substitute a synthetic here. Do upclass the wood with Decorating Rich touches: the deep leather chair (it can be *very* old and worn; leather looks richer when it looks ancient), the banker's green table lamp or the brass floor lamp, the framed library prints, the globe, the library steps, the books, the books—many with their paper covers removed.

If you can't afford an entire room of wood, one wall of a study or den is just about the same thing in feeling. Three softly painted walls emphasize one wood-paneled wall so much that all the eye sees is wood. Moldings placed at the baseboard, chair height, and at the ceiling add further éclat.

American Pedigree Floors: As for floors, the simpler, the better to give a luxe feeling to an American room, and that again means wood, glorious wood. The wide- or narrow-planked American floor is often warmed with a miniprinted rug, its tiny pattern repeated over and over. One can never go wrong with our old friend, the Oriental rug, which looks resplendent on a dark wooden floor. If you don't have wooden floors and can't afford to install them, simple wall-to-wall carpeting, preferably in a "velvet" finish, is a very plush American Pedigree look as well.

American Pedigree Lighting: This signature employs a wide variety of lighting—a green-shaded brass desk lamp, a wooden candlestick lamp or a brass floor light for reading next to a wing chair. I'd love a wooden, pewter, or brass "tankard" chandelier over a dining room table and brass swing-arm lamps with soft shades in other reading areas. Candlelight is always magnificent, and collections of lit candles in candlesticks add a special aura to a dinner party. Candles in glass wall sconces are also wonderful, as are those caught in hurricane glass. NOTE: There is nothing worse than candles that have never seen the light of a match . . . they're so hokey. Blacken the wick of new candles just to show they're working fellows, not merely ornamentation.

A true touch of Americana can be seen in a "Shenandoah" hanging lantern that has been electrified, but not too much of this please. Excessive numbers of hanging lanterns tend to look cutesy, not rich. One client found a marvelous tin chandelier, a reproduction of an original. It was not only gorgeous—but also remarkably inexpensive.

A classic wooden candlestick lamp

Iron lamp sconce with glass hurricane shades

A three-branch brass candlestick lamp with a tin shade in green

124

Hurricane glass shields candle in pewter candlestick

A metal ceiling fixture with "hurricane lamp" lights

American Clocks: There was nobody in early America who didn't love a clock, and no home in American Pedigree signature would be complete without a wonderful original or reproduction Early American clock with the detailing and architectural interest that made them gems. Best is a grandfather clock that stands tall as a patriarch should. You might choose a wall clock with an original painting on its pretty glass face or set in a panel underneath the face. You might choose a "banjo" clock in the shape of the famous instrument, perhaps with an American eagle perched on its top. Or, you might even opt for a "clock under glass," another style popular circa 1810. Decorating Rich American Pedigree style calls for at least one great clock —if not a clock collection.

American Metals: Paul Revere must have started this. The poshest-looking American Pedigree homes never fail to display gleaming silver, either sterling or stellar reproductions of real silver. An entire silver service displayed on a chest is a definite Masterstroke. Silver was (and is) a convenient means of preserving and displaying wealth. The Dutch brought wonderful silver to old New York. In the colonial times, men of wealth even had their silver coins fashioned into more useful and conspicuous objects like teapots, tankards, and snuff boxes. Any of these would also make a marvel of a Masterstroke on a table or lowboy and they can be transformed, of course, into flower holders or anything else that calls attention to their gleaming beauty.

Pewter, which is a combination of tin with lead or copper, is also

used with great elegance in mugs, candlesticks, and dishes in American Pedigree homes. Brass, used for andirons, lamps, hardware, fireplace screens, and myriad other items, is a prime metal in American Pedigree style.

American Pedigree Collections: In every signature, collections make an elegant statement, and collections of Americana are a statement of historical sensibility as well as of affluence.

Here are a few suggestions for collections:

- Autographs of famous Americans, mounted and framed
- Sandwich glass
- Photographs (America the land or America the people—old or current studies)
- Amusing or unusual items: wooden cigar store Indians, Statue of Liberty pins, flag paintings, brass cuspidors
- Eighteenth-century American doll furniture
- Pewter flagons
- Bennington pottery
- Watches with beautifully decorated cases
- China dishes or figurines

AMERICAN PEDIGREE ART

Paintings: American art, Pedigree style, consists for the most part of paintings, including family portraits, landscapes, and still life among others. These paintings should have a look of history and not a look of modernity. The original artists, of course, like Remington, Sargent, and the masters of the Hudson River School, are priced out of almost everyone's budget. Still, good copies of the era are available, and if framed majestically, in important-looking goldleaf or carved or stenciled wood frames, they give a splendid suggestion of "original." The important thing to remember here is, never buy a copy of an original that's familiar—for example, *George Washington Crossing the Delaware*. Original paintings from the era by lesser known artists are also available for the astute treasure hunter.

Sculpture: Despite the Decorating Rich rule of thumb about reproductions of familiar art, in the case of certain sculptors like Frederic Remington, who drew his inspiration from the American West, a bronze reproduction of such an unmistakably American scene is worth its weight in gold. These bronze castings are considered to be in excellent taste.

Prints: Art printed from original woodcuts, engravings, etchings, or lithographs are wonderful grace notes for this signature. Prints of American city life, landscapes, people and customs are fine. Prints of American battles or other scenes that exemplify a special period of American history are splendid. Look for Currier and Ives scenes and Audobon birds for special status.

Treasures from the Bookshop: One of the richest sources for American art is the dusty secondhand bookshop around the corner where extraordinarily fertile loam is waiting. The illustrations one finds in these forgotten books are fabulous and just waiting to be carefully removed and beautifully framed. I have seen such treasures that I defy anyone to guess came from the pages of a book. One client of mine collects *Valentine's Manuals,* a series of vintage books issued in the mid-1800s which documented the City of New York. He used to buy them for $20 a book, although now, he tells me, they can run upward of one or two hundred dollars a book for the best preserved. A bargain! In some of these books are hand-colored maps of old New York, lithographs of parades held in 1832, photographs of homes built on country streets (that are now major avenues), maps, charts, lists, official documents, names of every orphan in the local asylum —all eminently framable, all art, all Americana. Over his wing chair, my client hung a colored map of Old Harlem with all its country lanes and homes; the map came folded in the *Valentine's Manual,* stretches out to about four feet by four feet, and is a Masterstroke of elegance in his den.

AN AMERICAN PEDIGREE LIVING ROOM

Here is a classic example of a room that really comes under the heading of rich mix (see color insert). Although the wing chairs are

quintessentially American, the room nods to its English heritage in the fox-hunting prints and the custom designed fox-face rug. Chinese porcelains lend a touch of Oriental Grace. A Parsons table is nothing but Classic Contemporary. However, the dark wood paneling, the American brass chandelier, and the general ambiance say predominantly American Pedigree.

This expensive room is easily duplicated in Decorating Rich fashion. The wing chairs can be bought as reproductions, as can the porcelains. Look for hunting motifs in inexpensive art work and accessories. Parsons tables are readily available with inexpensive price tags. Sterling silver frames can be duplicated by coating any metal frame with the "Silver Solution" (see Resource Guide) to simulate the finest sterling at less than sterling prices. The plaster ceiling can be duplicated with composite plaster ceiling blocks. Unmatched occasional chairs are available in thrift shops and can be covered in a color-coordinated fabric. Look for architecturally interesting window panes and frames at salvage companies. Art lights over small, undistinguished oil paintings lend distinction.

Touches of class:

- A cut glass decanter filled with sherry
- Green plants and fresh flowers
- A china collection in a small niche
- A potpourri of throw pillows in good fabrics

All adds up to the warm, wooded look of the American hearth . . .

AN AMERICAN PEDIGREE LIVING ROOM: THE DECORATING RICH WAY	*Expensive Hallmarks*	*Decorating Rich*
	An original painting of a Revolutionary or Civil War battle scene, like *Washington Crossing the Delaware* historical "period" theme	A beautifully framed wallpaper panel in a stockwood frame
	A standing handcrafted wood lamp with brass shade, circa 1890	Wrought iron standing lamp bought inexpensively at auction, junk shop, or yard sale with new documentary fabric shade

Early American architectural details on corners, doorways, around fireplaces, on ceiling	Reproduction architectural brackets available by mail (see Resource Guide) or other reproduction architectural ornaments. Paint and add to walls or corners for a luxe touch of "genuine" Americana
A typical Early American staircase	It's no easy chore to change the shape of a staircase, but it's not so difficult to replace a handrail, balusters (the individual posts supporting the rail), or newel posts (the larger posts at the head, foot, and sometimes in the middle of a staircase). Research staircases of the American Pedigree period and choose new posts that will give class to your home. These can be bought custom-made, of course, but also in stock —and cut down to your specifications. Sometimes, wrecking companies have odd posts which would be a terrific touch and next to nothing in cost
An expensive animal skin rug on a wooden floor	Brown and white cowhide rugs can be purchased from a leather goods wholesaler whose skins are usually bought by clothing wholesalers: Find these wholesalers in the Yellow Pages and make friends. I have two clients who purchased slightly seconds in these skins. I prefer animal-printed wool rugs, rather than real skins, for humane considerations
Period furniture upholstered in documentary designs	Reproductions upholstered in mattress ticking or reproductions of antique printed linens offered by fine furniture companies that specialize in early American designs (like Baker and Kindel— see Resource Guide)
Tea table heavy in silver (silver service, etc.)	One authentic silver touch—a bit different, like a grand old silver ladle or a fabulous silver coffee urn (with ivory handles?)—and the rest of the tablescape composed of a great, lush tassel, a Victorian dish, etc. The eye falls on the silver Masterstroke making it all look terribly expensive
An antique sterling pen and pencil set with a wonderful desk blotter on a period desk	A simple, innocuous desk and blotter (leather framed?). Masterstroke: an extravagant quill pen. The eye sees the old-time quill and the whole look is rich! Let the quill pen perch in a

Authentic period furniture — reproduction Chinese porcelain inkwell, widely used in its original form in early America

If you can't afford the real thing (few can) or even a good reproduction, you can get the look and the feel of American Pedigree by displaying a children's size repro—often available as salesman's samples or in children's furniture stores—either by itself or on top of a simple wood chest that could pass for a colonial piece. Salesman samples come in rocking chairs, cabinets, highboys and lowboys, and other items. Or buy damaged goods: If the wood is good and hand-carved, you can have the piece refinished and reupholstered for a fraction of the cost of buying perfect Americana

AN AMERICAN PEDIGREE DINING ROOM

The dining-room table, a reproduction Duncan Phyfe, is diligently polished to bring up the luster and wood grain (see color insert). What gives it the luxury look are the lace-trimmed napkins, the stately pair of silver hurricane lamps with burning candles, the cut crystal wine decanter nestled in a filigree silver coaster, the abundant flower arrangement, the sterling silverware (silver plate can masquerade effectively).

The antique Chippendale chairs are classic to the signature and are readily available in reproduction.

Chinoiserie is a hallmark of American Pedigree. On the wallpaper, note it displayed in the delicate Oriental blossoms on a silver background, the colorfully patterned vases on the mantel, the Masterstroke Oriental rug on the traditional wooden floor.

The room takes its pedigree from the traditional moldings and mantel, available in reproduction from lumber yards.

The window treatment consists of folds of fabric and a festooned valance caught by matching rosettes.

American Pedigree is characterized by the gleam of the Chippendale wood, framed mirror, and the bronze and crystal chandelier.

A marble-faced hearth gives texture and elegance.

The room pictured here is of hallmark vintage: You can reproduce it in Decorating Rich style with some proper research.

Expensive Hallmarks	*Decorating Rich*
Handmade cornices and draperies	Cornices can be drawn on cheap wood and cut to shape in local lumber yards. They then can be covered in fabric, painted, or papered to get a look of luxury. Fabric, of course, can be purchased as seconds or firsts in a million different discount outlets, seamed, and simply hung, then gathered with a tieback
Hand-printed or -painted wall murals	Reproduction stock wallpapers are readily available and these give a wonderful flavor to a room. Here's another thought: Talented art students can often be hired (ask to see their portfolios) to hand-paint scenes on your walls, and there is nothing more elegant! Put notices on bulletin boards of schools or advertise for starving painters in your local newspaper. You must supply a scene or mural as a model from which to paint (perhaps you can cut out one panel from an expensive hand-painted wallpaper mural)
Richly grained marble on hearth, table, or sideboard	Slabs of not the best marble in marble-supply stores (see Yellow Pages or Resource Guide)
Original Chippendale furniture	An American Pedigree home with a touch of contemporary could do well with inexpensive (even poor) reproductions painted white or black and upholstered with wonderful "period" fabric. The paint gives a dash of pretty and the fabric speaks history
Lace, lace, and more lace was a ubiquitous hallmark of American Pedigree; it came in curtains, dresser shawls, table skirts, runners, and doilies on the dining room table	Handmade lace cloths, runners, and doilies are often available at estate sales and touches of real lace give instant prestige. Put a runner on your buffet (or under your bedroom perfume tray), a fine lace circle under the porcelain or fresh fruit table centerpiece. Don't overdo the lace, please —a touch or so is great: Anything more looks like a cottage industry product. NOTE: reproductions of fine old lace come in curtain panels
Sterling silver	Scratched silver plate, copper, bronze, or nickel can be coated with "Silver Solution" (see Resource Guide) to look like sterling

THE AMERICAN
PEDIGREE
DINING ROOM:
THE
DECORATING
RICH WAY

Magnificent hand-embroidered table linens	Again, check the estate sales: Sometimes you buy a whole box of "garbage" to get a treasure of, say, twelve hand-stitched napkins—well worth the price of the whole box!
Antique Chinese urns	New Chinese bowls (see Resource Guide)

Fail-Safe Tips for Achieving the American Pedigree Look

THE AMERICAN ICONS

Certain pieces of furniture seem to capture the essence reminiscent of the richest of American Pedigree. They are:

- Wing and Windsor chairs
- Grandfather clocks
- Highboys and lowboys (with brass hardware)

American icons: highboy with brass hardware; wing chair (note needlepoint pillow with American eagle motif and nail-head-studded footstool).

Any room rich in American Pedigree flavor ought to include examples of these icons.

As in any signature, the important, large pieces in the American Pedigree bedroom should reflect the tone of the home, and that includes, of course, beds that are appropriate companions to highboys, lowboys, Windsor chairs, and other Early American icons. The Pedigree four-poster is in this category, the posts almost always of wood although sometimes of brass. Canopied or uncanopied, depending on your preference, a particularly wonderful look comes with white dust ruffles and white linens topped with a spread in American Pedigree colors. Dressing tables with mirrors, highboys, upholstered easy chairs, desks, and linen chests are all options for the bedroom.

An American Pedigree four-poster bed

A four-poster with canopy

American icon: Grandfather Clock

PERIOD ACCESSORIES

Many of the nicest Early American accessories hail from New England, where joined stools (the common form of seating in seventeenth-century America), pewter flagons, delft pottery, garden stools, Oriental-inspired pottery, heavily ornate tops for clockcases and furniture (e.g., highboys and chairs) were created by Americans to add color and richness to their homes. The availability of walnut with its close graining gave craftsmen opportunities to carve panels, desk accessories, picture frames, and other objects with intricately figured surfaces.

GLORIFYING SMALL SPACES

Certainly in every signature, the signature point of view should extend throughout your home, even into bathrooms, kitchens, and small, neglected hallways. A "lost" corner can be enriched by one stunning period piece, a collection in the signature, or a touch of live greenery.

Glorifying small spaces: A Queen Anne bench, a candlestick collection, and greenery make a corner stair landing important.

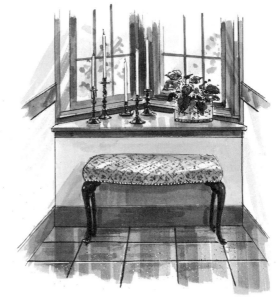

HONOR YOUR ANTIQUE DEALER

I have a client whose absolutely elegant, mostly American Pedigree home we furnished well within his budget. This particular client is a decorator's delight because he has made it his business to strike up a Relationship (with a capital R) with his local antique dealer, and

local, in this case, happens to be in the center of New York City, a place where you wouldn't think you could get bargains. You can. Since he drops in often at the dealer's, since he's genuinely friendly, and because the dealer has come to like him and know his tastes, he's the first one called when something interesting comes in. One day, it was an old and scruffy reproduction of a Thirteen Colonies flag. My client had just purchased a marvelous, huge gilt frame and we were looking for something to put in the frame. The flag, dirt and all, was perfect. In fact, a clean flag would have taken away the "antique" aura. The dark wood of his $50 reproduction "Chippendale" table, the American flag, the collection of early American pottery made the room breathe Americana.

Remember, it's worth your while to cultivate your antique store dealer's friendship. Let him know you'll buy dirty, broken iron lamp bases if they're wonderful. Another resourceful client made such a find. He went to Woolworth's, bought electrical wiring and Woolworth lampshades—not exactly Decorating Rich. Then he went to Bloomingdale's, bought fabulous iron-color velvet fabric in a Rousseau-type print, and recovered the dimestore shades, creating lamps that look like they cost thousands . . . for under $60. Now, that's decorating in a rich American mix.

REPRODUCTIONS: BAD, BETTER, GOOD, BEST

In this signature, as in others, you will be dealing in reproduction furniture to a large degree. All reproductions, including those of the five styles focused on in American Pedigree, range from:

- Bad—The poorest. Even if it's cheap, don't buy it.

- Better—You can work with it, perhaps with a few excellent pieces to take away the glare of its mediocrity.

- Good—A very fine reproduction. If the price is right, you're in luck.

- Best—A superb reproduction. Only an expert could tell it's not an original.

Even originals differ in workmanship and reproductions always have shining examples and careless examples. Often, the addition of superb hardware makes a "better" piece look like a "best": You're not married to the handles and latches that come with a piece of furniture. In addition to adding fabulous hardware, if you put an antique

135

pewter candlestick, an antique leather diary, and a reproduction library lamp on a mediocre, knock-off Queen Anne desk, the whole thing looks terrific. Looks rich.

And I can't say it enough: How do you know if something is Bad, Better, Good, or Best? You have to educate your eye. In Chapter VIII, Making It Work, I will tell you how to do it, but one good suggestion is to

Visit the Source: Early American furniture has been reproduced to death with hardly an attic or flea market free of it. Attics and flea markets are where most of it should stay because probably the worst furniture reproductions are to be found in this signature. The very best way to see the very best of the genre is to take a trip either to Williamsburg, Virginia, or Wilmington, Delaware. At Williamsburg, admittedly, you will find some rather corny tourist attractions, but you will also find an authentic, large-scale restoration of a colonial village. Apart from the tourist area, many private homes in the town are renovated into their early magnificence and you will get an idea of what American Pedigree—the best of it—should look like. In Wilmington, Delaware, you will find Winterthur, the great country estate that was the home of Henry Francis Dupont for decades. Now transformed into a distinguished museum, Winterthur is home to what is believed to be the largest and richest collection of American decorative arts in the world, with whole rooms decorated in the finest of American Pedigree. Winterthur beats even the White House as the most splendid example of this decorating signature. Visit these two places and take copious notes. They are a spellbinding chronicle of America's rich colonial past and an invaluable guide to this signature.

If you can't actually go, books and catalogs from these places are available for study (see Resource Guide).

AMERICAN PEDIGREE is not a look for movers and shakers on a fast, hard-edged track who might be more comfortable with a look that sings of tomorrow. It is for the more reflective, historically minded homeowner who values the essence of American origins. It is for those who cherish formality and dignity.

7

Oriental Grace

Does This Sound Like You?

- There's nothing more dramatic than a black lacquered chest inlaid with jade and mother-of-pearl lotus blossoms
- My colors? Cinnabar! Muted earth shades like olive, mustard, tan
- Paper lanterns give softer light than most lamps
- I love a low-low-low look. And sparseness
- Natural wooden floors, shoji screens, a few cushions: tranquilizing
- Portable partitions are good for the soul. Also privacy
- Money-in-the-bank decorating: monochromatic backgrounds with splashes of color; enamel, lacquered screens; one ruby sacred bird on a scroll
- Bamboo is good for pandas and me
- I'd do anything for an ebony sculpture
- Who says I can't have my cereal from an ancient bowl of aubergine purple and turquoise blue porcelain?
- Meditation is my middle name

- One day, I'd dearly love to see for myself the harmony of a Japanese tea ceremony
- I can think of a half-dozen places to put a sliding panel
- Keep your masses of flowers: I'll take three simple, smashing blooms in a low, gray plate
- Keep your giant cacti and flowering country elms: I'll take a miniature bonsai

Oriental Grace: I love it. It's the elegant, pure look of the enigmatic Japanese; the dramatic, lush look of the Chinese pagoda. It's a look of timeless style.

The Oriental Grace Look

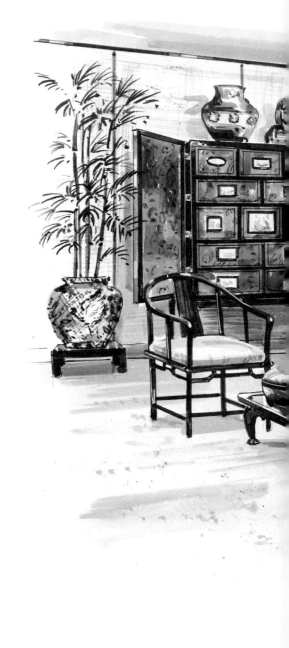

East Meets East: A sense of prescribed order is apparent in the pictured Oriental Grace living room whose mirrored panels and grass-cloth wallpaper panels (inspired by Japanese tatami) echo each other in exact-size duplication. Molding strips on the mirrors and the grass cloth give a custom "finished" look. The lowness of the lacquered table, the Chinese-style chairs, the pillows made from fragments of a Japanese obi, the Chinese porcelain urn on a lacquered stand and the Japanese-style candlesticks are juxtapositions of similar but different cultures. Masterstroke: a massive and detailed Chinese cabinet.

Can you see yourself, regal as a Chinese empress, entertaining in this room? A serene sense of another time, another place pervades the atmosphere. Delicate shadows from the ethereal bamboo play on the lacquered surfaces and the mirrors. It is an interesting, and at the same time, gentle room.

138

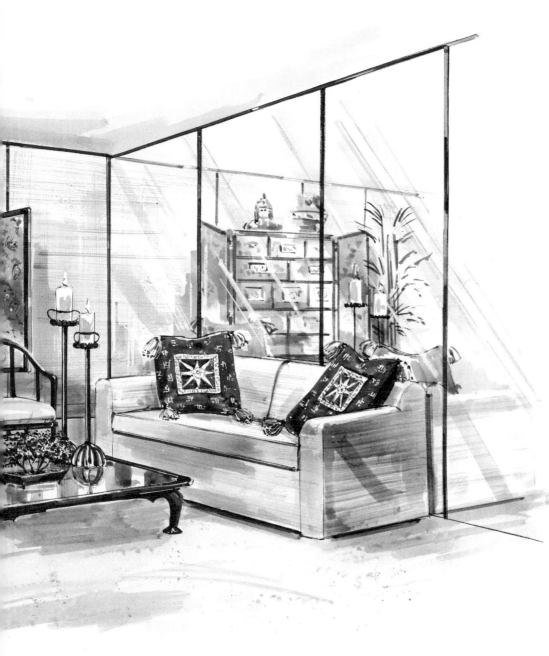

*An Oriental Grace
living room:*

139

The mysterious East has always cast a spell on us. In the past, our notions of things Oriental had to come from the history books and from the reports of a few transfixed travelers, but today, thousands of travelers dazzle the imagination with the exotica they have personally observed and brought back to embellish their own homes. Chinoiserie, the decoration influenced by Chinese art, was brought to Europe by medieval travelers. In the mid-eighteenth century, Chinese motifs of pagodas, birds, fish, flowers, and misty scenes were blended into English, Dutch, and French styles. Along with the fever for Chinese style came interest in the airiness, refinement and simplicity of Japanese homes, art, and architecture. Wider trade with both China and Japan opened doors and imports flooded into the West. In our century the "swinging sixties" blazed a colorful trail for embroideries, cottons, and brass that came out of Afghanistan, Thailand, India, and other Eastern lands. All this made the awful poetry of an eighteenth-century poet, James Cawthorn, seem remarkably prescient. Mr. Cawthorn noted,

> *Of late, 'tis true, quite sick of Rome and Greece*
> *We fetch our models from the wise Chinese;*
> *European artists are too cool and chaste*
> *For Mand'rin is the only man of taste.*

Oriental Grace is, to my mind, an absolutely perfect expression of rich decorating. Oriental Grace is the consummation of highly developed taste, developed, in fact, for centuries. All of the privileges that make rich people "different" are seen in the Oriental homage to pedigree, privacy, reflection, tranquility, and spiritualism. What's more, incorporating this exotica into your own home points to another rich penchant—that of acquisitions in the course of romantic travel. Indeed, today's tourists who bring back Far Eastern touches to their homes are no different than those eighteenth- and nineteenth-century "milords" who journeyed to Italy and Greece and brought back status symbols to decorate their homes and subtly remind their visitors of their erudition, travels, and affluence.

The Japanese style of decoration is serene, disciplined, uncluttered. Chinese decoration, while it has something in common with Japanese, is more elaborate, more sumptuous.

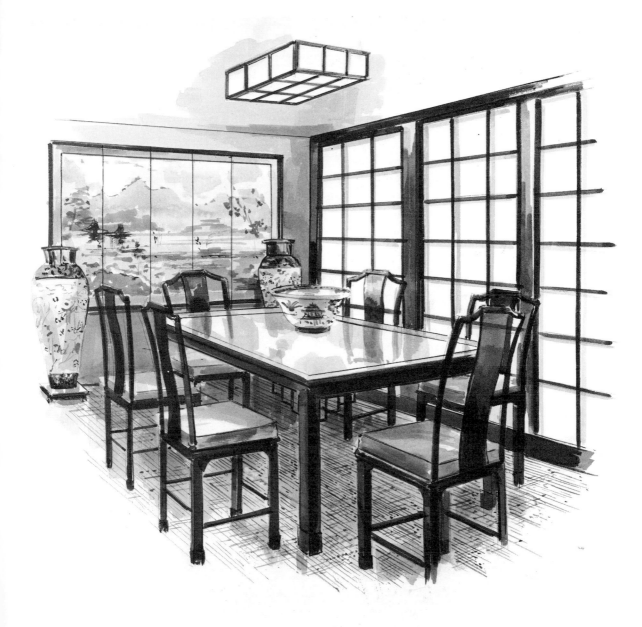

*An Oriental Grace
dining room*

I think the best application of Oriental Grace is when it's used in conjunction with modern Western furniture. One might be able to decorate with an almost pure Japanese flavor because it is so simple and elegant, but I'd strongly advise against a home that is exclusively Old World Chinese for reasons that are both elusive and practical. The effect would be affected rather than rich, forced rather than natural. Fortunately, there is a strong affinity between Chinese and Western decoration. I've used Chinese decorative touches in every one of the Decorating Rich signatures: a Chinese Coromandel lacquer screen in one client's French Country home; a Chinese cloisonné enamel incense burner and an Oriental rug in another client's very Classic Contemporary home; Chinese-print wallpaper in a home otherwise rich in American Pedigree; Chinese porcelain lamps everywhere.

While Far Eastern touches can definitely be married to each other and to other looks, let's consider Japanese and Chinese influences separately since they are so very different.

GET RICH QUICK! THE ELEMENTS OF CHINESE STYLE

Enamored with Enamel: The Chinese have long had a love affair with enamel, the glasslike substance used to coat or decorate metal or pottery. Cloisonné enamel, enamel work in which the colors are separated by wires forming an intricate pattern, is so magnificent (and expensive) that a little goes a long way. One can get rich quick with a vase, candelabra, incense burner, or box finished in this precious substance that gives a unique Chinese flavor to a room.

Ivory: Touches of intricately hand-carved ivory, the hard, creamy substance forming the tusks of elephants, are exquisite symbols of luxe.

That Fabulous Garden Stool: As in the European Opulent signature, garden stools are a sure sign of Chinese Splendor. It is inconceivable that the ancient Chinese would create a garden that didn't have a low barrel-, rectangular-, or drum-shaped seat that was impervious

to weather and often centuries. Wonderful replicas of these stools are readily available, and they instantly give a taste of color, beauty, and affluence to a room. They can be used as stools or as coffee or even night tables.

A classic barrel-shaped garden stool with a lotus flower pattern: perfect for end table or plant stand.

Birds and Fish: The Chinese have always been devoted to these two species. Ornamental fish breeding was a game of emperors. Consequently, spacious, deep crystal bowls with fish were a part of the furniture of imperial palaces and privileged homes in China. Today, fish and all, they make a nice touch in homes decorated in the style of Oriental Grace. Songbirds, the subject of poetry and prose in ancient and modern China, were everywhere, and the magnificently crafted bird cages in which they were housed were part of the decor and indeed are still quite lovely today. The cages (perhaps minus the birds) are also used for flowers, fragrances, and lamps in homes of taste.

Porcelain Power: Nothing says China more beautifully than porcelain, whether this precious translucent pottery comes in the form of lamps, vases, stools, or dishes. Originally, Chinese porcelain meant, to many, the Ming-style vibrant blue and white designs or the more complicated turquoise, blues, and greens found on sumptuous vases. Today, the "new" Chinese porcelains include simple, pure colors and forms with delicate, calligraphic qualities. Smooth, one-color glazes in the spirit of the Beijing court are as typically Chinese as the more familiar Ming blue and white.

A large, glazed porcelain bowl with magnificently enameled duck and lotus designs: used as planter or simply as powerful symbol of Oriental grace.

Chinese Wallpaper: Wallpaper was originally an invention of the Chinese. Oriental themes of landscapes, birds and flowers on a good paper go far to embellish this signature. Caution: Chinese wallpaper

Chinese-design wallpaper is timeless elegance.

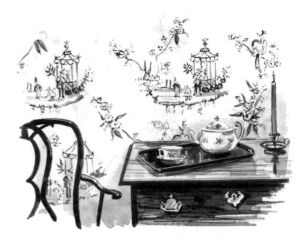

has been so widely copied that crass imitations are available. Using tacky copies, despite their Oriental themes, will detract instead of add to a look of palatial grace. The good news is that wonderful Chinese-flavored papers are readily available at discount prices.

Oriental Rugs: Always, in every signature, they're the final touch, and for Oriental Grace, this goes double. Although any fine Oriental rug would be appropriate, perhaps a Chinese sculpted rug would be particularly lovely in this signature.

GET RICH QUICK! THE ELEMENTS OF JAPANESE STYLE

Decorate with Shibui: *Shibui*—a Japanese word so big, so deep that it's almost impossible to translate into English, but it's the essence of this decorating look as well as the essence of all Japanese culture. *Shibui* is the most profound beauty word in any language. It means restraint—with a million nuances. It means understatement and quiet. It means that the less powerful thing may be the more effective. Shibui is a pale blue kimono which looks lovely but inconspicuous and plain at first sight: A closer look reveals little masterpieces of stitchery. Shibui is a garden made only with eleven rocks and raked gravel. At first sight, you wonder where the rose bush, the herb plantings, the forsythia are. A closer look, and you want to sit in the rock and gravel garden forever, dreaming long dreams.

144

A room decorated with Japanese shibui has stillness, discipline, and the elegance of tranquility. It is the quietest secret in the world of decorating, and the most elegant.

Once I had a client come in in lavish furs, a diamond as big as her knuckle, impeccable makeup, and hair in the latest style. She is an extraordinary woman, a high achiever, brittle, and on the cutting edge of every trend. I like her but she is anything but understated.

"Give me something with a traditional Japanese look," she said. "I want a home that reeks of mystery."

I talked her out of Japanese. She would have hated it anyway. Shibui never reeks. Shibui says beauty is in imagination. Everything is too much.

Decorate with Prescribed Order: Oriental Grace is tradition-rich and, as such, is faithful to the ways of ancestors. In Japan, traditional homes use movable wall panels called *fusuma,* which can be taken down and changed at a moment's notice; a big living room can become four small rooms simply by putting up and taking down the fusuma. Wealthy Japanese have several sets of fusuma in different motifs and colors. The point is this: Every single wall panel in traditional Japanese homes is exactly the same size, prescribed by history.

The Japanese use portable mats called *tatami mats* for sleeping, sitting, and walking on. These are composed of a sweet-smelling, thick rice straw core, a soft reed cover, and two borders of cloth or synthetic tape to protect the sides. These mats sometimes cover the whole floor. The crucial point: They are always six feet by three feet (about the size of a single bed) and about two inches thick. In every traditional home, every tatami mat is exactly the same size.

Thus, since the start of Japan's recorded history, every wall has always been in close proportion and relationship to every floor in every home. It is the secret of the way the Japanese get their splendid architectural effects of serenity, calm, and freedom. Now, we cannot expect to duplicate such discipline in our homes, nor, perhaps, do we wish to. However, to create a richly Japanese flavor in our home, we can't flout proportion. A home that has expensive furniture but not the feeling of balance and prescribed order that is quintessential Japanese will miss, totally, that look of elegance.

Screen Gems: To the Chinese, screens are protectors of modesty as well as protectors from drafts. To the Japanese, screens are another movable wall for a room. They are also used as decoration, sometimes hanging on a wall, sometimes adding interest or coverage to a difficult wall. The scenes on Japanese screens, which are usually painted paper, are simpler than Chinese screens, which may be encrusted with semiprecious stones. For special occasions, the Japanese may trot out a silver or gold screen.

The Smallest Gardens in the World: The Japanese traditionally make their gardens part of their house and so must you if you love this signature. They do this with many techniques that create the illusion of space, for example, dwarf plants kept under control by rigorous pruning. The sense of scale is exquisite; the use of materials from outside like twigs, bark, stones, and bamboo bring a sense of garden inside. The trick: plenty of space so nothing looks crowded. Areas of moss or gravel can isolate plants. A sectional sofa might wrap around such a tiny garden, sunk in a natural wood enclosure, for instance. Miniature gardens can happen on low tables, as well; they become the tablescapes that in other signatures are composed of collections or antiques. The Japanese decorative style is truly at one with nature. Outside, in a real garden, scales are also reduced: A small pond symbolizes a lake, a stone is a mountain. Ikebana, the Japanese

An ikebana floral arrangement in three levels: Note the contrast of dulled metal container on glossy laquered coffee table.

art of flower arrangement, takes for its asymmetrical theme the idea of earth, man, and sky, and represents these three in the three heights of flowers.

Textures: One of Oriental Grace's richest messages, particularly Japanese style, is sent through interesting things to touch: the smoothness of stone, the grain of wood, the crackliness of paper, the softness of silk, the integrity of straw, reeds, and bamboo—all so touchable.

Varying Levels: The traditional Japanese seem to seek varying levels within the same room on which to rest, visit, and meditate. These levels, often created by raised floor platforms, are covered with a minimum of furniture and other objects. The traditional Chinese, conversely, employ a profusion of chairs and other furniture on one level, as is common in Western civilization. Since the ancient Japanese eschewed chairs and instead kneeled on the floor or squatted on mats or cushions, the modern adaptation of such style has been to keep the setting close to the floor with very low-standing couches and perhaps a variety of cushions on the floor. Small tables, also quite low, create another level. A third level is reached in simple cupboards or lacquer decorated cabinets. And that's it. No armoires, no bar carts. Lots of unfilled space.

Paper and Wood, Everywhere!: The reasons wood and paper are so copiously used in Japan are practical: These materials provide the

A wood and fabric shoji lamp for floor or table

A Japanese-style table lamp in rice paper

A rice-paper lantern (elliptical shape)

best insulation from the heat and humidity of the nation. Bricks and stones are avoided because of frequent earthquakes. Doors, windows, screens, lamp shades are usually made from soft, translucent papers or delicate latticed wood. Cedar baths are standard. Wood and paper are taken to new heights in terms of fragrance, luster, and texture.

Doors That Slide: Opaque screens called shoji traditionally are used as sliding doors to divide rooms, and are removed when the occasion calls for one large area. Shoji are also used to screen windows so daylight but not drafts can enter. They are constructed from a simple, light wooden framework over which paper is pasted providing balanced sections that diffuse the outside light. (See illustration, p. 141.) Western decoration often uses shoji screens because their appeal is universal, and indeed, Americans have adapted the design in various ways. For instance, instead of paper panels, one of my clients has had a delicate painted scene applied to a sliding door. Another has wallpapered her doors and yet another has hung reed screening on her shoji doors.

A Tradition of Alcoves: Small, private spaces used for meditation, tea ceremonies, displays of flowers or art are traditional in a Japanese room. They can be simply constructed using screens, shoji, a raised platform covered with tatami, or any number of other devices. Often a corner can be converted into such an alcove providing a retreat from the rest of the room. Traditionally, the articles like decorative china or floral arrangements that are displayed in these semiprivate or very private spaces will vary according to seasons, occasions, or guests. The alcove can be lit traditionally, with candle or paper lantern, or in a modern fashion with a spot from the ceiling casting attention on the gentle displays.

Meditative Color: Natural colors of wood, clay, and hearth take precedence. Ivory or light brown is widely used. Traditionally, paint,

being unnatural in composition, is not really part of the Japanese scheme, but only the purist worries about that. In small but precious, vivid touches, dashes of brighter color can be introduced: a cinnabar lacquered frame, a green-patina statue, an orange sun in a painting. I don't have to point out how different this is from the European Opulent and American Pedigree signatures, which are often awash in multicolor explosions.

Quiet Walls: We've already said that Japanese walls are among the most flexible in the world because they are traditionally composed of sliding and interchangeable paper panels called fusuma which can be totally plain or decorated with paintings. These fusuma replace the architectural detail that is a grace note of European and American homes. If you are interpreting this look and wish not to involve yourself with fusuma, the best bet is to stick with quite plain walls, perhaps covered with simple grass cloth or painted in quiet beige tones. Complicated paper or paint styles will detract from the simplicity which is the trademark of Oriental Splendor, Japanese style.

Quiet Windows: Shoji screens are almost a necessity for the look. Still, simple matchstick or bamboo blinds are readily available and a very nice adaptation of the screened look. Perhaps the worst window treatment you could choose would be frilly curtains. They are not shibui, which is restrained and subtle, not cluttered or frilly.

Quiet Floors: The quiet look is further carried through on the floor. Traditionally, floors are made of wood, as they were in the ancient Japanese palaces and villas, and mats of various textures, some woven in patterns, some plain as in tatami, are placed on the floor for sitting or sleeping. Modern Japanese homes often have wall-to-wall tatami or sisal rugs which give the same feeling. Painted floor cloths are also used today, as well as tiled floors—both of which give a sparse elegance. Often, large cushions or padded wooden armrests will be found in a home rich with Oriental Grace.

Quiet Fabrics: In principle, since only bare essentials were included as furniture, the quieter the fabric the better. Seats made of rush or bamboo, plaited and sometimes bound with silken cloth or cords

*A Chinese ancestor
portrait on a scroll*

were the traditional ideal. In your own home that interprets this look, the interesting textures of silk or cotton fabrics in monotone to blend with the walls and floor are the fabrics of choice. These are obtainable in outlet fabric shops for a fraction of the original costs.

Quiet Art: Japanese art doesn't ever shriek for attention. Good reproductions of Japanese prints of flowers, birds, landscapes are available in many museum shops. Hand-painted scrolls can be found in antique shops and flea markets. Delicate lacquer boxes, sake (a fermented alcohol beverage made from rice) sets, and hand-carved ivory Buddhas all add up to a graceful Japanese style.

AN ORIENTAL GRACE LIVING ROOM/BEDROOM

A cool, spare, harmonious room is distinguished by the absence of clutter (see color insert). There are no fussy layers, few dramatic color accents, no skirts, no bows: just serenity. The colors are monochromatic, taken from the pebbled beiges of the Japanese stone garden. Interesting textures take the place of color—silk on the sofa, grass cloth on the wall, sisal on the floor. Unbroken color is accented by the platform, also covered in sisal. The mushroom-colored sisal (nubby beige carpeting would be an alternative choice) is inspired by the clean-cut tatami mats of the Japanese. The shapes of the windows and the mirrors echo the gridlike effects of traditional wall partitions and shoji screens. These vertical grids seem to inspire quietness. Horizontal interest is achieved by the low-slung couches and the low glass coffee table, reminiscent of the pillow-seating of the Japanese: Indeed, pillows are everywhere to encourage floor comfort.

Note the rich respect for nature brought indoors. The traditional three-height flower arrangement is flanked by ethereal green shoots.

The delicate potted plant that stands on the window seat is inspired by the bamboo tree that is ubiquitous in Eastern culture. Nature shows through the rough textured pottery, the clay that gives ancient form, beauty, and color to the room.

Restful unity is attained in this place. If there is no separate room to call a bedroom, this room, in its functional simplicity, would serve. Draw up a few cushions, or a futon, and the living room is easily transformed into a bedroom. In an unseen corner, a copy of an eighteenth-century Japanese screen unfolds. The uncurtained windows allow light to cast shadows. This is Oriental Grace.

Expensive Hallmarks	*Decorating Rich*	**ORIENTAL GRACE: THE DECORATING RICH WAY**
Sliding screens and doors	Bamboo blinds mounted on the ceiling can be pulled down or up to give privacy or to partition rooms in same manner as shoji screens	
An expensive black lacquered table	A low, long block of wood covered either in black lacquer or in black vinyl: It's what you will put on the table that will catch the eye, perhaps some quiet art? (p. 139.) The table itself is merely a stage set for the tablescape (if it isn't obtrusive)	
Antique Oriental silk throw pillows on an expensive beige silk couch	Threadbare "obis," the traditional garb of the Chinese woman, often can be found in fairs and thrift shops. Use a wonderful pair of Chinese silk pajamas along with the good parts of the threadbare obis to make throw pillows. These can be Masterstrokes on an otherwise bland and inexpensive, neutral-colored couch. Another wonderful and quite inexpensive way to make Oriental throw pillows is from a silk scarf with a Chinese or Japanese motif	
Original Oriental paintings	A magnificent silk Japanese kimono or Chinese obi (either the whole garment or a remnant) framed in Lucite and hung on the wall: This lends a superb touch of Far Eastern elegance. Scrolls and wood block prints are also elegant	
Traditional Chinese carp swimming in an indoor sunken pool	A huge crystal bowl of water with a floor of rocks and two large, lazy goldfish swimming in Oriental splendor: Gives the tranquil "feel" of an Oriental fish pond	

Mahogany end table inlaid with semiprecious stones	Breakfast "slats" tray in neutral wood mounted on a lacquer or Lucite cube and used as a coffee or end table: Gives the "feel" of the Far East without the cost
Banquettes	Decorating Rich banquettes aren't very different from the expensive hallmark version: One may be covered in more lavish material but both make a rich point. Always low, used for sitting, eating, or sleeping, they can be constructed from cheap wood and covered in industrial carpet to match the floor, with big and small throw pillows for comfort. They're versatile (can even have lift-up lids for storage) and very Far Eastern in simplicity
An antique Oriental porcelain lamp	A Noguchi rice-paper lamp
An antique porcelain dish holding flowers in the traditional three heights	A flat glass bowl with black rocks on the bottom holding three blue irises (or other flower) caught in spiked "frog" flower holder
Tatami mats, fusuma walls, low, expensive, carved wood couches	Tatami, which can be bought cheaply, can cover walls, low foam cubes used for sitting-sleeping pads, even the floors! Accent with a stunning Noguchi rice-paper lamp. Or, install sisal in twenty-inch square (worn or stained portions can be easily replaced) on floors (and on walls as well)
A miniature indoor garden in a specially created floor inset	Long, arching-into-the-room bamboo plants or ficus trees give the illusion of an indoor garden
An antique hardwood chair	The peacock fan-back wicker chair, first brought from China to America by clipper ships in the eighteenth century, is a classic and a favorite Oriental touch: Organic, natural, and beautiful, it's available in reproduction (see Resource Guide)

Fail-Safe Tips for Achieving the Oriental Grace Look

Both the Japanese and Chinese, as well as other Oriental cultures, revere age and prescribed order as passed down from ancient ancestors. This is exhibited by ancestral paintings, the ages of the traditional bonsai trees, use of wood that has aged for centuries. We in America have come to appreciate the luxury of patina—the beauty of weathered barn siding and well-worn paneling or furniture—but the Japanese and Chinese take reverence for age one step further philosophically. They see the dignity and sadness of mortality; the ripening and maturing of people and objects that come with time. Therefore, Orientally splendid rooms will always display some object or art that is worthy of reverence because it is very old. Natural materials are best to illustrate this feeling: wood that has been worn away from years of footsteps, stones that are covered with lichens, bamboo that is weathered.

REVERENCE FOR AGE AND ANCESTORS

FAIL-SAFE TIPS FOR ACHIEVING THE JAPANESE LOOK

"Incomplete" is not usually considered terrific, but when it comes to Japanese design, the term takes on new meaning. By leaving something unfinished or unsaid by only suggesting nuances of what is not fully revealed, the observer is forced to finish it herself to complete the idea. This implies that the person who inhabits a Japanese-designed room becomes part of its life; every time she enters it she may see something new in the "unfinished" part. The incompletion then sustains interest. The room never becomes dull. Rooms, artwork, gardens—everything has space, has a part that seems fraught with meaning even though it is not crammed full with color and objects. A few branches in a corner of a painting might convey the sense of the whole tree. The absence of unneeded detail in a room makes a powerful statement. The suggested rather than the obvious is deeply Japanese. Like an iceberg, Japanese home design is twenty percent on the surface and eighty percent below surface, unseen but powerfully present.

UNSPOKEN ELOQUENCE

Whatever you do, don't think:

- High Tech, which is trendy and transient; Oriental Grace is constant as the sea
- Rubber, plastic, neon, fiberglass, Lucite—anything artificial
- Excessive
- Drapes, skirted tables, bold prints
- Very tall furniture
- Velvet

FAIL-SAFE TIPS FOR ACHIEVING THE CHINESE LOOK

FURNITURE

Chinese furniture has been largely independent of fashion and current trends, even Chinese trends. Although it is difficult to generalize, and one might write a history of the complicated differences within the various Chinese dynasties and periods, certain specifics always stand out, certain touches give a distinctly Chinese feeling. Every generation, I might add, finds its own China. When eighteenth-century Europe first opened its doors to Chinese trade, it was considered so exotic, so mysterious, that only the most extravagant designs, sprawling dragons, huge golden squatting Buddhas and multitiered pagodas were exhibited in wealthy homes. As trade opened up, and American as well as European homes became more familiar with Chinese style, elegant carved wooden furniture, bamboo furniture, exquisite porcelains, and magnificent touches of brass,

enamel, and semiprecious stones became more popular with those who considered themselves tastemakers. Today, the "new" Chinese furniture may include all of the above, but often in lighter wood finishes than the dark woods and lacquers traditionally associated with the Chinese.

I once had two clients who had very little money: Budget was the name of the game for them. They hadn't the funds to do much in the way of world traveling, but they'd saved

A bamboo chair,
intricately patterned

154

enough for an all-inclusive spartan tour to
China (a place about which they'd always
dreamed). They studied about the land before
they left and they thought about the kinds of
rich touches they wanted to bring home.
When there, they focused on purchasing al-
most immediately. Three hundred dollars
bought them a handmade Chinese rug. Fifty
dollars bought an exquisite cloisonné covered
dish. Another few dollars bought them a tiny
golden Buddha. Those items alone, they

A woven peacock chair

told me with glee, would have cost more than the entire trip had
they been purchased in America.

Which brings me to a nice point. If you're planning to travel abroad
(or know someone who is), save some dollars and shop! That's what
the rich do. There are certain items indigenous to other countries
that are mind-boggling bargains when purchased in their native
land. A Baccarat crystal decanter can be purchased for half the price
in France that it would cost here. Ceramics from Mexico, Portugal,
or France cost a fraction of their American price when purchased in
their land of origin. These special gems bring an aura of faraway
lands, opulence, and pleasure. They are written into the code of rich
decoration. If you're planning a trip anyway, make it pay off in your
home.

On to the nitty-gritty. When searching for Chinese furnishings,
consider:

Hardwoods: What we in the West call rosewood, a type of wood with
close grain and colors ranging from yellow-brown to various hues of

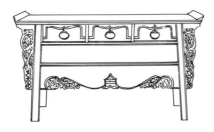

*A hardwood Chinese
altar table with
elaborately carved
motifs*

155

red-brown, is the Chinese wood of choice for tables, chairs, chests, and many stools. The chairs often have elaborately carved or cut-out motifs and are sometimes finished off with fine brocade seat cushions.

Lacquer: Sometimes the hardwood furniture is lacquered in cinnabar red or ebony black and often carved with varying motifs ranging from mythical animals (dragons, the phoenix, and strange birds) to misty landscapes. Sometimes the lacquer is inlaid with mother-of-pearl and semiprecious stone accents. One of my clients has a magnificent carved lacquer chest inset with sterling silver touches. Quite beautiful.

Metal Hinges, Handles, and Locks: Much Chinese furniture gives a special play to decorative and functional touches of copper and other alloys similar to brass and bronze. Circles, squares, rectangles, and undefined shapes provide finishing touches to chests, doors, cupboards, and other pieces. Good reproductions of vintage Chinese furniture will feature excellent metalwork; poor reproductions can always be spotted when the metalware is tinny looking. A mediocre hardwood chest can be transformed into one of luxurious beauty by installing good period metal hardware on it.

Elaborate metal hardware is typical of Chinese style.

Curved and Splayed Legs: Much of the wonderful wooden furniture (and reproductions) of Old China has legs that are gracefully bowed, curved, and splayed, in both inward and outward directions. I note that early Chinese thrones displayed this unusual but lovely touch,

and certainly the furniture of the people would be designed to emulate the royal touches. Chippendale tables often have the same curved legs (known as cabriole), clearly inspired by the Chinese.

Ball-and-Claw Feet: Much Chinese cabinetry is distinguished by feet that look like animal claws. It's traditional.

Chinese fabrics are extraordinarily rich. They range from the exquisite heavily brocaded silk pajama jackets (which can be made into pillows or framed in a Lucite box and hung on the wall) to the simple textured raw silks which can be used in upholstery or drapes to great

FABRICS

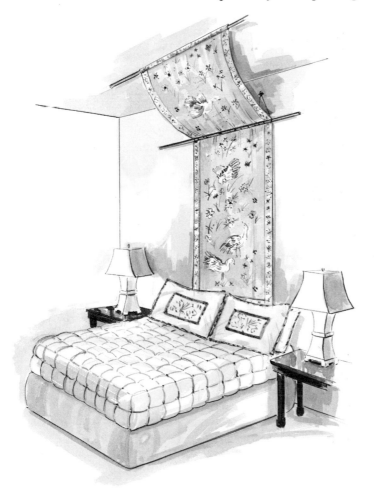

A fine piece of Chinese-patterned silk and two brass bars create a magnificant instant canopy.

157

effect. I particularly love hand-painted or printed silk or cotton in the clear colors and delicate story designs the Chinese do so well; it can be used in so many ways:

- Hang it on a rod, scroll-like, for art
- Cover a screen to use as a room divider
- Finally (my favorite), float it canopy-style on brass or wooden rods on the wall behind your bed. It evokes a dreamy, faraway mood and it's far less expensive than a traditional Chinese wedding bed

ALWAYS THINK COLLECTIONS

A tablescape is a wonderful way to bring Oriental elegance into your home. A collection of blue and white Chinese porcelain, for example —all massed, all with the same point of view—is a definite attention-getter.

Some other superb possibilities:

- Bronze Buddhas
- Lotus-inspired vases
- Ivory or jade carvings
- Fans
- White porcelain figures

The exotic, mysterious East has always beckoned to millionaires, adventurers, and intrepid voyagers to distant places. Traditionally, it was only the millionaires who could duplicate this rich look of enigmatic beauty. Now, anyone who cracks the code of Oriental Grace can have a home of intriguing splendor.

If your personality is in harmony with restraint and subtle nuances, JAPANESE GRACE is the Oriental ambiance with which you should dwell. If your personality is captured by the color, pattern, and intricacies of the Far East, then CHINESE GRACE should spice up your rooms. Perhaps a combination of both?

Decorating Rich, after all, is a matter of bringing the riches of the world through your own front door and the riches of the mystical East are legendary.

8

All Through the House

When decorating in rich signatures, elegant homes continue the basic point of view all through the house. This does not imply a slavish adherence to signature, but certainly the theme should be made clear when one opens the door and reiterated when one uses a bathroom or kitchen or when one simply passes through a hallway, particularly an entrance hall.

Here are some Decorating Rich tips for enhancing bathrooms and kitchens:

BATHS

- Try a small Oriental rug over a plain tiled floor for instant cachet

- Wallpaper creeping up the side of a tub, a hand-painted mural on a wall, or trompe l'oeil on floor or tub is wonderful

- Marble, Mexican onyx, or slate bathroom vanities: Sellouts of builders' overpurchases are often listed in newspapers. A carpenter can build, from cheap wood, a vanity around an old-fashioned sink and the slate, marble, or onyx slabs affixed to the cheap wood give instant status

- A small crystal chandelier is opulent beyond words!

EUROPEAN OPULENCE

CLASSIC CONTEMPORARY	• Graphic art (including posters) framed in good chrome or Lucite lends cachet
	• Stunning, sleek Italian chrome or Lucite faucets and knobs for High Tech sink and tub (and door knobs) lend clout
	• Built-in storage whenever possible (for makeup, laundry, and towels) lend uncluttered ambiance
	• Wall-to-wall mirrors with large globe makeup lights are spectacular
	• *Large* growing plants soften an antiseptic feeling
COUNTRY CHARM	• Paint an old linoleum floor with yacht paint, stencil country ducks or flowers around the edge, and polyurethane or varnish the whole thing
	• Use a pretty antique mirror instead of an ordinary medicine cabinet mirror
	• Stencil a design on the wall around a plain medicine cabinet
	• A small wicker stand can hold an antique porcelain bowl and pitcher
	• A collection of pretty hand mirrors can grace a whole wall
	• An old herb-drying rack will serve charmingly as a towel holder
AMERICAN PEDIGREE	• A tiny bathroom can be given American Pedigree importance with an antique wooden shaving stand that holds period shaving accessories (shaving brush, ceramic shaving cup, mustache comb)
	• An old pine chest of drawers topped with a marble slab adds authenticity
	• A white ironstone soup tureen is splendid filled with potpourri
	• A child's Windsor chair stacked with towels is charming
	• An antique mirror of the period lends heritage
ORIENTAL GRACE	• A black lacquered shelf creates an instant vanity: Place a small bamboo stool in front
	• Use a small Oriental porcelain bowl for a soap dish, or a larger one as a stand for a bonsai tree
	• Wood-block prints or Japanese scrolls can be hung in spartan simplicity
	• Try shoji screens on the windows or instead of doors

KITCHENS

- Use French, English, or Italian tiles on the sink backsplash
- An antique tea set in porcelain, sprouting fresh flowers from the pot calls for admiration
- Finish counter stools or breakfast chairs with appropriately tassled or fringed cushions
- Marbled shelves are elegant for cannisters and cut glass containers
- A collection of cookbooks featuring ethnic gourmet recipes (e.g., *Mastering the Art of French Cooking* by Julia Child) is a splendid touch

- Carry the High Tech look into everything utilitarian, from lighting to drain boards and trash baskets
- Stainless steel worktops are *de rigueur*
- Laminated plastic cabinets are sleek
- Black or gray grids can be used to hang utensils or cooking gloves
- Tables and chairs made from tubular steel and canvas give a clean, smart look
- Fluorescent lighting strips under cabinets provide efficient task lights
- Stark abstract art is stunning in the kitchen

- A small pine or stenciled dresser is wonderful for silverware or table linens
- A pine or oak refectory table can have a sheaf of wheat visible in an open drawer
- Colored country tiles on the floor or painted floor cloths are smashing
- An old wooden icebox can hold potatoes and onions
- A collection of antique tin cookie cutters, or Early American cookware make a Country Charm point

- A Windsor-type rocker in the corner can hold a turn-of-the-century bisque or rag doll
- Wooden storage cabinet doors can be painted or stenciled with American Pedigree motifs or murals
- A plate rack might display pewter plates

- A black wrought iron chandelier echoed by wrought iron draw pulls and kitchen hearth equipment are perfect pedigree
- A shelf of beautifully bound American history books adds a nice accompanying touch for that solitary cup of coffee
- A collection of copperware molds is useful and decorative

ORIENTAL GRACE

- Try wallpaper in Japanese earth colors of mustard, eggplant, terra cotta; rice paper or grass cloth wall coverings are great
- A bamboo-textured ceiling makes the point
- Lacquered serving trays are wonderful and stackable
- Straw place mats, lacquer or mother-of-pearl napkin rings are quiet grace notes
- A display of Japanese pottery, with or without flowers, fits almost anywhere

9

Making It Work

The Act-As-If Principle

Imagine a room filled with passionate, laughing voices, sparkling conversation, sophisticated fashion. Imagine the room growing quiet as one particular woman enters. She's far from the most beautiful woman in the room. In fact, her features are quite uneven. She's not a familiar movie star or socialite, but her attitude and self-assurance create instant panache. She speaks with warmth, she's in control— you just have to look at her. Her style gives the illusion of perfect features, great wealth, and wit.

The effect is a knockout.

The first step to looking rich is to stop being self-conscious. The same holds true for Decorating Rich. Only when you are able to act as if you deserve a richly lovely home, act as if you have high standards, act as if you know what you're doing—only then can you begin to decorate in the style you admire.

In order to acquire confidence, you must educate your eye. The cool, unflappable, stunning woman who quiets a noisy room is dressed with style, not necessarily with money. She pays attention to details. She's chosen her outfit with regard to appropriateness as well

as chic. Her look spells quality—even if not everything on her person is expensive. She's learned how to do it, how to educate her eye to fashion style. You can educate your decorating eye in the same way.

Educating Your Eye

ARM YOURSELF

I'm a great believer in folders—nice, clearly labeled folders, the size a lawyer uses. If you have a Color folder, a Fabric folder, an Idea folder, Living Room, Dining Room, and Lighting folders—you get the idea—you can't go wrong.

In these folders, you'll put the magazine photographs of specific pieces of furniture and room arrangements that you love, plus loose notes that relate to each subject, plus experts' names and sources you've heard about that relate to each subject. A casual friend tells you she's got the best couch upholsterer in the entire world. You're not ready for couch upholsterers, but maybe soon you will be. The name of the expert gets stuffed into the living room folder, along with all the couch photographs from *House Beautiful*.

While you're at it, alphabetize the folders and find them a spiffy place to live, like a file cabinet. File cabinets, by the way, belong in offices or hidden in large closets; they are never conspicuous when you are Decorating Rich.

I'm also a believer in notebooks for jotting down ideas and sketches. You don't have to be an artist to draw pictures. No one will see them but you (and your decorator, if you opt for professional help). Nothing like a quick sketch to jog your memory of the lamp that impressed you three weeks ago.

CHECK OUT THE REAL THING

Before you buy, give yourself an education in elegance. You must develop quality taste if you immerse yourself in quality. During this time of checking out, don't spend a dime—even if you fall in love with something. Your job is to become sensitive to what's good. You will reach the point (believe me) when by looking and touching, you

can select or reject what's rich looking and what's ordinary looking. You will be able to judge if a fabric, design, or style is:

- Timeless
- Comfortable
- Exclusive

- Fine quality
- Witty
- Appropriate

For the next couple of weeks, then, take a part of each day to do some of the following in your quest for an education in elegance:

Haunt the Museums: Most of the Decorating Rich looks have their roots steeped in history. If you browse with a purpose, note the way artifacts are displayed on columns, see the way the grain shows through a Victorian table, check out the color of patina, the quality of the tarnish of the ages—you'll know it when you see it in the flea markets, auction houses, and not-so-fancy antique stores. Just as you have to cultivate a taste for tofu or caviar, you have to cultivate a taste for rich elegance. You'll find your great copies of the originals when you are familiar with the real thing.

Visit Restored Homes: A visit to Roosevelt's Campobello, Jefferson's Monticello, or other elegant homes will give you an idea of original period beauty.

Visit Local Homes: Old and new elegant homes in your community are often available to visit on house tours. Many women's clubs and charities sponsor such tours for a small fee. These are usually listed in local newspapers under weekend events.

Check Out the Best Stores and be selective about their addresses— save the discount stores (many are listed in our Resource Guide) for when you're ready to buy. View the model rooms in the fanciest stores in your neighborhood. Don't be overwhelmed by the majesty of a display. Zero in on details: What's on that tablescape? How is the lamp placed—in the center of the table, or to one side? Break the rooms into component parts in your observing eye and focus on specifics: That's how a decorator observes a room, in small sections, layering detail on detail.

Make Friends with Antique Dealers: Most of them love to talk. Be respectful, and you'll glean whatever knowledge the dealer wishes to share. (Also, he may remember you when he gets in something good.) Antique shows and posh shops are further sources for self-education.

Don't Miss Decorator Showcases: Watch your local newspaper or favorite decorating magazine for announcements of decorator showcases. These are often held in wonderful mansions or historical country estates which the philanthropic rich have temporarily opened up to the public for reasons of charity. Within the great house, the public —for a small, tax-deductible entrance fee—will find many rooms, each decorated by either a world-renowned interior designer or a bright, young, up-and-coming professional. Their best work is available for you either to copy intact or to extract ideas from. The advantage for the decorator is that her work is exposed to a large public. The consumer can see the ideas of a dozen or more designers and perhaps, if he wishes, choose one expert to call on for his own home. The rooms are finished from floor to ceiling and all the accessories, even fruit and flowers, are produced as complements. I might add that decorators often visit these showcases to take inspiration from the work of other decorators.

Browse in Used Bookstores: They're the best. Many vintage books sport magnificent etchings and hand-colored prints: With wonderful frames, they could look splendid in your home. Remember—you're only looking and learning now. You'll return to buy later.

Wander Old Hotel Lobbies, a neglected source for educating your eye. The best of the vintage hotels display extraordinary creativity in furnishings and can give you superb ideas.

Really Watch Television: The art directors of shows like *Dynasty,* *Falcon Crest,* and *Hotel* thoroughly research rich decorating to make their points. Take advantage of their labor and take notes. You see the most stunning things in television living rooms.

Love Your Library—and Your Newsstand: Read, read, read. The

elite magazines that cater to educated and wealthy consumers are the best for your education. A magazine selling for ninety-nine cents at the supermarket may be trendy and have cute ideas, but it's not Decorating Rich. From the magazines, clip, clip, clip, and file.

Finally, Hit the Auctions: Tape your bidding finger down, but note the asking prices in catalogs and then note the actual selling price. This is a superb way to find out true value in a competitive market. If you discover that you can buy a small, silver Victorian frame for $50 at auction, why pay $45 for a cheap reproduction in a department store? Every auction is not the same. Famed auction galleries like Christie's and Sotheby Parke Bernet cater to unlimited budgets, for the most part, but it's not a bad idea to attend them even if you don't intend to buy, simply to educate your eye. Even in these high-gloss establishments, occasional bargains are to be found and you may be lucky. So, don't be intimidated. Go look at the preauction exhibition, which is often free of charge. Smaller auctions abound and at these houses, both in the city and in the country, contents of estates, single treasures and one of a kind relics are available. Record sample measurements in your notebook so you have a rough idea of size and scale to guide you with later planning. A tape measure should live in your purse.

TRUST YOURSELF

As you educate your eye, you'll begin to see what meets the standard for rich decoration, and what doesn't. If you've filled your eyes and sense of touch with wonderful examples of elegant decorating, you will not only act as if you were to the manor born, you will come to believe it. You won't be able to buy a tacky, tawdry piece of furniture: Something inside you will always hold out for the posh message. You'll recognize quality when you see it.

Taking Stock

After your self-education, you'll need to take stock and make some crucial decisions.

AFFIRM YOUR POINT OF VIEW

Don't leave home without it.

You must find a point of view (a signature), then stick to it. Call it a theme, call it a dream, call it a frame-work—whatever you buy from now on—carpets, chairs, or colors—ought to fit appropriately under the umbrella of your particular decorating signature. This is not to say that elegant homes stick slavishly to a signature, never venturing out into other looks—not at all. An Oriental rug, as we know, looks divine in every single signature. A sleek Lucite table could blend in quite well with an otherwise European Opulent home. But the emphasis, the large spaces, ought to be unified in point of view. The first giveaway of amateurish and cheap decoration is chaotic mishmash. Informal Country/Formal European is not a valid Decorating Rich signature. Avoid visual chaos: Have a point of view.

If you're about to decorate a home in the West and you've decided you're a Country Charm kind of person, optimally that point of view should be expressed in the art, the architecture, the fabrics—almost every part of your home. Dominances of terra cotta and white with accents of sand, stone, and wood and other natural western elements could be terrific highlights. Once you've taken the western Country Charm point of view, run with it, emphasize it, implement it. Don't invite velvets in, don't encourage lace and silver. They don't fit into your point of view, which is images of desert and country. Black, for example, is not a color that is compatible with your point of view. Neither is royal blue.

Things that are out of context are not suitable and they defeat a point of view. What do I mean by out of context? Simple. An adobe hearth in a Manhattan townhouse, Art Deco design in a New England farmhouse are out of context. Decoration that is not *appropriate* is not a rich look at all.

MAKE THE CHOICES: HOW MUCH MONEY, HOW MUCH DECORATING, HOW SOON?

The very next thing you need to do is decide how much you can afford to decorate, economically and psychologically, in the next few months. It is essential at this stage of the game to have a general idea of budget. This idea doesn't have to be inflexible, but a realistic figure

will provide a foundation from which to begin. If you haven't the funds or energy to revamp the entire house or apartment, work on only one or two areas. Plan on consistency throughout. An American Pedigree living room suggests that the spirit of Americana eventually pervades the rest of the house.

For now, though, make the first choice. How much? How soon? To determine this, you'll need to zero in on your budget no matter how modest in scope it will be. Answer the following questions in approximate terms. What can you spend on original purchases? What can you spend on refurbishing old pieces? What can you spend on remodeling the structure of the house? (If you don't plan to stay for a long while, better to buy quality furniture than remodel a kitchen for a new tenant.) NOTE: Even if you plan to move in the near future, it pays to spend a little money on the walls or floors of your home. Sometimes a paint job can raise the punch of a whole room or an inexpensive wallpaper border can not only make the difference between a rich and poor look but can bring up the whole image of the house for prospective buyers.

After you determine an approximate budget for yourself, determine your priority choices. What room should you do first? (Do you expect to entertain a lot? The living room gets priority. Is your psyche Number One? The bedroom gets done first.)

Find a point of view. Make your choices on budget and priorities. Then,

TAKE STOCK: WHAT ARE YOUR GIVENS?

"Givens" are those items you already have that are definite "keeps," and also those that are possible "keeps." You're about to begin a no-nonsense appraisal, an essential step in the quest of a richly decorated appearance.

This takes courage.

Look around. Assess what you have. What can be revamped and rescued and what must be discarded? If you are sure that what you already own will fit into your Decorating Rich signature, keep it. But please don't retain something too wrong, too big, or too ugly because of inertia (that state that makes you incapable of making the decision to discard).

Let your eye alight on the table you've always hated, the lamp that was all right but nothing special, the painting your mother gave you that you know is good but, well, uninspiring. Be ruthless. Give away or sell these things. Don't, however, be rash. If you suspect paint or carpentry might resurrect an undistinguished armoire or chest, ask your best friend to store it in her attic while you decide if it will fit into your scheme. Think of it this way: It is better to live for a while with an empty living room than with a wishy-washy living room. A chair that might have possibility reupholstered or recovered is a "maybe" and should be put aside in a spare room, a parental attic, or in storage space you can rent for very little money. But junk goes out. Part of the excitement of a new beginning comes from the purification process of discarding. If you are truly serious about Decorating Rich, get rid of the Dreadful Yellow Flowered Mistake. Discarding is probably the most difficult part of what you're about to undertake.

Now, look around again. Let your eye alight on the few treasures (there may be none) you've managed to accumulate in your life so far. Rooms rarely spring full blown like Eve from Adam's rib and one exquisite piece can be the basis for the new room or color scheme. Somewhere in your travels, for instance, you bought a tiny but gorgeous Indian throw pillow. Or Aunt Anna left you her favorite Limoges dish and the colors of that dish make you feel happy. A room and even a home can be created from the inspiration of a single object or idea. A collection of jade elephants can be the starting point of a bedroom and provide the character of a new home.

If there is one warning in all this, it is to be reasonable. If you can possibly envisage another life for a piece of furniture that may just need a coat of paint or refinishing, don't junk it forever. Prudence pays off. But if in your heart of hearts you are certain that you'll never love the clawed coffee table, well, the Salvation Army will love it. What you should have no problems with are the cartons, old file cabinets, and makeshift storage chests that seem to have always been sitting there in the corner. *Out! Now!*

MAKE THE MOST OF YOUR GIVENS

Keep this in mind: You will want to build on the furnishings you've kept. You will want to make them look special. Eventually, you will enhance the piano by adding an antique wooden music stand and

you might even hang framed prints from a very old book of music. If you've kept the nice brass bed, eventually you can cover it with a vintage patchwork quilt and hang an "ancestor" on the wall for your American Pedigree look. Givens can also include focal points that can be "natural"—the fireplace or a view (which is the reason you place your furniture there) or a point you create, like a media center or a large, important painting you wish to occupy center stage. Get maximum mileage from reasonable givens that you can keep through changing homes and times.

CONSIDER THE ARCHITECTURE

Architecture is also a "given." Study your home with a critical eye to note the built-ins, the forms and features of the room with which you're working—and work around them, if necessary.

The Windows: Will you need to cover them for privacy? Will you want to dramatize a great view or hide a terrible one? How will the seating plan augment the view? It's interesting to note that in conversation, people rarely look at a view but only at each other. Therefore, a good seating plan might be to have people face each other, not the window, and then, draw attention to the great view by the adroit placement of an interesting piece of furniture or art.

The Fireplace: Do you want to make it a focal point by placing furniture and wonderful containers of kindling or fireplace tools beside it? Or is the fireplace an eyesore? Is it painted a distinctly "unrich" color? Can it be restored with reasonable cost?

Wall Architecture: Moldings, exposed beams, columns, wainscotting, chair rails—such details add interest and give authenticity to your decorating signature; on the other hand, a certain architectural detail might be antithetical to your signature and thus might have to be transformed or removed. For example, exposed wooden beams on the wall or ceiling would not be suitable to a European Opulent signature. On the other hand, if your walls and ceiling are quite barren, you might want to add appropriate architectural interest— eminently doable for very little cost.

Doors, Closets, Walking Patterns, Outlets: Check them out; will they interfere with furniture placement or access? Can you hide your extension cords? Will you be able to open your breakfront to get the silver if a guest is seated directly in front? Will an opening door bop a chair's occupant?

Storage Space: The rich always have a place to put everything. Now is the time to consider ways to expand drawers and closets and utilize existing and possible storage space to maximum advantage.

Aloneness: Everyone needs, if not a room of her own, at least a breathing space of her own. This is a definite Decorating Rich principle. Consider the life-styles of everyone who lives in your home and how you can enhance them by adding work, hobby, or reading and thinking space. Sometimes, only a few feet in a corner will do the trick. Sometimes, a large room can be divided, by an impermanent screen or a more permanent wall, into two smaller rooms. Find a bit of privacy for each member of the household.

The Decorating Process

Now comes the fun part. You've taken stock—you're ready to start. What I'm about to tell you now is the process that every good decorator uses.

THE FLOOR PLAN

Take a yardstick and measure the room (or rooms) to be decorated, then make a map.

You are going to draw a rough view of an empty room as if you were suspended in air and looking down upon it. If you are a perfectionist, draw it on quarter-inch graph paper, where each square can represent one square foot and the rest of your measurements can be approximate scale. If you are not such a perfectionist, use a plain, large white piece of paper.

Room Map

The ideas in these plans should get you started arranging your rooms creatively. Keep in mind that one part of a setting for a large room could be used in a small space, if that's what you have to work with in your own home. Also, pay attention to lighting. A ◯ indicates an area where you need a floor or table lamp; a ⌓ means a pin-up wall lamp might be handy; and a ◌ means the area calls for an overhead, recessed, or hanging ceiling fixture. Pay particular attention to how you will plug in lighting. Remember extension cords can be safely run under furniture and carpets to provide lighting away from walls. Cords lying in corners, hanging down walls, or in non-traffic areas can be concealed by placing plants or accessories in front of them.

Lighting is one of the most important elements in a successful room. Floor lamps, table lamps, and hanging fixtures can provide general illumination as well as task lighting. Wall sconces, picture and bookcase lights, ceiling and floor spots, and track lighting can provide important, decorative accent lighting. Awareness of the wide variety of lighting sources available will help you improve the function and mood of your rooms.

Formal Living Room

This large, gracious living room lives up to its potential by inviting relaxed conversation and the enjoyment of music. The decorative screen (A) serves as a backdrop for a pair of comfortable sofas (B) and a pull-up chair (C). Two wing chairs (D) sit by the fire with a low tea table (E) in between. The rear of the room houses a grand piano (F), with a settee (G) and chairs (H) conveniently placed for listening. The fireplace is flanked by tall built-in bookcases, and antique pieces (J) along the walls balance the room. Area carpets further define the space.

Reprinted with permission of Janet Alcorn, Decor-Aide Space Planner Alameda, CA 94501 415-521-4442

173

- Indicate the length of each wall, where the windows and doors are and in which direction they open
- Indicate each closet and electrical outlet
- Indicate radiators and other heat or air-conditioning supply sources
- Indicate wall or ceiling-hung fixtures that will probably remain
- If there is an architectural element in your room around which you must plan, like a column or a fireplace or an odd-shaped wall, be sure to include it on your sketch
- With small neat numbers, just as you've recorded the length of each wall, record the size of each window in its place on the sketch. You'll need the outside height and width of the window, its distance from the floor and from the ceiling, and the inside height and width of the window (from the beginning of the frame)

Don't be neurotic about this drawing; it doesn't have to look like an architect's rendering. No one but you (and perhaps your decorator) will ever have to see it. But to be usable it should be neat, the annotations small and outside of the floor area.

When you finish your room map, it should be an accurate rendition of a room without a stitch of furniture in it: All you should be able to see are the architectural and other permanent givens of the room.

Now, take a pencil and draw little patterns of the "missings."

You have before you a room with all its givens. What are the "missings"? Chairs, couches, tables, pianos, lights, rugs, bookcases, cabinets . . . all those items of furniture you've been planning to buy —right now or eventually—*plus* the few things you already have that you plan to keep.

On a heavy piece of colored construction paper (oaktag is good), draw a series of small, different-shaped patterns to represent the different pieces of furniture you want—chairs, tables, dressers . . . whatever. (In other words, a couch doesn't have to actually be a tiny couch picture but perhaps a rounded or rectangular pattern to represent the shape of the couch you think you'll eventually purchase.) Then cut out the shapes. It's important that the furniture patterns be in the same scale as the floor plan. If they're too big or small, you won't be able to tell what will work.

Since you are not an architect, your sketches will have to be approximate, but use your good sense. A pattern of a night table will

not be as large as the bed pattern. You need relative sizes of things to give yourself a visual image of a room that's not yet invented. The more exact you are, the clearer the image will be.

Make sure you note, within the tiny pattern, the approximate size of the item to be placed in the room: You will get its size by measuring the approximate space available for the piece. For instance, if the bedroom wall that is to accommodate the bed is only twelve feet long, and you know you must leave room for night tables on either side of the bed, then your bed can realistically be no larger than a certain size. When you are out on the actual purchasing path, you must know measurements. Imagine buying the most magnificent armoire in town, watching two burly deliverymen wrestling it up the stairs because you've forgotten to measure the apartment house elevator, and then—the awful realization—it cannot possibly fit!

NOTE: If all of this sounds a bit complicated there are commercial kits available to help with pattern making and space planning; the one I like best is

Decor-Aide Space Planner
1147 Verdemar
Alameda, CA 94501
415-521-4442

A room-planning and furniture-arranging kit, including 700 punch-out furniture symbols.

Now—play.
Spend a few days pushing your patterns around. Do you think your couch should be in a corner? *Wait* a moment! What's so terrible about placing it in the middle of the room—something you never thought of before. Hey! It works! Then, the two chairs could go right here . . . And, so on.

As you play, if you're catching on to Decorating Rich, you'll see that there's something big that must be taken into consideration on this room sketch: what I like to call a civilized comfort plan.

The best kinds of rich folk are highly civilized (although I've known some who weren't). One of the hallmarks of civilized wealth

**THE CIVILIZED
COMFORT PLAN**

175

is the instinctive provision of comfort for self and guest. Rich decorating pays attention to civilized comfort in dining, traffic patterns, conversation areas, and the all-around smooth operation of a home. This specifically means that as you play with furniture patterns on your rough sketch, you should make very sure that:

- *In the dining room*, there will be
 —comfortable room at the dining table for as many adults as you usually need to seat
 —room behind the table for a guest to get in and out of a chair (at least 2¼ feet)
 —room on the table to serve each guest
 —space to put a buffet or other serving piece to hold trays and other dining necessities

- *In the living room*
 —the placement of the coffee table allows guests to comfortably rest their feet on the floor as well as move a bit (you need at least eighteen inches)
 —your guests can comfortably view a wonderful view—if there is one
 —seating for desks or pianos is easily accessible
 —chairs and couches are placed in U-shaped conversational groupings
 —you're quite conscious of where you'll need good lights, even if you don't yet know exactly with what lighting fixtures you'll end up

- *In the bedroom*
 —there's room on each side of the bed for easy and safe getting in and out
 —there's comfortable table room for books or snacks
 —closets and dressers are arranged so roommates or spouses won't trip over each other

- *In studies or dens*
 —there's room for a bar or bookcases
 —there's room for working and relaxing—comfortable seating? a place to lie down?
 —there is an abundance of task lights well placed for comfort
 —there's room for electronic equipment of your choice

- *Traffic patterns are unobstructed:*
 —are entranceways cluttered with furniture?
 —are passageways and vestibules well lit?
 —can guests move smoothly from hors d'oeuvres to dining table?
 —if you usually serve food buffet style, is there room for easy access to plates and foods, and an easy return to a place to sit?

- *Telephone outlets and appropriate wiring for lighting:*
 —decide where you'll want lighting and telephones before you begin to
 decorate and arrange for wiring terminals

As you play with your room map and the small, movable cutouts and
as you think about civilized comfort, you'll begin to get a clearer idea
of the furniture and arrangements most akin to an opulent look and
a personally satisfying life-style. You'll also get a stronger sense of
what will realistically *fit*.

Perhaps you'll feel disappointment. The three-piece sectional is
simply not going to make it—not if you want your antique love seat,
as well, and that's a *must*. It's time to go back to your pictures, the
myriads of photographs you cut from decorating magazines as you
were educating your eye. Find alternative possibilities. And don't
forget: You haven't yet gone out to buy. Somehow, when you're
ready, really ready, all kinds of new potential arises.

Now, armed with an educated eye, a general idea of signature, a
floor plan and an overview of the givens and the missings, and folders
filled with pictures and notes of possibilities, you're ready to

COLLECT SAMPLES

You will need a large compartmented envelope or briefcase. You
will be collecting color and fabric swatches so that when you begin
to buy, you can match them with paints, tiles, carpets, and a host of
other possibilities.

Visit the great fabric houses, the local fabric stores, and the smaller
fabric departments found in most department stores. Pick out some
possibilities and ask for swatches. From the museums, the maga-
zines, the house tours, you've established a general sense of what you
love, and what best fits in with your point of view and your decorating
signature. Even if fabric houses are only "open to the trade," many
will allow you to browse if not to buy, and many will provide swatches
upon request. Keep your needs in mind—don't collect material cra-
zily and indiscriminately. This is an opportune time to start paring
down.

**BE OPEN TO
ALTERNATIVES**

Visit the wallpaper stores next. You're still taking information in, not buying. Show the salesperson some of your fabric swatches and ask to see wallpapers that might blend beautifully. Don't be close-minded or stubborn. Sometimes an expert can see a splendid coordination in an unlikely match. Give it a chance. Live with the idea and the sample for a while. Get expert opinions from your best-taste friends (and from your decorator, if you have one. If you have a decorator, she will certainly bring samples to you or, if you prefer, accompany you on your forays). Collect marvelous wallpapers and file them in the appropriate folders. Remember, forget "cute"— think Regal, Elegant, Rich.

Next, visit the flooring stores. Also check out rugs, tiles, vinyl, wood at the lumber yards. Many dealers will be pleased to supply samples to match against your own floors—squares of rugs or vinyl, for example. It's a good idea to bring your fabric and wallpaper swatches with you so you can confer with the flooring people about coordination.

Finally, collect color. Collecting color is a large part of preparation. Even if you've not yet made many color decisions, and your fabrics, wallpapers, and flooring are in rainbow pandemonium, it will come . . . believe me. Take your collections to the paint stores and ask for free coordinating color chips to blend in with your other samples. Keep your point of view in mind but don't let it paralyze you. For instance, Oriental Grace doesn't only embrace carnelian reds but also a wonderful amalgam of browns, blacks, tans. Be open-minded. Use the color computers available in the most modern paint stores. If you feed a swatch of material or a color photograph into such a computer, it will break down its varying elements and formulate exact paint matches.

If you're really stymied about possible color combinations for your room, try these suggestions:

• Find a painting you admire, one that blends in well with your signature. You don't have to love the subject; if you admire the colors, buy a postcard or a poster reproduction, study it at home, and then let it inspire you in fabric or paint choice

- Check out the world around you. Color harmony may be found in the parts of a single flower, a section of woods or field. Consider the colors in a single sunrise, the beach, the desert

- Do you have an Oriental rug or a blanket you adore? Perhaps its colors can be used for your room

- Buy ten dollars' worth of fruit and vegetables or flowers. Arrange them endlessly until you find an appealing color group

- Check out your closet. What looks good on your person may not be terrific for your home, but it's a clue to your favorite shades

Your choices at this stage may be eclectic, but don't worry, there's time to narrow down. Collections always get narrowed down; it happens all by itself in almost every case. I once had a client who was wild with color anxiety. It didn't seem as if we'd ever be able to take the fear out of decorating—as if she'd ever be able to select a signature with colors and textures. Finally, as she made her rounds collecting, putting great but different combinations into her folders, she found she was collecting more tans and beiges, fewer and fewer blues and greens, fewer and fewer purples and reds. Many grays. It just happened. The colors and the combinations chose her, after a while. She'd educated her eye and pared down without even knowing it and the tans, beiges, and grays turned out to be the best, richest Classic Contemporary look—one for which she was born!

THE PARING-
DOWN PROCESS

This is the same paring-down process another client discovered when, after a six-week self-education, she found she had a file chock-full of pictures of sleigh beds and white lacy linens. She wasn't even aware that she kept cutting out the same bed, over and over. In this way, she found her European Opulence bedroom.

To sum up: Collect samples of wallpapers, paints, floors, and colors in many combinations that feel comfortable. One day, spread out all your colors on the floor. Separate them into reasonable families. Many will be duplicates, but don't worry: You are zeroing in, refining your tastes, marrying the color and texture combinations that until now have been floating aimlessly in your consciousness.

Finally, refine the collections. Pare down. Throw out the erratic choices, the ones about which you say, "What could have been in my mind to choose *this* monstrosity?" Put the doubtfuls aside. Then make a final folder in which you keep only those members of the

collection that make your heart zing, that reflect your signature. This is *it*.

THE SCOUT-OUT

If you were asked to define good, rich taste, you might have problems with the words, but if you've followed my plan to educate your eye, I'm willing to bet you wouldn't have trouble spotting it.

Someone once asked the late Fats Waller, "What is swing?" He replied, "Boy, if you gotta ask, you ain't got it." The same goes for good taste.

Do you have to be born with it? Purists might say yes, but they'd be wrong. Swing, clothes sense, decorating sense, taste: They're acquired.

You've acquired an eye for the look of rich decorating. The last step before buying is a reconnaissance to survey what's available for purchase. Go out on the shopping trail to scout out the $600 Chippendale reproduction bureau that comes closest to the $10,000 number you saw at the decorator's showcase. For your Oriental Grace signature and own satisfaction, try to find the Chinese screen that is not rare but is still wonderful—and affordable. Consider these scout-outs as practice runs. Test yourself. Look at a chair in a really shoddy shop and explain to yourself why it's terrible after examining the upholstery, fabric, seams, design, and color.

It's a good idea at this point to go on a nonpurchasing, "just looking" scout-out with a mentor—someone whose elegant taste you admire. Find out his or her reasons for liking or rejecting something, and bounce yours off, as well. Trust your own judgment now. It's pretty solid . . . probably as solid as most professionals if you've been reading carefully.

When you reach home after a scout-out, and you've taken the measurements of specific appealing items, do this:

On a large roll of plain, brown wrapping paper or newspaper, as best as you can, draw the couch (or chair, lamp, footstool, or table) *life size*, then cut it out. Place the paper where you envision the piece will go. See if it is in scale with what's already in the room and what you hope to add. Walk around it, allowing access where required.

Does it look good? Then it's a clear possibility.

Quality Control

You've educated your eye, made your floor plans, and scouted out what you want, and, at last, it's time to buy. Now it's time to talk about quality control.

It's the little details, the construction of furniture, choice of color, flooring, and art that require attention to quality. Sometimes, one must opt for excellent quality, making no compromises . . . and I shall explain this thinking when I tell you about Oriental rugs, on page 187. Other times, providing rich details on and around not-so-rich larger objects takes the observer's eye off the mundane and onto the richer, smaller detail. You might say the tail wags the dog.

Let me give you an example: For one client decorating on a budget, I ordered a simple, inexpensive white couch, far from the best quality of upholstery, far from the best quality of cotton. The very best that could be said of it, in fact, was that it was innocuous. And that was precisely what I wanted because I also ordered for the couch absolutely fabulous, huge throw pillows. They were covered with beautiful Ralph Lauren sheets and constructed with an interesting gathered welting which drew attention away from the inconspicuous couch. There's nothing terrible about the couch; it's a background, soft and unnoticeable. However, although far from costly, the couch combined with the pillows gives the impression of rich. In that same client's living room, we dealt our Masterstroke: an authentic French Directoire table in marble-topped tulipwood which the client had inherited from her grandmother. Next to the palatial table, we placed a good reproduction of a French Directoire chair and on the other side of the chair, a $49 sleek, little Parsons table, painted with a faux marble finish. Near the Parsons table, we placed good reproductions of a pair of Louis XVI giltwood torchères we found covered with the dust of the last twenty years in an offbeat antique shop. It worked phenomenally well! The room with the almost-cheap couch, Parsons table, and French reproductions next to the one genuine antique and flooded with fresh flowers exuded High Style and all for under $2,000.

THE MORAL: If you must sacrifice quality, don't panic. The ambiance of the best is always possible to achieve with something less than the best.

Isn't it great that you've educated your eye to know what true quality looks like so you can find a great facsimile of it? These are the things to look for:

ATTENTION TO DETAIL

In every signature, attention to detail makes a big difference. A meticulously crafted door knocker faithfully reproduced to mesh with your particular point of view (a fierce brass lion for European Opulence, a sliver of chrome for Classic Contemporary, a black wrought iron pull for American Pedigree) gives a message of elegance before one even steps over the threshold.

UPHOLSTERY

If you can't buy the most expensive couch, here's how to find one that is an excellent reproduction of a high-quality piece. Look for:

- *Straight seams and welts* (the ornamental finish covering the seams)

- *Fabric cut to match the frame:* Corners should be square when they're square and round when they're round, with no empty gapping space (as when a square corner is placed on a round pillow)

- *Matched patterns:* Flower or other design motifs must be repeated in proper continuity. One out-of-place leaf will grab your attention, forever.

- *Comfort:* If there was ever a sure giveaway to rich, it's comfort. Most decorators know that what's inside a couch counts at least as much as, probably more than, what's on the outside. Opulent, sinking-into, pure down is my favorite filling; feathers and down are the next in luxury. Combinations of down work well. You can buy upholstery filling in wholesale or discount stores.

- *Appropriate fabric:* Heavy velvets and damask look distinctly nonrich in a country atmosphere.

- *Durability counts most* when a fabric will get heavy wear and closely woven, heavier fabrics will look infinitely richer than even the finest fragile silk or cotton that is shopworn and damaged by the traffic. Heavy raw silks are extraordinarily choice. Other animal fibers like mohair and wool as well as vegetable fibers like cotton and linen, and even some well-made rayons can be wonderfully luxuriant as well. The combination

of weave and fiber determines the beauty and durability of a fabric. One other thing: You have to like the way it looks and feels. If it feels itchy, it's not rich.

Some caveats on upholstery:

1. Loose pillows are the acme of comfort and luxury. If an upholstered piece has rigidly-attached pillows, it's not nearly as wonderful.

2. If you find a fine piece at an antique shop with damaged upholstery, consider a great slipcover!

3. Upholstery skirts should fall to the floor: More fabric is a richer look. If you have a piece custom made, order extra material. You'll use it on something to "pull your room together," I guarantee it.

COLOR

The rich find color identities that to them spell elegant. Red is Diana Vreeland's signature. When famed decorator Elsie DeWolfe saw the beige Acropolis for the first time, she said, "It's my color!" By the many tricks color can play, by the extraordinary beauty it bestows, the entire concept of rich decorating is served. As you learn to control the quality of your furniture, you must also learn to control the quality of the color in your home. Garish, poorly applied color can destroy everything you are trying to achieve and, in contrast, quality color can enhance it.

Monocolor: You can choose one hue and use it in varying intensities, and in different fabrics and patterns. A Country Charm home could use variations of great pinky-rose cabbage roses with pale rose walls, a rose/lime crewel rug, a rose floral stencil border around the walls, a rose chintz fabric on the plush armchairs; rosy botanicals on the wall. The lime-green accents come in short, unexpected zaps—not large clouts of color.

Color Links: Pattern can overpower, so avoid too many color patterns. Still, patterns can be linked by having a color in common—azure-blue stripes and azure-blue florals, for example. If the colors are the same, the designs and scale can be different.

Color Coordinates: Quality looks are also derived from different hues that agree with each other. Pick a color scheme from a print fabric that you love—a dress or a quilt; or pick a scheme from a painting or an Oriental rug. The largest amount of color will be the dominant color in your room, used for the walls, ceiling, or floor; echoes of this color will be felt throughout the room as you decorate. The next most important color can be used for large pieces of upholstery, echoed again in smaller touches. The brightest colors in the scheme you've chosen will be your accent colors, used in art, throw pillows, and other small dashes. Never use a color from a scheme just once: It must echo somewhere else.

Neutral Colors: Neutrals, contrary to rumor, are not boring. Contrary to belief, neutrals are not just white; they come in beiges, browns, grays, "greiges," mushrooms, chestnuts. They're calm, restful, rich looking, elegant. Neutrals serve as backgrounds in floor, walls, and ceiling, and lend themselves to being built up in tones and varying textures.

Black and White: Black and white have crisp, clean graphic appeal, particularly exciting in the Classic Contemporary signature. A black and white tiled floor in an all-white room can be nothing less than spectacular. Black lacquered furniture with white cushions, severely framed in black artwork, and echoes of black and white throughout make a statement with a capital S. Add another color to black and white—just one, so as not to take away from the excitement—and you have another powerful infallible.

Just Fabulous White: Plain old white is never plain. White gives rich messages of assurance: No wonder that weddings, the White House, and vanilla ice cream are such staples of white in our lives. White makes things that are not so wonderful, quite wonderful. Cheap woods, for instance, take on freshness and charm when painted white. An old wrought iron mirror becomes a touch of luxe in white. If you couple inexpensive painted furniture painted white with or-nate, baroque accessories, the look is pure elegance. If you paint a metal thrift-shop bed white and pile it high with crisp, white linens, it becomes a bed of luxury. Unrelated furniture, inherited or picked

up at thrift shops, becomes charmingly united when white-washed; upholster the seats of eight different white chairs in the same fabric, and they're worth a fortune in luxury impact. Can't afford a great bed? Tile a cheap wooden platform in shining white, put it under your mattress and spring, again piled high with great antique-looking linens, couple it with a few dark Old World type paintings and old leather-bound books—and you have a *look* in your bedroom.

Color It Big: Light colors make rooms look larger. They tend to "erase" corners. Light colors on ceilings have the effect of raising them. Light, unbroken expanses of floor color them larger than they are.

Color It Small: By the same token, sometimes one wants to make space seem more intimate and warm. Dark colors do this trick. Ceilings seem to lower when painted darker than walls. Too-long rooms become more balanced if the long walls are painted in dark colors and the shorter walls in light.

Color It Out: Darkness makes loathed objects seem to disappear; deep, dark shades over an ugly radiator almost paint it out of the picture.

LIGHTING

Quality lighting counts more in the decorating scheme than you'd believe possible. Highlighting the one really expensive thing in the room, soft-glowing areas that you don't want to stand out—the most extraordinarily rich effects come from elegant lighting.

In the finest homes, lighting is broken down into four categories:

1. *Task lighting:* This is your reading, sewing, cooking light.

2. *Highlighting:* The special-effect lights that say Look! when spotlighting art or specific furniture. You'd better make sure you're pointing to a worthy place.

3. *Background lighting:* Diffuse, shadowy, atmospheric lights behind valances or cornices or in recessed fixtures in the ceiling.

4. *Status lighting:* Crystal chandeliers, exotic and costly urns transformed into lamps, era originals (Art Deco or Art Nouveau forms, for example). Chandeliers, by the way, must be big: Small, dinky chandeliers are often cheap looking.

Wisely placed light can serve as architecture as it separates furniture groupings and defines and changes spaces. Your best friend? A knowledgeable person in a good lighting store.

Balance when using lamps is essential. Ornate, statuesque lamps look silly in tiny apartments. Squat, little lamps look foolish on large tables. Lamp shades that are the wrong style for the lamp or too big or small or that are crafted from cheap paper take away from a luxury look.

Two absolute truths:

1. Lights that flicker belong in discos not homes.

2. Do-it-yourself "Tiffany" lamp shade kits never fooled anyone.

Consider installing dimmers: They lend texture and elegance to a room's look. Few rooms should be lit to the same intensity all the time and dimmers provide mood opulence.

Finally, the classic bases for lamps that are always rich-looking? It's hard to go wrong with architectural columns, candlestick shapes, and Oriental vases.

FLOOR COVERINGS

There are almost unlimited choices for floors: soft-surface materials like rugs and carpets, man-made hard-surface materials like tiles and vinyls, and natural hard-surface materials like woods and marbles. If none of these makes you happy, there's a wonderful world of paint and stenciling which is not technically floor covering but floor transforming.

On the floor, good taste and quality material can't be separated. Since floors are subject to such wear, poor quality and inferior workmanship take no time at all to show their seedy surfaces.

Floors shouldn't be fragile unless they are just for looking at. It's hard to live comfortably in a home where one must flutter with butterfly feet on an art-masterpiece floor.

Floors shouldn't shriek. They're too big and too obvious to demand all that much attention.

Here are some basics about quality control of floor coverings:

Carpets ought to have character. For the most opulent and luxurious look, all-wool can't be beat. Beware, though: You can be shown a "bargain" all-wool that is indeed all wool but, because of its poor and loose construction, is no bargain. The density of a carpet is the best indication of quality. The deeper and denser the pile, the finer and more long-wearing it will be. Bend back a corner of the carpet to see how much backing shows; the more backing visible, the less fiber there is to walk on and look plush.

Excellent synthetic blends are available today for far less money than you'd pay for good, all-wool carpeting. The best synthetics are usually good looking, quite strong, and cleanable. However, if you choose a synthetic, no matter what texture (looped, high pile, soft velvety finish), make sure that it doesn't have that shining, giveaway glint of cheap synthetic.

Define space with area rugs. Choose interesting textures and fine design which can, like a good painting, set the mood and theme of a room. The standards of good carpeting can be applied to rugs. That is, go for the wool, if possible, and the tightest, densest weave. All kinds of wonderful rugs are available: European Opulence looks marvelous with a zebra print; Classic Contemporary loves sophisticated dhurries that range from primitive to highly styled geometrics; Country Charm loves mellow, woven hooked rugs. Every signature loves Oriental rugs.

Orientals: An Oriental rug is a real investment. For my money, there is no rug more rich looking, more useful in every single signature—especially European Opulence—than the classic, aristocratic Oriental rug . . . the real thing, never a machine-made copy, which is dreadful. The designs (there are myriads of them), warmth, and color of an authentic, hand-knotted Oriental rug lend instant class to any decor. They can be used anywhere, in any part of the house, and they are smashing, even with ultra-modern glass and steel interiors.

Oriental rugs are not just floor coverings, but art forms that date from 3000 B.C. Antique (the most costly) and new hand-knotted Orientals can be found at auctions for a fraction of the price (given your luck) that you'd pay in a retail store. There are many types of Oriental

rugs—Persian, Turkoman, Caucasian, Chinese, Indian, and Turkish, to name a few—and the first thing is to choose colors and patterns that please. All true Orientals are made by hand with the yarns knotted through a backing made of linen and cotton—the more knots per square, the better the quality. The clearer the color, the better the quality. It's important to buy an Oriental rug through a reputable dealer or auction house since the art of this weave is so complicated, it can become a life's work to spot the best, or even the next to the next to the best.

Unlike other types of decoration, with Orientals there is no such thing as cachet in a copy. There *are* no wonderful copies. If you decide to go for this type of floor covering, shop and shop until you find the real thing at a price that won't break you. Just like diamonds, they increase in value as the years pass.

WOOD FLOORS

Marvelous wood, gleaming with the sheen of the centuries (or with terrific polish that *looks* like the sheen of the centuries) fulfills the current trend to opulence. If your floors need work, ask at the lumber yard for an experienced flooring person or check the local newspaper for flooring services. The local art schools may also be able to suggest a talented student who can install a new floor or refinish or paint an old one.

Some specific suggestions for unique, rich-looking wood floors:

- Have dull or damaged floors sanded and refinished to restore glow

- Wood floors can be stained in different shades: Color-cue them to the woods of the room

- Parquet is always in good taste and can be purchased in varying thicknesses. It is a clear mark of status and not that difficult to install

- Wood also comes in wide plank strips for Country Charm floors

- Bleached wooden floors, sanded first, are an alternative to the dark-wooded versions for a lighter, airier look. This kind of floor works nicely in the Classic Contemporary signature. My suggestion is to keep the same floor look throughout a level, to maintain an unbroken and free-flowing line

- Paint checkerboard or stripe patterns following the grain of the wood that either picks up other colors of the room or is in a classic black and white for a wonderful Country Charm appeal

• A stunning look is a wood floor painted white (which can hide flaws in a cheaper wood). TIP: Boat deck paint is the best paint of all because it doesn't turn yellow when polyurethaned

NOTE: All painted or stained wooden floors, incidentally, need several coats of clear finish like polyurethane.

Ceramic tiles and vinyl tiles, good ones, can be bought at discount prices or as seconds (no one but an expert will spot the tiny imperfections) for a fraction of the price you'd pay in a retail store. They wear like iron, need little maintenance, and with the right choice in the right place, look fabulous. Black and white tiles laid in stark checkerboard grids are simply stunning, and I've seen the most elegant homes with this look. Ceramic tiles can be charming. Inlaid vinyls keep their good looks for years. Terrazzo and flagstone can be used with splendid effects, inside as well as outside. Marble is the height of luxury and the height of price, but sometimes you can find a sale on seconds. Cork is quiet and luxurious, but wears horribly. Stay away from asphalt tile: It's brittle and it cracks and stains—definitely *not* a rich look. Bricks, slate, and quarry tile, particularly wonderful for Country Charm, have also been used to dazzling effect in the most contemporary homes.

RESILIENT AND HARD-SURFACE FLOORING

Originally designed as the answer for the poor man who couldn't afford rugs, floor stenciling has now come into its own. Some of the most opulent and exciting floors are uniquely stenciled with borders, trompe l'oeil patterns, naif art designs—you name it! All you need to stencil a floor is two hands, a good how-to book, and artistic aptitude.

STENCILED FLOORS

A painted stencil floor

189

FLOOR CLOTHS Cheaper than a rug and often much more gorgeous, floor cloths are easy to make, transportable (unlike flooring and tiles), and lend themselves to an infinite number of hand-picked colors and designs. They usually cover just an area rather than the whole floor. Painted on primed or unprimed artists' canvas and then finished off with polyurethane, floor cloths can be created to complement any signature. Art students, again, provide talented and reasonably priced labor.

WALL COVERINGS

There's practically no end to them. Almost anything can be put on the wall and your educated eye will tell you whether it's rich or poor looking. The choice is staggering and it's a good thing, because when a room needs color, texture, pattern, or just something fascinating to wake it up, a wonderful wall will do the trick.

WALLPAPER Heavier papers are usually higher in quality than lighter ones, and also more costly. The cheapest papers are machine-printed, thin, unwieldy, and tend to shrink or stretch. The better quality wallpapers usually have two layers of paper bonded together for strength. Hand-printed papers are the most expensive and they come silk-screened, block-printed, or stenciled. Wallpaper outlet stores, by the way, are everywhere and the most expensive papers can usually be found in such outlets for as much as a third to a half off the retail price.

WALL FABRICS The softest walls are fabric covered, and shirred material can take the place of missing architectural effects for a quality rich look. There is a wide range of wall fabrics: delicate grass cloths, silks, leather, suede—only your imagination sets limits. Padded fabric adds another dimension of luxe: soundproofing.

PAINT Finally, some of the most exquisite walls in the world are made of very unworldly paint. Hand-done stenciling, trompe l'oeil, fake marbling can give luxurious effects. Make sure you use excellent paint: Cracking, peeling, and bubbling walls look cheap—unless they're on the Greek Acropolis. Walls to be painted must be in super condition or smoothed by spackle or a layer of canvas.

Some special effects:

- *Glazing:* A transparent film on top of an opaque base of paint; adds character, depth, and highlights

- *Dragging:* A reasonably firm brush dragged vertically over a thin glaze gives delicately irregular vertical striations and a sense of texture, as in a natural fiber or grain. A second glaze dragged horizontally produces a "woven-silk" appearance

- *Stippling:* Walls are given an "orange peel" texture and an impression of delicate freckles of color by pressing small brushes into wet glaze or pushing dry rags or paint rollers with care over wet glaze

- *Rag Rolling:* Walls are given an ethereal, cloudy effect by rolling down wet glaze with bunched rags in loose "sausage" shapes. Different textured rags provide varying effects (try linen, cheesecloth, lace, or jute rags to see which you prefer)

- *Stenciling:* Repetition of a design in Contemporary, Country, Oriental, European, or American motifs by means of a stencil gives the effect of moldings, hand painting, or good wallpaper. It's unique, individual, easy to learn

- *Be creative:* Ever think of stamped tin on a wall? Ceramic tile? Mirrors? Silver leaf? Stainless steel? Vinyl? Cork? Flannel? Anything's possible

DO IT YOURSELF? WELL, MAYBE

As we've seen, you can get away with using less than the best quality in a couch if you embellish that couch with extraordinary pillows that pull the attention. In craft work, however, like painting, gold-leafing, stripping and refinishing furniture, often the look of quality is best served by having a professional do it. There's nothing like clumsy gold-leafing to *immediately* read poor. Think about it. Artistic people are to be found in art schools and in the Yellow Pages —many places that suggest they will be reasonably priced. Always ask to see a sample of work.

But if you're sure you can handle it (stenciling, for instance, with a good how-to book, is relatively simple) give it a shot!

ART

Even if you can't afford masterpieces, you can get the look of quality by your art presentation. A good print, carefully excised from

an old book, looks posh if it's matted beautifully, framed exquisitely, and displayed, either alone or in a group, with sensitivity.

A word on frames: Make sure they're great. Look at the paintings in museums and you'll note they're never devalued by cheap frames. Sometimes a thrift-shop piece of art can be made to look spectacular if framed well.

A few words about quality display:

- Art hung together must be linked in subject matter (all horses? all people?), frame color (all gilt? all black?), or technique (all black and white drawings? all lithographs?). This is *not* a linked group: a botanical in a gilt frame, a black and white architectural drawing, an unframed photo. Grouped artwork should be linked not only when on walls, but also on tables and bookcases, along shelves

- Negative space: When grouping several objects or paintings on the wall or on a table, consider not only the objects themselves but the interesting shape of the space around the objects—this is Negative Space, the places left empty. It has to flow serenely and paint its own beauty

- Don't ignore balance in your presentation. Balance doesn't necessarily mean pairs but it does mean an equal amount of mass. A large painting

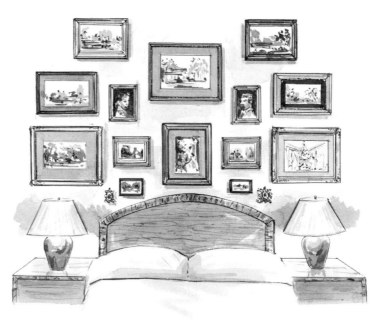

Consideration of balance and negative space makes a good art display.

on one side of the wall should be balanced by a group of smaller ones on the other side. TIP: Lay everything out on the floor before you hang it. Balance textures, as well. In a Classic Contemporary room, for instance, polished, glossy-surface tables and other furniture do well when balanced with a few mat finish, dull-surface pieces of art. And never ignore balance by putting a small picture over a large piece of furniture—or the converse

Art presentation: Grouping plates makes each one look impressively antique.

- In displaying art, understand that the lighting is what often provides the rich look. Art lights perched on top of a painting make it look more remarkable. "Up" lights on sculpture or plants create their own moving shadows. Track lights give individual pieces or groupings added drama. Individual spots on a piece of art say "important"

- Most expensive paintings and prints are framed with the mat and the frame in unequal widths. The mat can be wider than the frame, or vice versa, but equalizing the two cheapens the look of the art

- If you're hanging posters, go for something unfamiliar. This would not be Degas dancers

- Architectural drawings of old greenhouses or medieval French buildings hung in multiples give more clout than hung singly

- Sporting prints are given richness by the color of the mats and frames. Go for traditional very dark green or deep, rich oxblood red mats with gold wood or burled wood frames

Sporting prints depict the rich life.

- If you have had a professional framer frame your art, ask for his/her thoughts on grouping it

- If you have a black and white photograph you love, or a group of such photographs, consider enlarging it greatly to make a photographic mural

193

along one wall. This can give a smashing effect, even better than a costly hand-painted wall mural

THREE WISE ART MAXIMS

1. *Botanical prints* of herbs, flowers, vegetables, or fruits are particularly rich art. Hang them in singles, matched, or unmatched, groups. I love to connect them with charming ribbons running behind and down the center of each.

 Botanical realities, by the way (live plants and fresh flowers), are no less a form of rich art. Live plants should be massive and important—no ditzy little sprouts. One unusual exotic plant is marvelous. Ficus trees are swell (and inexpensive). Never, never, never put a plastic tree or flower in your home. It's simply the antithesis of rich decorating. *No* exceptions.

Botanical prints hung with rosettes and tassels

2. *Trompe l'oeil paintings* are a wonderful and witty art form. A skilled artist can paint two- or three-dimensional fantasies on any surface. A "bookcase" on a door, a country scene on a city wall, "marble" pillars majestically rising from the floor—if it fools the eye, it charms the heart.

3. I *love* a hung *tapestry* for a rich look! The best, of course, is a sixteenth-century woven European tapestry, many of which hang in the most prestigious museums in the world. Don't have one? Well, you're in luck: The revival of tapestry weaving, among the most important forms of artistic expression in medieval times, is upon us and one can purchase a new tapestry that looks quite fine. A hung tapestry is a rich decorating touch for every single signature, even, perhaps especially,

Contemporary. It can set the color scheme for an entire home. These new tapestries are available in large sizes for under a thousand dollars. A small piece of tapestry can be purchased for significantly fewer dollars and displayed as a small wall hanging, framed, or secured in Plexiglas: In fact, these "fragments" often give an especially rich touch because they really look as if they're original—and therefore priceless. Tapestries are easily hung, usually by a simple rod attached to loops on the back (exactly as they were hung in medieval times). *Now, the important part:* Never buy a new tapestry that's familiar—say, a copy of the famed "Unicorn in Captivity." Everyone *knows* you don't own the original. But a copy of a tapestry that's unfamiliar—shepherds making wool or an autumnal landscape—might be an original passed down to you through generations. Who's to say no?

One Last Word Before You Spend

Do make sure you've read this entire book, not just the section you suspect is your signature. The Decorating Rich tips in one signature are often applicable to other signatures.

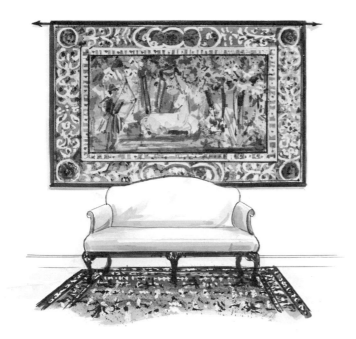

Tapestries and Oriental rugs are glorious in every signature.

The Treasure Hunt

At last—it's really time! The excitement begins, the treasure hunt awaits your educated eye and your dauntless spirit. I wish you delightful finds. I wish you the richest of elegant decoration.

Now, fall in love with the following new hunting grounds that will serve up reproductions and pieces crying out for just a tad of refinishing: These are your buried treasures. Rich tastes are well sated at:

The Reproduction Houses: Many of them are listed in the Resource Guide under the particular decorating signatures.

Junk and Secondhand Shops: Don't let scruffiness bother you. On the other hand, just looking scruffy is no guarantee of bargains. Many dealers purposely cultivate scruffiness to make you think they don't know what they have. They do.

Auctions: Particularly suburban and country auctions.

Wrecking and Salvage Companies: These fertile hunting grounds announce sales of great stuff in the newspapers (when public buildings are torn down). Check the Resource Guide under Salvage Companies. Some are open all the time and have a huge ever-changing inventory of architectural details and furniture, not just announced sales.

Thrift and Consignment Shops: Markdown sales are regularly held here.

Moving and Storage Companies: Annual sales of unclaimed goods are announced in local papers. These are wonderful sources!

City Auctions: Many big cities (including New York) hold sales of goods seized for nonpayment of custom duties or city taxes. Literally troves of fine furnishings are to be found; watch the papers.

Flea Markets: Big business. Go early for the best deals.

Posh Antique Shops: They don't charge for looking and learning.

Garage, Rummage, Tag, or Lawn Sales: It's rare to find true treasures here; people generally know what they have. But then again, there were the famous, signed Windsor chairs my co-author sold for $100 the pair at her garage sale . . . Arrrrgh.

Street Fairs and Street Finds: Art talent and "white elephants" are to be found at local street fairs. Check curbside and dumpsters in prosperous neighborhoods on "clean-up" days for discarded treasures.

Bulletin Boards, Classified Ads: Check for-sale notices out at the Y where you swim or the school you attend. Check the newspapers for classified ads. People who haven't the time or talent to fix up treasures often dispose of them for peanuts. In local newspapers, special "shopper" pages often carry notices of great buys.

Catalogs: You would be surprised at what you can find in catalogs today. Just about everything! The best treasures are to be found here at reasonable prices. One of my clients found fabulous library steps (he uses them as a night table) and a superb reproduction of a pie-crust tea table that was prettier and less costly than anything we'd seen in the showrooms.

NOTE: As you treasure hunt, remember these Decorating Rich absolutes:

- *The most elegant looks are personalized.* You've got to make a signature of your own. Your home must have—in art, collections, furniture— things that are indelibly printed *you.*

- *Luxurious homes are comfortable:* The very essence of luxury is comfort. Old money understands this. New money sometimes forgets.

- *A monied look communicates status.* Don't be afraid of elitism; class means richness of taste as well as dollars, and status symbols say you have discerning judgment as well as power and position.

Conclusion

I can't say it enough: Never, ever be embarrassed to aspire to the look of elegance. It is an honorable yearning. It is dignified to wish to live with quality.

No one ever bought a stick of furniture without secretly harboring the hope it would enhance an image. Few would think of admitting they try to Decorate Rich, but they do. Would anyone ever design a home to look poor?

The look of money alone won't do it. Many rich people show their affluence and still have ugly homes. Cracking the code of the rich who have taste—that is what buys rich decorating. Let's face it: It's easier to buy a look of elegance and quality if you have money. Still, the absolute truth is that Decorating Rich is within your power and your budget once you know what you want to achieve.

Go for it. Don't hide behind mediocrity because you feel you don't have the dollars. A rich look is there for everyone who cares enough to spend a little time educating her eye and then following the secrets of *Decorating Rich.*

Finally, never ignore the Comfort Connection in your quest for an elegant home. It is, perhaps, the key to cracking the code. Old money understands this; new money sometimes forgets.

"Lately I have been thinking," said Billy Baldwin, decorator to the rich and famous of our time, "how comfort is perhaps the ultimate luxury."

Baldwin was absolutely correct. Decorating that goes in and out of fashion is transiently rich. Comfortable, classic decorating is perennially rich.

Resource Guide

NOTE: I've listed here some of my favorite sources for reproduction furniture and accessories. I'd like to note that often the very best place to buy a wide range of English, French, Oriental, country, and American merchandise is at large department stores during sales. Stores like Bloomingdale's, Lord and Taylor, Bullocks, Macy's, Neiman Marcus, and Marshall Field usually have sales twice a year (and sometimes oftener).

This resource section is not definitive or exhaustive; it is meant as a guide. I've endeavored to be up to date and accurate but if addresses or telephone numbers have been changed, you can obtain the correct listings from telephone information services.

You will find both discount and high-price sources (listed as "Hallmark") in this book. I've included the latter for the purpose of educating your eye and also for that occasional masterpiece fabric, furnishing, or accessory on which you don't mind splurging. Major listed sources are catalogs and mail-order furnishings and accessories.

One more note: Although *Decorating Rich* provides you with the know-how to design your own elegant homes, if you prefer to use the expertise of a professional interior designer, there are resources to

check. Try looking in the home magazines for rooms you think are wonderful and see who's credited. Or try the referral services of organizations to which decorators belong (like ASID—American Society of Interior Designers) and ask for recommendations. Last, check out the model rooms in large department stores to find the names of decorators whose work you admire.

American Pedigree

Architectural Details

Art

Catalogs (Mail Order for All Signatures)

Classic Contemporary (Reproductions and Originals)

Country Charm

European Opulence

Fabrics, Discount

Fabrics and Wallpapers, Hallmark

Floor Coverings

Furniture, Discount and Clearance Centers

Furniture Manufacturers, Hallmark

Glass, Mirror, Marble

Greenery

Lighting

Linens, Discount

Oriental Grace

Salvage Companies and Eclectic Shops

Touches of Class (Trimmings, Hardware, Silver, Pillows, Scents)

Wall Coverings

Window Treatments

American Pedigree

A Touch of Dutch
P.O. Box 0154
Strasburg, PA 17579
717-687-6859

Amish country quilts and crafts. Catalog, $2.

The Colonial Williamsburg Foundation
P.O. Box CH, Dept. 023
Williamsburg, VA 23187
1-800-446-9240
In VA: 804-229-1000

Licenses thirty-seven manufacturers, which create quality reproductions of more than twenty-five hundred objects. There are fifty-seven Williamsburg shops nationwide. Color catalog for mail order: $7.95 + $1.00 postage.

Eldred Wheeler Company, Inc.

60 Sharp Street
Hingham, MA 02043
617-337-5311

Handcrafters of fine eighteenth-century American reproduction furniture. Represented in forty stores. Catalog, $4.

Ethan Allen
Ethan Allen Drive
Danbury, CT 06811
203-743-8000

Reproduction American furniture; 350 nationwide stores will give you free catalog, or send $7.50.

Frederick Duckloe & Bros., Inc.
P.O. Box 427
Portland, PA 18351
717-897-6172

Specialists in superb Windsor chairs. Seventy-five-page catalog for Windsor and other colonial furniture, $6.

Heritage Clock and Brassmiths
Heritage Industrial Park
Drawer 1577
Lexington, NC 27293
704-956-2113

Reproductions of old masters clocks. Retail and mail order. Catalog, $1.

Historic Charleston Reproductions
105 Broad Street
Charleston, SC 29401
803-723-8292

The finest furniture manufacturers reproduce treasures from historic Charleston. Magnificent eighty-page color mail-order catalog, $7.50.

The Marshall Co. Woodworks
17610 Shoshoni Trail
Nevada City, CA 95959
916-265-8727

Constructs Colonial, Early American, Period, and Shaker furniture. Custom design plus stock mail order. Catalog $3.

Mill House Antiques
Route 6
Woodbury, CT 06798
203-263-3446

Huge showroom of antique English furniture and accessories.

Olde Virginea Floorcloth & Trading Co.
P.O. Box 3305
Portsmouth, VA 23701
804-393-0095

Handcrafted eighteenth-century reproduction pencil-post beds, hand-stenciled floor cloths, bed steps. Silhouettes made from snapshots. Catalog, $3.

Pennsylvania House
137 North 10 Street
Lewisburg, PA 17837
1-800-782-9663

Manufacturer and retail chain of furniture. Catalog available at nearest dealer.

Williamsburg Pottery
Route 60
Lightfoot, VA 23090
804-564-3326

Factory seconds on lamps, pewter, pottery,

glassware at big discounts. Free brochure.

Winterthur
Winterthur, DE 19735
302-656-8591
Tours: 302-888-4600

Authentic reproductions of antique furnishings bearing Winterthur trademark available in stores throughout the United States. Beautiful 128-page color catalog, $10.

Architectural Details

(SEE ALSO SALVAGE COMPANIES, PAGE 216)

AA-Abbingdon Ceiling Co., Inc.
2149 Utica Avenue
Brooklyn, NY 11234

Pressed-metal ceilings and cornices. Free brochure.

Architectural Sculpture
242 Lafayette Street
New York, NY 10012
212-431-5873

Cast plaster ceiling medallions, pedestals, plaques, moldings. Catalog.

Century Hall
2064 Briarcliff Road NE
Suite 112
Atlanta, GA 30329
404-321-4626

Mail-order classic and contemporary plaster reproductions of columns, fretwork table bases. Glass tops may be ordered. Free catalog.

The Decorators Supply Corp.
3610 South Morgan Street
Chicago, IL 60609
312-847-6300

Mail-order composition and plaster moldings and ornamentation; wood mantels. Catalog available.

Dykes Lumber
348 West 44 Street
New York, NY 10036
212-246-6480

Focal Point brand products, paneling, extensive choice of moldings, etc.

Florida Mantel Shop
3800 NE Second Avenue
Miami, FL 33137
305-576-0225

Antique and reproduction wood and marble mantels. Focal Point moldings. Brochure.

203

Focal Point, Inc.
P.O. Box 93327
Atlanta, GA 30377-0327
1-800-662-5550

Manufacturer of lightweight composite easy-to-install moldings, ceiling medallions, plaster niches. Museum-authenticated. Call for nearest dealer.

Heritage Mantels
Box 240
Southport, CT 06490
203-335-0552

Marble reproductions. Catalog, $3.

Janovic Plaza
1150 Third Avenue
New York, NY 10021
212-772-1400

Reproduction moldings, paint, wallpaper and window treatments. Carries Fleck Stone spray paint that mimics the look of granite.

Materials Unlimited
2 West Michigan Avenue
Ypsilanti, MI 48197
313-483-6980

New and antique building materials. Also antique furniture and accessories.

Nostalgia
307 Stiles Avenue
Savannah, GA 31401
912-232-2324

Authentic reproductions of architectural antiques. Fireplace surrounds, ironwork, leaded glass, pedestal lavatories. Catalog.

Old World Molding & Finishing
115 Allen Boulevard
Farmingdale, NY 11735
516-293-1789

Hardwood modular paneling, cabinetry, and moldings machine-carved for luxury look on a budget. Handsome catalog, $3.

Readybuilt Products Company
P.O. Box 4425
Baltimore, MD 21223
301-233-5833
Retail Store: 1707 McHenry Street
Baltimore, MD 21223

Manufacturer of meticulously crafted wood mantels. Contact for nearest distributor. Catalog.

Renovation Concepts
213 Washington Avenue N
Minneapolis, MN 55401
612-333-5766

Gigantic selection of unique and hard-to-find items. Free brochure.

Restoration Works
810-812 Main Street
Buffalo, NY 14202
716-856-8000

Hardware, bathtubs, ceiling medallions. Catalog, $2.

Vintage Wood Works
513 S. Adams, 1286
Fredericksburg, TX 78624
512-997-9513

Victorian and Country Gingerbread (spandrels, brackets, shelves, cornices, etc.). Direct factory prices. Catalog, $2.

World of Molding
3109 South Main Street
Santa Ana, CA 92707-4234
714-556-7772

Quality wood moldings, Victorian fretbrackets, and complete line of Focal Point brand products. Catalog, $3.

Worthington Group, Ltd.
P.O. Box 53101
Atlanta, GA 30355
404-872-1608

Classic architectural details: columns, pedestals, brackets in wood or plaster. Glass tabletops. Mail-order catalog free.

Art

Art Institute of Chicago
Museum Shop
Michigan Avenue
Chicago, IL 60603
1-800-624-9000
IL: 312-443-3535

Reasonably priced reproductions from the museum collection, including silhouette plates, etched glass, sculpture. Free catalog.

Bernice Jackson
P.O. Box 1188
Concord, MA 01742
617-369-9088

Original Art Nouveau and Art Deco posters plus sheet music and paper collectibles.

The Colonial Williamsburg Foundation
P.O. Box CH, Dept. 023
Williamsburg, VA 23187
1-800-446-9240
VA: 804-229-1000

Prints, etchings, engravings, and frames. Available at museum shop, nation-wide Williamsburg galleries, or mail-order catalog.

East Hampton Center for Contemporary Art
16R Newtown Lane
East Hampton, NY 11937
516-324-8939

Original and magnificent works by emerging artists. Subsidized gallery creates substantial savings.

Ed Waldman
231 East 58 Street
New York, NY 10022
212-838-2140

Fine art restorer and framer.

Eli Wilner & Company, Inc.
1525 York Avenue
New York, NY 10028
212-744-6521

Over 1,000 original period frames, mostly eighteenth-century American. Frame restoration, frame appraisals, and picture-hanging services available.

FPG International Corp.
251 Park Avenue South
New York, NY 10010
212-777-4210

A vast library of existing fine photography; may be purchased for framing or photomurals. Free catalog.

Framer's Workroom
1484 Third Avenue
New York, NY 10028
212-570-0919

Well-priced custom or do-it-yourself framing.

French Kisses
7 St. Mark's Place
New York, NY 10003
212-460-8195

Vintage movie posters, fine photographs, framing. Moderate prices. Mail-order lists available.

Luciana Associates
133 Mulberry Street
New York, NY 10013
212-941-7415

Art/source for limited-edition prints and lithographs, original watercolors, pastels, and paintings.

Mark Humphrey
95 Main Street
Southampton, NY 11968
516-283-3113

Originals by emerging artists. Prints, posters, and framing.

Mark Victor Venaglia
132 West 24 Street
Box 7
New York, NY 10011
212-255-2772

Trompe l'oeil artist.

Metropolitan Museum of Art
Shop: Fifth Avenue & 82 Street
New York, NY 10028
212-535-7710

Catalog: Special Service Office
Middle Village, NY 11381
312-673-6006

Quality reproduction sculpture, drawings, ceramics, decorative boxes. Free 130-page color catalog.

Modern Age Photos
1150 Avenue of the Americas
New York, NY 10036
212-977-1800

Photo murals made.

Mystic Seaport Museum Stores, Inc.
Mystic, CT 06355-0008
203-572-8551

Marine art, prints, and posters. Catalog, $1.

Paintings by Lois Cogen
229 Steven Place
Woodmere, NY 11598
516-295-3087

Custom-painted large contemporary canvases.

Peabody Museum Gift Shop
East India Square
Salem, MA 01970
617-745-1876

Limited-edition maritime prints, ship portraits. Free brochure.

Pir Imports
3033 North Lincoln Avenue
Chicago, IL 60657
1-800-621-1244

Reproduction European antique tapestries, Oriental rugs, contemporary woven sculptures. Catalog.

Portraits by Virginia Ferrara
330 East 93 Street #3B
New York, NY 10128
212-534-7654

From life or photos; portraits in oils, pastels, watercolors, or black and white.

Silhouettes by Deborah O'Connor
P.O. Box 512
Wakefield, RI 02880
401-789-8764

One of the few remaining cut-paper silhouettists in the country. Will mail designs or do your silhouette from photo. Brochure.

Stubbs Books and Prints, Inc.
28 East 18 Street
New York, NY 10003
212-982-8368

Fine architectural, decorative, and unusual drawings and prints.

Tromploy, Inc.
400 Lafayette Street
New York, NY 10003
212-420-1639

Decorative painting: Unusual painted treatments of walls, ceilings, floors, and furniture.

Ursus Prints
981 Madison Avenue
New York, NY 10021
212-772-8787

Fine antique decorative prints, originals only, especially botanicals.

Catalogs

MAIL-ORDER FOR ALL SIGNATURES

Adele Bishop
P.O. Box 3349
Kinston, NC
28502-3349
ATT: Diane Chapman
1-800-334-4186
NC: 919-527-4186

Creative floor, wall, and furniture stencils and supplies. Catalog, $3.

Charles Keath, Ltd.
1265 Oakbrook Drive
Norcross, GA 30093
1-800-241-1122
GA: 404-449-3100

Tasteful selection of reproduction accessories, horse prints, and furniture. Carries candle adapter and shade to create "candle lamp."

Cohasset Colonials by Hagerty
838AX Ship Street
Cohasset, MA 02025
617-383-0110

Reproduction furniture and accessories, including four-poster Sheraton bed, Queen Anne porringer table, fishnet canopy, pewter candlesticks, Shaker furniture. Furniture shipped assembled or in kit. Forty-page catalog, $2.50.

Collectors' Guild, Ltd.
1625 Bathgate Avenue
Bronx, NY 10457
1-800-228-5000
NY: 212-901-5271

Prints, pillows, pedestals.

Fortunoff
1300 Old Country Road
Westbury, NY
516-832-8700

A wide variety of discount home furnishings. Mail-order plus retail stores.

Gardener's Eden
P.O. Box 7307
San Francisco, CA
94120-7307
415-421-4242

Indoor/outdoor garden furniture and accessories.

Lillian Vernon
510 South Fulton Avenue
Mount Vernon, NY 10550
914-699-4131

A potpourri of accessories, many exclusively Vernon.

Masterworks
189A North Cobb Parkway
Suite 7
Marietta, GA
30062-9990
1-800-365-3555

Superb collection of home furnishings:
lamps, architectural accessories, prints, glass tabletops.

National Trust for Historic Preservation
1600 H Street, NW
Washington, DC 20006
202-673-4200

Historically faithful reproductions of antique furniture, art, porcelains, Remington's cowboy bronzes.

The Old House Journal Catalog
69A Seventh Avenue
Brooklyn, NY 11217
718-636-4514

An encyclopedic resource guide (flooring, lighting, bathroom fixtures, hardware, etc.), $14.95.

Orvis
Blue Hills Drive
P.O. Box 12000
Roanoke, VA
24022-8001
1-800-541-3541

Accessories with sporting motif. Duck decoys, hunting horn lamps, ship's clock. (Has several retail stores.)

Pottery Barn
P.O. Box 7044
San Francisco, CA
94120-7044
415-421-3400

A tasteful selection of china, glassware,
serving carts, candelabra. Retail chain and mail order. Carries *Patina-Green*, a solution to "antique" metals.

Sears Roebuck
National chain
Call 312-265-2053 (or see White Pages) for nearest store, catalog.

A wide variety of home furnishings, including unpainted pine and oak furniture. Catalog $4, refundable with purchase.

Spiegel
1040 West 35 Street
Chicago, IL
60609-1494
1-800-345-4506

Magnificent array of home furniture and accessories. Tremendous selection and excellent value. Beautiful color catalog $2, redeemable with purchase.

Williams-Sonoma
5750 Hollis Street
Emoryville, CA 94608
415-652-1553

Table and kitchen ware; Paris bistro and park furniture.

Classic Contemporary (Reproductions and Originals)

Atelier International
Internation Design
Center of NY
30-20 Thomson
Avenue, Center 2
Long Island City, NY
11101
718-392-0300

Manufacturer to the
design trade of noted
architect-designed
contemporary furniture:
LeCorbusier,
Mackintosh, Frank
Lloyd Wright. October
warehouse sale, open to
public, at 235 Express
Street, Plainview, LI.
516-935-6700

Bon Marche
72 Fifth Avenue
New York, NY 10011
212-620-5592

Well-priced
reproduction Bauhaus
furniture and lighting.
Marble and glass
tabletops good value.

Civilisation
78 Second Avenue
New York, NY 10003
212-254-3788

One-of-a-kind and
limited-edition
contemporary crafts,
furniture, floor cloths.

Conran's
Mail Order Dept. 9404
1690 Oak Street, P.O.
Box 1412
Lakewood, NJ 08701
201-905-8800

Competitively priced
contemporary
furnishings and
accessories. Nationwide
twenty-store chain plus
mail order. Catalog, $2.

Deco Deluxe
Place des Antiquaires
125 E. 57 Street,
Gallery 31, 32
New York, NY 10022
212-688-2677

Exquisite original Art
Deco furniture,
accessories, and works
of art.

Design World
55 West 21 Street
New York, NY 10010
212-929-5559

Custom-designed,
custom-color lacquer
furniture direct from
factory. Occasional sale
of designer samples.

The Door Store
One Park Avenue
New York, NY 10016
212-679-9700

Modular stock wall
units, platform beds,
mix-and-match dining
furniture. A New York
City chain. Direct-from-
manufacturer imports,
many items
unassembled.

Hudson Papertube
Company
80 Furler Street
Totowa, NJ 07511
212-226-3858
201-256-3602

Brown-paper
nonstructural columns,
available in diameters
from 1″ to 16″, up to 12′
tall. Also known as
sonotubes. (May be
painted or papered for
room dividers, table
bases, wine racks, etc.)

Knoll Warehouse
36-30 Steinway Street
Long Island City, NY
11101
718-937-4330

Fine designer chairs,
tables, sofas at fifty
percent discount.

Mel Brown Furniture
International
5840 South Figueroa
Los Angeles, CA 90003
213-778-4444

Contemporary modular
seating, lacquer
bedrooms, excellent
lighting designs.
Competitive prices.

Modern Furniture Barn
430 Bedford Road
Box N
Armonk, NY 10504
914-273-3900

Three floors of
authentic contemporary
classics including
original Eames chair

and ottoman.
Exceptional values.

Murphy Door Bed
Company
5300 New Horizons
Boulevard
Amityville, NY 11701
516-957-5200

The manufacturer of the
original disappearing
Murphy bed, which lifts
into walls or cabinets.
Call for nearest store; if
none, will sell direct.
Catalog, $1.

Palazzetti
515 Madison Avenue
New York, NY 10022
212-832-1199

The largest importer of
classic contemporary
furniture: Mackintosh,
Hoffman, Bauhaus.
Italian factory
reproduces from
original prototypes and
specifications. Reliable,
prompt shipping.
Chicago, LA, Dallas
branches. Send for free
poster of designs.

Scandinavian Gallery
185 Madison Avenue
New York, NY 10035
212-689-6890

National chain of sixty-
four stores that import
moderate-priced
furniture from
Scandinavia.

Sedia
63 Wareham Street
Boston, MA 02118
617-451-2474

Architect-designed
furniture from the
twenties and thirties
reproduced to original
specifications. Discount.
Catalog.

Workbench
470 Park Avenue South
New York, NY 10016
212-532-7900

National chain featuring
well-priced modern
furniture.

Country Charm

American Roots
Box 2462
New Preston, CT 06777
203-868-2095

Handmade American
folk-art twig furniture.
Catalog, $2.

Arte de Mexico
5356 Riverton Avenue
North Hollywood, CA
91601
878-769-5090

Southwestern and
Mexican handcrafted
furniture, accessories,
doors, stone, and
lighting fixtures. Color
catalog, $3.

Betsy Williams
155 Chestnut Street
Andover, MA 01810
617-475-2540

Dried flower
arrangements made to
match your fabric.
Brochure, $2.

Country Designs
Spread Eagle Village
503 West Lancaster
Avenue
Wayne, Pa 19087
215-687-5805

Four floors of original
eighteenth- and
nineteenth-century
French and English
country furniture and
accessories.

Country Gear, Ltd.
Main Street
Bridgehampton, NY
11932
516-537-1032

Well-priced original
nineteenth-century
English and Irish pine
furniture and unusual
accessories.

Country Loft Antiques
88 Main Street North
Woodbury, CT 06798
203-226-4500

Original French country
antique furniture and
accessories. Farm tables
and chairs, kilim rugs,
and French pottery.

Echo Bridge Mall
381 Eliot Street at
Chestnut St.
Newton Upper Falls,
MA 02164

Country antique
dealers. Lace,
china, glassware,
silver, collectables

Hancock Shaker Village
Museum Shop
Hancock Shaker Village
P.O. Box 898
Pittsfield, MA 01202
413-443-0188

Handmade museum-
quality Shaker crafts
and furniture. Shaker
pegs and furniture kits
available. Free
mimeographed catalog.

Hand Made Quilts
P.O. Box 215
Lampeter, PA 17537

Magnificent custom-
made quilts. Mail order
from color brochure.
Also sells old samplers.

Howard Kaplan's
French Country Store
35 East 10 Street
New York, NY 10003
212-529-1200

Original and
reproduction furniture,
ceramics, and fabrics.

Jacqueline Jewett
Bradley Hill Road
Blauvert, NY 10913
914-358-7767

Hand-crocheted,
individually designed
pillows and afghans.
Brochure.

Kimberly Haldeman
848 Pleasure Road
Lancaster, PA 17601
717-293-9458

Pillows, hand quilted in
traditional Amish
designs. Mail order.

The Lane Company, Inc.
P.O. Box 151
Altavista, VA 24517
804-369-5641

American West and
Southwest furniture
reproductions.
Manufacturer: Call for
nearest store. Catalog,
$5.

Lloyd's Antique &
Auction Service
496 Main Street
Eastport, NY 11941
516-325-1819

Wide assortment direct
from estates.

Museum of American
Folk Art
55 West 53 Street
New York, NY 10019
212-974-0368

Handcrafted, popular-
priced carvings,
watercolors, and toys in
the folk art tradition.

Pennsylvania Dutch
Quilts
P.O. Box 430
Norristown, PA 19404
215-539-3010

Magnificent color
catalog: "Comfort and
Joy, Quilts for All
Seasons," $10
refundable with
purchase.

Pennsylvania House
137 North 10 Street
Lewisburg, PA 17837
1-800-782-9663

Manufacturer and
retailer of furniture
including country style.
Catalog available at
nearest dealer.

Philadelphia
Floorcloths, Inc.
510 Merwyn Road
Narbeth, PA 19072
215-664-7692

Polyurethane-coated,
hand-painted country-
designed floor cloths
and table runners.
Brochure and price list
available.

The Picket Fence
Route 37
Sherman Common
Sherman, CT 06784
203-355-4911
212-722-6796

Antique and
handcrafted quilts.

Pier 1 Imports
Executive Office
301 Commerce Street
Fort Worth, TX 76102
Customer Service:
817-878-8068

Budget-priced wicker
and rattan furniture,
baskets, country
accessories; 300 stores
nationwide.

Rue de France
78 Thames Street
Dept. PD
Newport, RI 02840
401-846-2084

Traditional French
country lace for
windows, doors, bed,
and bath. Mail order.
Catalog, $2.

Ruth Arzt, Ltd.
85 Leewater Avenue
Massapequa, NY 11758
516-541-1427

Splendid antique quilts,
bed and table linens.

Scott Jordan Furniture
327 Atlantic Avenue
Brooklyn, NY 11217
718-522-4459

Fine Shaker
reproductions. Catalog
and seat tape samples,
$1.

J. Seitz & Company
Route 45—Main Street
New Preston, CT 06777
203-868-0119

Country and
Southwestern painted
furniture with folk
motifs. Write for price
list. Brochure.

St. Joseph's Lakota
Development Council
Chamberlain, SD 57326

Quilts handmade by
Lakota Indians. Art and
artifacts available. Free
color brochure for mail
order.

Wicker Outlet
173 Main Street
West Orange, NJ 07052
201-731-1440

General wicker
merchandise from
cheval mirrors to camel-
back sofas.

Workbench
470 Park Avenue South
New York, NY 10016
212-532-7900

National chain that
carries Shaker
reproductions.

Yellow Monkey
Antiques
Route 35
Cross River, NY 10518
914-763-5848

Large selection of
original English
stripped pine and
eighteenth-century
country furniture and
accessories.

European Opulence

Ballard Designs
2148-J Hills Avenue
NE
Atlanta, GA 30318
404-351-5099

Mail-order
reproductions of classic
columns, tripod dolphin
bases, garden statuary,
sconces, etc. Catalog,
$2.

The Bombay Company
550 Bailey, Suite 400
Fort Worth, TX
76107-2110
800-535-6876

Reproductions of
eighteenth- and
nineteenth-century
English antiques and
decorative accessories,
lamps, and prints.
Cheval mirrors,
painter's easels, butler's
tables. Summer sale.
Extensive mail order.
Free catalog.

Brookes-Reynolds
Furniture
1232 Bandera Highway
Kerrville, TX 78028
512-257-8050

Discounted fine
furniture and
accessories. Major
American manufacturers
as well as imported
French and Italian
antique reproductions.

Cabbages and Kings
813 Lexington Avenue
New York, NY 10021
212-355-5513

English gentlemen's
antique and reproduction
decanters, walking
sticks, magnifying
glasses, sporting
prints, and etchings.

Charles P. Rogers Brass
Beds
899 First Avenue
New York, NY 10022
1-800-272-7726
NY: 212-935-6900

Quality brass at direct factory prices. Retail and mail order. Catalog, $1.

Decoration Day
2076 Boston Post Road
Larchmont, NY 10538
914-834-9252

Tassels, tiebacks, and silk and dried floral arrangements.

Faces of Time II
32 West 40 Street
Suite 2D
New York, NY 10018
212-921-0822

Elegant European tabletop, bar, and vanity accessories. To the trade by appointment. Call for retail locations.

Newel Art Galleries, Inc.
425 East 53 Street
New York, NY 10022
212-758-1970

I agree with Newel's logo that it is "the largest and most extraordinary antique resource in the world." With five floors of remarkable furniture and accessories, this source is perfect for finding a Masterstroke.

Old Town Crossing
82 Main Street
Southampton, NY
11968
516-283-7740

Distinctive small English antique silver,

wood, needlepoint items.

Rena Fortgang Antiques
33 Muttontown Road
Syosset, NY 11791
516-364-2573

Design studio with selected English and French accessories and furniture.

Fabrics, Discount

(SEE ALSO FABRICS AND WALLPAPERS)

If you're interested in a finished product, ask each company if it will make a window treatment, slipcovers, or bed treatment from the fabric you've selected. Many do this at discount prices, as well.

Beckenstein Home Design Center
130 Orchard Street
New York, NY 10022
1-800-221-2727
NY: 212-475-4525

A large selection of designer fabrics. Custom reupholstery and slipcovers.

Bloomcrest Fabric Discount Center
1874 North Grand Avenue
Baldwin, NY 11510
516-867-9880

Fabrics only for slipcovers and upholstery.

Calico Corners
National chain
1-800-821-7700
Call for nearest store and information.

Everfast/Danneman
9 Rockford Road
Wilmington, DE 19806
302-654-8831

Chain in VA, MD, PA, NJ, CT, RI.

Fabrics by Phone
1-800-233-7012
PA: 1-800-692-7345

Call 9-5 EST for free sample of fabrics priced from $3 to $12 a yard.

Hancock Fabrics, Inc.
Tupelo, MS
601-842-2834

Nationwide supermarket of fabrics, competitively priced; two-hundred-store chain. Call for nearest store.

Home Fabric Mills, Inc.
882 South Main Street
Cheshire, CT 06410
203-272-3529

Shop by mail. Brochure.

Midas Fabric Outlet
4813 West Market Street
Greensboro, NC 24707
919-294-9000

Competitively priced quality fabrics and upholstery service. Raleigh, NC, branch.

Mill End Shops
Sunrise Highway &
Carleton Avenue
East Islip, NY 11730
516-581-9877

Remnants at deep discounts.

Poppy Fabric
5151 Broadway
Oakland, CA 94611
415-655-5151

Huge savings on current designer first-quality fabrics direct from mill Well stocked; will also locate name brands. Coordinating wallpapers, shades, shower curtains.

Silk Surplus
223 East 58 Street
New York, NY 10022
212-223-9401
212-753-6511

Exclusive outlet for Scalamandré designer fabrics and trimmings as well as Standard Trimming Company. Five NY-metro locations.

Fabrics and Wallpapers, Hallmark

(SEE ALSO FABRICS, DISCOUNT; AND

WALL COVERINGS, PAGE 218)

Available through designers and architects except where retail store is noted.

Boussac of France
979 Third Avenue
New York, NY 10022
212-421-0534

Importers of fine French fabric. Expensive.

Fabriyaz
41 Madison Avenue
New York, NY 10010
212-686-3311

Manufacturer of designer fabrics. Call for nearest store or showroom.

First Editions
979 Third Avenue
New York, NY 10022
212-355-1150

Contemporary hand-printed papers and fabrics.

Hinson
979 Third Avenue
New York, NY 10022
212-475-4100

Updated classics in fabrics and wallpapers, including "Wildflowers of America" designed by Lady Bird Johnson.

Kinney Wallcoverings
204 East 58 Street
New York, NY 10022
212-759-9018

Showroom for Sterling Prints wall coverings and Fabriyaz fabrics, including those designed by Mario Buatta.

Laura Ashley
714 Madison Avenue
New York, NY 10021
1-800-223-8917
NY: 212-735-5000

A retail chain of exemplary English fabrics, wallpapers, and borders.

Pierre Deux
870 Madison Avenue
New York, NY 10028
212-570-9343

A retail chain of exemplary Country French fabrics, wallpapers, and borders.

Roger Arlington, Inc.
979 Third Avenue
New York, NY 10022
212-752-5288

Leopard- and tiger-print fabric and Deco-inspired wallpapers (shagreen).

Scalamandré
950 Third Avenue
New York, NY 10017
212-980-3888

Fine reproductions of historical patterns and huge selection of other elegant designs.

Sterling Prints
23645 Mercantile Road
Cleveland, OH 44122
216-765-8700

Manufacturer of specific designer wall coverings that are distributed exclusively through Kinney Wallcoverings. Call TELEMARKETING at the above telephone number for the nearest store.

Victorian Collectibles
845 East Glenbrook Road
Milwaukee, WI 53217
414-352-6910

Authentic documentary wallpaper, borders, and ceiling papers. Brochure, $3.

Floor Coverings

ABC Carpet
881 Broadway
New York, NY 10003
212-677-6970

Discount rugs and carpets, including industrial.

American Olean Tile
1000 Cannon Avenue
Lansdale, PA 19446
215-855-1111

Ceramic tile manufacturer. See Yellow Pages for nearest location.

Bill's Carpet Warehouse
Executive Offices
7100 Rutherford Road
Baltimore, MD 21207
301-298-5814

Twenty-three discount carpet stores; remnants and Oriental rugs.

Central Carpet, Inc.
426 Columbus Avenue
New York, NY 10024
212-787-8813

Carpets and Oriental rugs at substantial discount.

Country Floors
15 East 16 Street
New York, NY
10003-3104
212-627-8300

8735 Melrose Avenue
Los Angeles, CA 90069
213-657-0510

Importer of original and handmade decorative ceramic tiles for floors and walls. Also carries terra cotta planters and assorted accessories. 96-page color catalog, $10. Chain; call for nearest location.

Folkheart Rag Rugs
19 Main Street
Bristol, VT 05443
802-453-4101

Charming hand-woven cotton rag rugs, plaid or hand-stenciled. Mail order. Brochure, $1.

Pemaquid Floor Cloths
P.O. Box 77
Round Pond, ME
04564
207-529-5633

Hand-stenciled canvas
floor coverings in
original and traditional
designs. Mail order.
Color brochure, $2.

Philadelphia
Floorcloths
510 Merwyn Road
Narberth, PA 19072
215-664-7692

Hand-painted canvas
floor cloths and table
runners. Mail order.
Brochure, $2.

**FURNITURE—SEE
FURNITURE,
DISCOUNT AND
CLEARANCE
CENTERS AND
FURNITURE
MANUFACTURERS,
HALLMARK.**

*Furniture,
Discount
and Clearance
Centers*

**(SEE ALSO
FURNITURE
MANUFACTURERS,
HALLMARK.
SEE ALSO SPECIFIC
SIGNATURE
DESIGNATIONS)**

Bloomingdale's
Clearance Center
155 Glen Cove Road
Carle Place, NY 11514
516-248-1400

Fifty-two thousand
square feet of
discontinued
merchandise, floor
samples, and canceled
special orders.

Decorator's Warehouse
616 West 46 Street
New York, NY
212-489-7575

Fifty thousand square
feet of close-out and
discontinued fine
furniture.

Edgar B
Box 849
Clemmons, NC 27012
1-800-255-6589
NC: 919-766-7321

Extensive mail-order
selection of high-quality
brand-name furniture at
deep discounts; 196-
page color catalog, $12.

James Roy, Inc.
15 East 32d Street
New York, NY 10016
212-679-2565

They guarantee one
third off manufacturer's
suggested retail price.

Macy's Furniture
Clearance Center
174 Glen Cove Road
Carle Place, NY 11514
516-746-1490

A chain; call Macy's
near you for nearest
center.

Major Furniture
Showroom
45 West 25 Street
New York, NY 10010
212-691-9885

Approximately thirty
percent discount on
name-brand
upholstered and case
goods (wood).

Mecklenburg Furniture
Shops
520 Providence Road
P.O. Box 6005
Charlotte, NC 28207
704-333-5891

Large retail showroom
plus telemarketing. Will
locate name-brand
furniture at discount
and ship.

Sears Roebuck Surplus
Store
Route 25A
Rocky Point, NY 11778
516-821-1800

One of 108 surplus
stores; call 312-265-2053
for nearest location.

Spiegel Outlet Store
9950 Joliet Road
Countryside, IL 60513
312-357-3370

Dramatically discounted
furniture and bedding
from Spiegel's catalog.
Nine other stores in
Illinois.

Turner Tolson
P.O. Drawer 1507
New Bern, NC 28560
1-800-334-6616
NC: 1-800-682-3016
919-638-2121

Fine furnishings
delivered anywhere in
the United States at
deep discount.
Brochures available.

The West Side Design
Center
8 West 30 Street
New York, NY 10001
212-889-6347

First-quality European
and Contemporary
furniture at substantial
savings. Forty-eight
thousand square feet
enables volume buying.

*Furniture
Manufacturers,
Hallmark*

**(SEE ALSO
FURNITURE, AND
DISCOUNT
CLEARANCE
CENTERS)**

Baker Furniture
Company
1661 Monroe Avenue
Grand Rapids, MI
49505
616-361-7321

Manufacturers of fine
furniture, including
reproductions of
eighteenth-century

American and English;
Far East collection,
Louis XVI bedroom.
Various-priced catalogs
available.

Bielecky Bros.
306 East 61 Street
New York, NY 10021
212-753-2355

Manufacturers of top-
of-the-line cane and
wicker. Call for nearest
store.

Century Furniture
Company
Marketing and
Advertising Department
P.O. Box 608
Hickory, NC 28603
1-800-852-5552
NC: 704-328-1857

Manufacturers of
elegant traditional and
contemporary furniture.
Free brochures.

Deutsch Wicker
196 Lexington Avenue
New York, NY 10016
1-800-223-4550
for product information
NY: 212-683-8746

Rattan and wicker sofas,
chairs, tables, beds,
mirrors, and trunks.
Write for catalog, $3.

Eldred Wheeler
Company Inc.
60 Sharp Street
Hingham, MA 02043
617-337-5311

Handcrafters of fine
eighteenth-
century American
reproduction furniture.
Represented in forty
stores. Catalog, $4.

Elkins
200 Lexington Avenue
New York, NY 10016
212-686-9292

Specializes in
polyurethane lacquer-
finished contemporary
designs.

Habersham Plantation
P.O. Box 1209
Toccoa, GA 30577
1-800-241-0716
GA: 1-800-342-0419

Manufacturer of
outstanding
reproduction Country
and American furniture.
Ninety-six-page color
catalog and reference
book, $12.

Henredon Furniture
Industries
P.O. Box 70
Morgantown, NC 29655
704-437-5261

Reproduction furniture
manufacturer.

Kindel Furniture
Company
100 Garden, SE
Grand Rapids, MI
49507
616-243-3676

Fine traditional
reproductions. Catalog,
$10.

Kittinger Company
1893 Elmwood Avenue
Buffalo, NY 14207
716-876-1000

Fine traditional
furniture.

La Barge
Holland, MI 49422
1-800-253-3870

Fine reproduction
mirrors, glass and brass
tables, accessories.

The Lane Company, Inc.
P.O. Box 151
Altavista, VA 24517
804-369-5641

Excellent furniture.
Forty-eight-page color
catalog, $5.

Rousseau, Inc.
521 North Hamilton
Street, Box 835
High Point, NC
27261-0835
919-889-0146

Importer of fine French
country furniture.
Catalog.

Glass, Mirrors, Marble

Academy Glass and
Mirror Co.
26 Bruckner Boulevard
Bronx, NY 10454
212-288-3673

Custom mirrors, glass
for all purposes.

Associated Marble
Industry Inc.
101 West End Avenue
Inwood, NY 11696
516-371-4307
718-297-8401

Source for marble,
granite, slate. Custom
work. Free brochure.

Continental Creative
Sales, Inc.
141 Lanza Avenue
Garfield, NJ 07026
201-546-9660

Marble and granite
suppliers and
fabricators.

Pittsburgh-Corning Co.
800 Presque Isle Drive
Pittsburgh, PA 15239
412-327-6100

Manufacturer of glass
blocks. Widely
distributed. Catalog.

Supro Building
Products Corp.
48-16 70 Street
Woodside, NY 11377
718-429-5110

Distributor for
Pittsburgh-Corning
glass blocks.

Westhampton Glass and
Metal
50 Riverhead Road
Westhampton Beach,
NY 11978
516-288-1727

Glass, mirrors,
tabletops.

Zecca Mirror & Glass
1108 First Avenue
New York, NY 10021
212-758-0639

Installers of custom
mirrors.

Greenery

Bonsai Designs
Shop: 855 Lexington
Avenue
New York, NY 10021
Nursery:
1862 Newbridge Road
North Bellmore, NY
11710
516-785-1330

Bonsai trees, mail-order
and retail. Free
brochure.

Grass Roots Garden
131 Spring Street
New York, NY 10012
212-226-2662

Ming aralia, pencil
cactus, and other house
trees and plants.

Greer Gardens
1280 Goodpasture
Island Road
Eugene, OR
97401-1794
503-686-8266

Ornamental trees and
flowering plants,
including bonsai plants
and pots. Extensive
mail-order catalog, $2.

Martin Viette Nurseries
Northern Boulevard
East Norwich, NY
11732
516-922-5530

Horticultural center.
Orchids.

Moniebogue Florist
126 Montauk Highway
Westhampton Beach,
NY 11978
516-288-1601

Orchids and other exotic
plants, plus baskets,
cachepots, and dried
floral arrangements.

Surroundings
2295 Broadway
New York, NY 10024
212-580-8982

Lady palm, dracaena,
and other house trees
and plants.

Toni DiPace
Mill Road
Calverton, NY 11933
516-727-5152

A nursery specializing
in exotic blooms and
specimen plants;
orchids.

Wayside Gardens
1 Garden Lane
Hodges, SC
29695-0001
1-800-845-1124

Large color catalog of
glorious and unusual
flowering plants, $1.
Mail-order.

HARDWARE—SEE
TOUCHES OF CLASS,
PAGE 217.

Lighting

Authentic Designs
The Mill Road
West Rupert, VT 05776
802-394-7713

Makers of Colonial and
Early American
handcrafted lighting
fixtures. Catalog, $3.

Bowery Lighting
Executive Offices
132 Bowery
New York, NY 10013
212-966-4034

Discount traditional and
contemporary lighting.
Crystal chandeliers,
original and
reproduction Tizio
lamps. Six stores.

George Kovacs
330 East 59 Street
New York, NY 10022
212-838-3400

Manufacturer of quality
contemporary lighting.
Watch for annual sales.
For product
information, 212-944-
9606.

Handsome Rewards
19465 Brennan Avenue
Perris, CA 92379
714-943-2023

Mail-order catalog of
many items including
"Wireless Wonder," a

battery-operated picture
light.

Just Shades
21 Spring Street
New York, NY 10012
212-966-2757

Silk, parchment, and
string discounted lamp
shades. Finials. Bring
your lamp for proper fit.

Lee's Studio Lighting
1069 Third Avenue
New York, NY 10021
212-371-1122

Discount name-brand
contemporary lighting.
Also Memphis chair #1
(see page 61).

Lighting by Gregory, Inc.
158 Bowery
New York, NY 10013
212-226-1276

Vast array of quality
lighting at discount.
Other stores in Fort
Lee, New Jersey, and
Scarsdale, New York.

Light 'n' Lovely
1355 Beacon Street
Brookline, MA 02146
617-731-2345

A wide selection of
contemporary name-
brand lighting at
discount. Ready-made
and custom shades.
Repairs.

Lightolier
100 Lighting Way
Secaucus, NJ 07094
201-864-3000

Manufacturer of exemplary contemporary lighting including faux stone. Chain; call for nearest store. Catalog.

Lt. Moses Willard, Inc.
1156 U.S. Highway 50
Milford, OH 45150
513-831-8956

Custom-crafted folk art and Colonial reproduction lighting. Thirty-six color combinations. Send $4 for catalog and name of nearest store.

NY Gas Lighting Co.
145 Bowery
New York, NY 10002
212-226-2840

Reproduction classic French and English lighting fixtures at discount. Established 1905.

Roy Electric Co., Inc.
1054 Coney Island Road
Brooklyn, NY 11230
718-339-6311

Original and reproduction Victorian to Art Deco lighting. Catalog, $3. Companion plumbing fixture catalog, $5.

Shades of New England
17 Arlington Street
Northampton, MA 01060
413-586-1511

Lovely selection of handmade cut and pierced parchment lamp shades inspired by the perforated tin lanterns of Colonial America. Signed by artist Kathleen Hession.

Smart Shades Co., Inc.
127-03 20th Avenue
College Point, NY 11355
212-358-8454
718-358-9385

Manufacturer of fine lamp shades. Catalog.

Starbrite Lighting, Ltd.
25 Saw Mill River Road
Yonkers, NY 10701
1-800-221-3116
NY: 914-965-7465

Manufacturer of undershelf strip lighting. Brochure.

Times Square Lighting
318 West 47 Street
New York, NY 10036
212-245-4155

Accent and spot lighting, dimmers. Catalog, $5.

Victorian Reproduction Lighting Company
P.O. Box 597
Minneapolis, MN 55458
612-338-3636

High-quality handcrafted lighting designs. Catalog, $4.

Linens, Discount

(FOR BEDSPREADS, SEE ALSO WINDOW TREATMENTS, PAGE 218)

Domestications
Unique Merchandise Mart
Building 40
Hanover, PA 17333
1-800-621-5800

Mail-order discount sheets, towels, bedspreads. Free catalog.

Eldridge Textile Company
277 Grand Street
New York, NY 10002
212-925-1523

First-quality name brands; average thirty percent discount.

Ezra Cohen Corp.
307 Grand Street
New York, NY 10002
212-925-7800

First-quality name brands. Workroom for custom drapes, dust ruffles, shams.

Fieldcrest Cannon, Inc.
Highway 14
Eden, NC 27288
919-627-3350 (NC)
Fieldcrest:
1-800-841-3336
Cannon:
1-800-237-3209

Twenty-three authorized factory outlet

stores; forty to sixty percent discount on seconds and discontinued patterns. Brochure.

Milmor Textiles
541 Broadway
New York, NY 10012
212-226-2444

First-quality name brands slightly above wholesale.

Wamsutta Mills Store
36 Groce Road
Lyman, SC 29365
803-433-4645

Discounted discontinued patterns and seconds.

MARBLE—SEE GLASS, MIRRORS, MARBLE, PAGE 213.

MIRRORS—SEE GLASS, MIRRORS, MARBLE, PAGE 213.

Oriental Grace

Akari Association
Isamu Noguchi Museum
32–37 Vernon Boulevard
Long Island City, NY 11106
718-204-7088

Genuine Akasi table and floor lamps of hand-made paper and bamboo ribbing,

designed by the famed sculptor. Stands available. Beautiful and well priced. Catalog, $1.

Arise Futon Mattress Company, Inc.
Executive Offices
39 Katonah Avenue
Katonah, NY 10536
914-232-4491

Chain in and around New York City. Easily-moved or stored comfortable mattresses and frames. Catalog, $2.

Asian House, Inc.
888 Seventh Avenue
New York, NY 10019
212-581-2294

Furniture, accessories, screens, and lamps from China, Japan, Korea, and the Philippines.

Azuma
666 Lexington Avenue
New York, NY 10021
212-752-0599

Budget-priced accessories and furniture.

Blue Horizons
205 Florida Street
San Francisco, CA 94103
415-626-1602

Mail-order Japanese shoji screen kits, in stock and custom sizes. Brochure.

Dragonwood Imports, Inc.
154 Hempstead Turnpike
West Hempstead, NY 11552
516-486-2444

Chinese furniture, porcelains, and screens, competitively priced.

Eastern Trading and Import Company
35 Willow Park Center
Farmingdale, NY 11735
516-293-3411

Imported Chinese antiques and contemporary furniture, carved and inlaid screens, ivory, lamps, lacquer.

Far Eastern Fabrics
171 Madison Avenue
New York, NY 10035
212-683-2623

Scarves for throw pillows and larger bolts of silks and cottons for upholstery or canopies.

Pier 1 Imports
Executive Office
301 Commerce Street
Ft. Worth, TX 76102
Customer Service:
817-878-8068

Budget-priced wicker, rattan, and lacquer. Three hundred stores nationwide.

Shibui Wallcoverings
P.O. Box 1638
Rohnert Park, CA 94928
1-800-824-3030
CA: 707-526-6170

Nature's own textures: grass cloth, jute, foliage. Deep discounts. For eighty samples and information, send $2 refundable with order.

Shibumi Trading, Ltd.
P.O. Box 1-F, Dept. DR
Eugene, OR 97440
1-800-843-2565
OR: 503-683-1331

Antique sake jars, kimonos; hand-picked collection to bring the Zen spirit of Japan into your home. Thirty-six-page color catalog, $2.

Yellow Monkey Antiques
Route 35
Cross River, NY 10518
914-763-5848

The Empire wing offers originals and fine reproductions from the Far East.

Salvage Companies and Eclectic Shops

Great for finding architectural artifacts, doors, mantels, chandeliers, gargoyles, stained glass, odd and wonderful art. Treasures of the future from buildings of the past.

Architectural Antiques
1330 East Second Street
Little Rock, AR 72202
501-372-1744

Brochure.

Architectural Salvage Warehouse
337 Berry Street
Brooklyn, NY 11211
718-388-4527

New York City Landmark Preservation warehouse.

Great American Salvage Company
34 Cooper Square
New York, NY 10003
212-505-0070

Chain (five other cities) with large inventory. Brochure.

Irreplaceable Artifacts
14 Second Avenue
New York, NY 10003
212-777-2900

Catalog, $3.

Pelnick Wrecking Company
1749 Erie Boulevard East
Syracuse, NY 13210
315-472-1031

"Salvage everything worth keeping" is its slogan.

United House Wrecking, Inc.
535 Hope Street
Stanford, CT 06906
203-348-5371

Many items from Europe.

Wrecking Bar, Inc.
292 Moreland Avenue NE
Atlanta, GA 30307
404-525-0468

Architectural artifacts and quality antiques.

Touches of Class (Trimmings, Hardware, Silver, Pillows, Scents)

Anne Tarasoff Etc.
8 Main Street
Roslyn, NY 11576
516-621-1107

Designer-selected decorative accessories (vases, boxes, candlesticks).

Beverly Bremer Silver Shop
3164 Peachtree Road NE
Atlanta, GA 30305
404-261-4009

Discount new and used silver flatware and hollowware. Will locate missing flatware pieces.

Ball and Ball
463 West Lincoln Highway
Exton, PA 19341
215-363-7330

Eighteenth- and nineteenth-century reproduction hardware for drawers, doors, windows, and shutters. Will repair, copy, or match almost any hardware. Free brochure; catalog, $5.

Boyds Madison Avenue
655 Madison Avenue
New York, NY 10021
212-838-6558

This posh pharmacy carries an extraordinary array of atomizers, decorative combs and brushes, potpourri, soaps, and vanity mirrors.

Crabtree & Evelyn
Scarborough & Company
1310 Madison Avenue
New York, NY 10128
212-298-3923

Crabtree & Evelyn
Executive Office:
P.O. Box 167
Woodstock Hill, CT 06281
1-800-624-5211 for nearest store
CT: 203-928-2766

For the elegant scent: Fine soaps, potpourri, candles, room sprays,

shelf-lining paper in a variety of colors and fragrances. Free mail-order catalog.

Hyman Hendler & Sons
67 West 38 Street
New York, NY 10018
212-840-8393

Tassels and tiebacks, fringes, cords, and ropes.

Horton Brasses
P.O. Box 95
Cromwell, CT 06416
203-635-4400

Reproduction Early American hardware. Retail and mail order. Catalog, $3.

J. Donald Fox
P.O. Box 995
Hampton, NH 03842
603-474-2225

Beautiful handmade weathervanes. Brochure, and price list, $1.

Period Furniture Hardware Company Inc.
P.O. Box 314, Charles Street Station
Boston, MA 02114
617-227-0758

A superb selection of drawer pulls, door knobs, keys, and clock finials, from Chinese characters and American eagle motifs; 120-page catalog, $3.50.

The Pillowry
19 East 69 Street
New York, NY 10021
212-628-3844

Pillows made from antique and vintage kilim and knotted rugs.

Quogue Emporium
99 Riverhead Road
Westhampton Beach, NY 11978
516-288-6262

Hand-selected picture frames, candlesticks, silver-plate, wicker furniture, etc.

Renovator's Supply, Inc.
4671 Renovators Old Mill
Miller Falls, MA 01349
413-659-3773

Fine hardware, plumbing, and lighting. Mail order; catalog, $3.

Sheffield Plate Polish Company, Ltd.
500 Davis Street
Suite 605
Evanston, IL 60201
312-328-3100

Manufacturer of the "Silver Solution" and the "Gold Solution," unique formulas that add pure silver or gold to silver-plate, copper, bronze, brass, nickel. Sold in stores and catalogs (Starcrest of California, Walter Drake). Instant richness.

Simon's Hardware
421 Third Avenue
New York, NY 10016
212-532-9220

A gigantic stock of
knobs, pulls, locks . . .

Sunrise Specialty Co.
2310 Fourth Street
Berkeley, CA 94701
415-845-4751

Fine antique-style
bathroom fixtures and
faucets.

The Tinsel Trading
Company
47 West 38 Street
New York, NY 10018
212-730-1030

Trims, tassels, cordings.

Westhampton Greenery
19 Mitchell Road
Westhampton Beach,
NY 11978
516-288-4438

Custom holiday
wreaths, including the
"Hampton Classic,"
and other decorative
accessories. Retail and
mail order. Free
brochure.

Wolfman-Gold & Good
Company
484 Broome Street
New York, NY 10013
212-431-1888

Delightful tabletop
accessories, bird houses,
antique paper hat boxes,
linens, and laces.

Wall Coverings

**(SEE ALSO FABRICS
AND WALLPAPERS,
HALLMARK, PAGE 210)**

American Discount
Wallcoverings
1411 Fifth Avenue
Pittsburgh, PA 15219
1-800-245-1768
PA: 412-471-6941

Large discounts on
wallpapers, related
fabrics, mini and micro
blinds, pleated shades.

Bradbury & Bradbury
Wallpapers
P.O. Box 155
Benicia, CA 94510
707-746-1900

Spectacular hand-
printed Victorian
silkscreen wallpapers
for walls, ceilings, and
borders. In-house
design service available
for use of papers.
Catalog, $6.

Fabulous Wallcoverings
846 Route 17 North
Paramus, NJ 07652
201-967-9680

Chain of discount
wallpapers and grass
cloth direct from mill.

Famous Wallcoverings
811 North Federal
Highway
Hallandale, FL 33009
305-458-1444

Six Florida locations
stock a wide variety of
discount wallpapers and
borders.

Hudson-Shatz Painting
Company, Inc.
429 West 53 Street
New York, NY 10019
212-757-6363

Decorative painting
techniques: gold leafing,
marbelizing,
electrostatic painting for
metal. Contractors.

Imperial Wallpaper
1-800-631-9341 (phone
only)

Name-brand wallpaper
at thirty to sixty percent
discount. Call with
name of book and
pattern number.

Janovic Plaza
1150 Third Avenue
New York, NY 10021
212-772-1400

Wide selection of paints
and color charts. Many
wallpaper books. One
store of a chain.

Stik-Trim Industries, Inc.
1001 Avenue of the
Americas
New York, NY 10018
212-354-1440

Manufacturer of self-
adhesive easy-to-apply
fabric borders. Write or
call for nearest dealer
and brochure.

Wall Street Wallpaper
2660 Harrison Street
San Francisco, CA
94110
415-285-0870

Discount wallpapers,
ten to fifty percent off.
Mail/phone orders.

Window
Treatments

Bedspread Mill Outlet
and Window Decorating
Center
69 State Road
North Dartmouth, MA
02747
617-992-6600

Discount bedspreads,
draperies, cornices,
valances, balloon
shades. Customized.

The Claesson Company, Inc.
Route One, P.O. Box
130
Cape Neddick, ME
03902
207-363-5059

Exclusive importer and
distributor of unique
and inexpensive
swagholders from
Sweden. Easy
installation and no
sewing for an instant
rich look. Also lace
fabrics and curtain
valances from Sweden
and Germany. Write or
call for information.

Country Curtains
Stockbridge, MA 01262
Phone orders:
413-243-1300
Customer service:
413-243-9910

A wide selection of balloon, ruffled, fringed, tiered, swag, and lace curtains, as well as canopies, bedspreads, tablecloths, and curtain rods. Free fabric swatches. Free fifty-page color catalog.

Five Town Decorators, Ltd.
346 Central Avenue
Lawrence, NY 11559
516-569-2608

Custom draperies, plus slipcovers, bedspreads, and reupholstery of antiques.

Joanna Blinds
4300 Madison Street, Suite B
Hillside, IL 60162
1-800-562-6620

Manufacturer of fine shutters and blinds. Call for nearest store.

Lexington Bazaar
1037 Lexington Avenue
New York, NY 10021
212-734-8119

Home accessories, including a large selection of inexpensive matchstick blinds.

Medina Decorators, Inc.
49 Lincoln Blvd.
Hempstead, NY 11550
516-481-4886

Drapes, blinds, shades. Free shop-at-home service includes upholstery.

Sabel Designs
530 Boston Post Road, Dept. 187
Marlboro, MA 01752
1-800-222-1669
MA: 617-485-0808
1-800-222-1552, MA only

Discount mail-order name-brand blinds, mini-blinds, shades. Free brochures.

Books

Better Homes and Gardens. Des Moines, Iowa: Meredith Corp., 1981.

————. *Your Windows and Doors.* Des Moines, Iowa: Meredith Corp., 1983.

Beurdeley, Michel. *Chinese Furniture.* Tokyo, Japan: Kodansha International (distributed through Harper & Row), 1979.

Cantor, Jay E. *Winterthur.* New York: Harry N. Abrams, Inc., 1985.

Clifton-Mogg, Caroline, and Piers Feetham. *Displaying Pictures and Photographs.* New York: Crown, 1988.

Conran, Terence. *New House Book.* New York: Villard Books, 1985.

Creative Ideas for Living. *Creative Ideas for Decorating.* Birmingham, Ala.: Oxmoor House, 1987.

de Wolf, Elsie. *The House in Good Taste.* New York: The Century Co., 1913.

Dickson, Elizabeth. *The Englishwoman's Bedroom.* Salem, New Hampshire: Salem House, 1985.

Emmerling, Mary Ellisor. *American Country.* New York: Clarkson N. Potter Inc., 1980.

Feild, Rachael. *Buying Antique Furniture.* London, England: Macdonald & Co., 1984.

Gandy, Charles D., and Susan Zimmerman Stidham. *Contemporary Classics.* New York: McGraw-Hill, 1981.

Gilliat, Mary. *Book of Color.* Boston: Little, Brown, 1985.

————. *Decorating on the Cheap.* New York: Workman Publishing, 1984.

Graham-Barber, Lynda, and Elizabeth V. Warren. *Personality Decorating.* New York: Fawcett-Columbine, 1985.

Guild, Tricia. *Designing with Flowers.* New York: Crown, 1986.

Hemming, Charles. *Paint Finishes.* Secaucus, New Jersey: Chartwell Books, Inc., 1985.

Horn, Richard. *Memphis.* New York: Quarto Marketing, Inc., 1985.

House and Garden's Best in Decoration. New York: Random House, 1987.

Innes, Jocasta. *Paint Magic.* New York: Pantheon, 1987.

Jenkins, Jo-An. *Decorating Furniture.* New York: Putnam, 1984.

Koji, Yagi. *A Japanese Touch for Your Home.* Tokyo, Japan: Kodansha International (distributed through Harper & Row), 1982.

Kron, Joan. *Home-Psych.* New York: Clarkson N. Potter, Inc., 1983.

————, and Suzanne Slesin. *High-Tech.* New York: Clarkson N. Potter, Inc., 1978.

Leopold, Allison Kyle. *Victorian Splendor.* New York: Stewart, Tabori, Chang, 1986.

Lesieutre, Alain. *The Spirit and Splendor of Art Deco.* New Jersey: Castle, 1978.

Liebetrau, Preben. *Oriental Rugs in Colour.* New York: Macmillan, 1962.

Mavher, Christine, and Sharon Woods. *Santa Fe Style.* New York: Rizzoli, 1986.

Mazzurco, Philip. *Media Design.* New York: Macmillan, 1984.

Miller, Judith, and Martin Miller. *The Antiques Directory.* Boston: G. K. Hall & Co., 1985.

Moulin, Pierre, Pierre LeVec, and Linda Dannenberg. *Pierre Deux's Country Book.* New York: Clarkson N. Potter, Inc., 1984.

Naylor, Gillian. *The Bauhaus Reassessed.* New York: E. P. Dutton, 1985.

Niesewand, Nonie, and David Stevens. *Conran's Creative Home Design.* New York: Little, Brown & Co., 1987.

Niles, Bo. *White by Design.* New York: Stewart, Tabori, Chang, 1984.

O'Neil, Isabel. *The Art of the Painted Finish.* New York: William Morrow, 1971.

Rense, Paige. *Decorating for Celebrities.* New York: Doubleday & Co., 1980.

Rossbach, Sarah. *Interior Design with Feng Shui.* New York: E. P. Dutton, 1987.

Rybczynski, Witold. *Home.* New York: Viking Press, 1986.

Sabino, Catherine, and Angelo Tondini. *Italian Style.* New York: Clarkson N. Potter, Inc., 1985.

Sack, Albert. *Fine Points of Furniture.* New York: Crown, 1978.

Slesin, Suzanne, and Stafford Cliff. *English Style.* New York: Clarkson N. Potter, Inc., 1984.

——. *French Style.* New York: Clarkson N. Potter, Inc., 1982.

——, and Daniel Rozensztroch. *Japanese Style.* New York: Clarkson N. Potter, Inc., 1987.

Sudjie, Deyan. *The Lighting Book.* New York: Crown, 1985.

Swedberg, Robert, and Harriett Swedberg. *Country Pine Furniture.* Des Moines, Iowa: Wallace-Homestead, 1983.

Sweeney, John A. *The Treasure House of Early American Rooms.* New York: W. W. Norton, 1963.

Szenasy, Susan S. *The Home.* New York: Macmillan, 1985.

Waites, Raymond, Behye Martin, and Norma Skurka. *Country Style.* New York: Harper & Row, 1984.

Wise, Herbert H. *Attention to Detail.* New York: Putnam, 1979.

Periodicals

Antiques
Architectural Digest
Art and Antiques
Better Homes and Gardens Decorating
Colonial Homes
Country Living
Early American Life
Home
House and Garden
House Beautiful
House in the Hamptons International
Metropolis
Metropolitan Home
Southern Accents
Traditional Home
Western Accents